KT-417-511

RODIN

MONIQUE LAURENT

RODIN

TRANSLATED BY EMILY READ

BARRIE & JENKINS

LONDON

First published in Great Britain in 1990 by
Barrie & Jenkins Ltd
20 Vauxhall Bridge Road, SW1V 2SA

Copyright © 1988 Sté Nlle des Éditions du Chêne

Translation copyright © 1990 Emily Read

All rights reserved. No part of this publication may be reproduced, stored
in a retrieval system, or transmitted in any form or by any means, electronic,
mechanical, photocopying, recording or otherwise, without prior permission in
writing from the publisher.

British Library Cataloguing in Publication Data
Laurent, Monique
 Rodin.
 1. French sculpture. Rodin, Auguste. – Biographies
 I. Title
 730'.92'4

 ISBN 0-7126-2059-1

Typeset by SX Composing Ltd
Printed in Switzerland

Rodin

Auguste Rodin – with the exception of Pablo Picasso no other European artist has been both so notorious and so famous in his own lifetime. His renown extended far beyond Europe, to the United States in the West and to Japan in the East. Indeed, it was in Japan that the literary review, *Shirakaba,* brought out a special issue to mark his seventieth birthday and when Rodin died in 1917 the world press praised his genius in terms amounting to idolatry. Such acclaim can have its drawbacks and official recognition can come like the kiss of death: the artist's reputation becomes embalmed in respectability and his work itself neglected or treated with condescending over-familiarity. This is what happened to Rodin and for a time he became the victim of his own success. Genuine appreciation of certain of his works has been dulled by too frequent exposure to reproductions of his most celebrated creations and commercialisation of his masterpieces has done its worst: *The Thinker,* for example, has been exploited to advertise computers, household gadgets and philosophy textbooks. His life-work, though admired, has been regarded by some as old-fashioned and by others as excessively romantic.

Today this trend is being reversed and several factors have contributed to his rediscovery. A return to certain lyrical qualities in sculpture, as illustrated in the work of Germaine Richier and Giacometti, has turned attention towards him. Exhibitions of his work are constantly on the move from Japan to Scandinavia, Mexico to India or Germany, from Spain to the United States. Endless scholarly studies are published, made possible by researchers having access to unpublished archives and studio stocks kept at the Musée Rodin.

A great movement has begun. People are no longer happy just to cast a fresh eye on well-known pieces, they wish to study maquettes, sketches and variations which have remained hitherto undiscovered, and whose bold inventiveness appeals to modern sensibilities. There are also thousands of drawings in which he celebrates the sensuality of the female form in its infinite variety and to which contemporary erotic awareness strongly responds.

Today, more than ever before, Rodin enjoys world-wide acclaim. The aim of this book is to attempt a biographical journey through the medium of his work for both his public and private life were always entirely dominated by his vocation. Although he lived so comparatively recently, it is hard to have a clear picture of Rodin. Documents concerning him must be handled with care; he went from being attacked to becoming world famous, so that his actions and words, more or less accurately related by those around him, and the mass of articles about him, both polemics and eulogies, have sometimes succeeded in obscuring the truth about the difficult and glorious life of a brilliant personality endowed with very human failings.

To understand the importance of Rodin's contribution to sculpture (he was the exact contemporary of the painter Claude Monet) we must first look at the state of sculpture in France in the second half of the nineteenth century, and observe that the plastic arts were dominated by painting rather than sculpture. It was painting that held the interest of the patrons, the critics and the public at the Salons. Painting was where the geniuses were to be found. Perhaps it was the rapidity of execution that appealed to the contemporary taste for spontaneity.

The material demands of sculpture explain why it evolved more slowly than painting. A painter's costs are modest, sculpture is expensive. The tools and materials, the space needed to make and store work in progress all make sculpture an onerous task. Also the technical demands are such that collaborators are necessary – *praticiens,* moulders, casters, polishers – who all share with the artist in the final realisation of the work. Sculptors at that time, and Rodin in particular, were essentially modellers, working in earth and clay, making a small scale sketch in free but accurate workmanship of their first conception of the work. After this preliminary stage, which they rarely

kept, the work, now in a definitive format and relief, was "mounted" in clay kept soft by being wrapped in damp cloths between sessions. When the work reached the desired degree of perfection, a plaster mould was made to produce an identical shape, then taken to the founder who, in several complex operations, would cast the work in bronze. The moulding operation usually involved the destruction of the clay and the plaster cast then took on the value of an original.

In the case of a marble or stone statue, he did not hew directly like Michelangelo, attacking the stone with chisel or mallet until the statue appeared. A plaster original remained the starting point and the shape was transferred to the marble by means of a mechanical procedure derived from the draughtsman's pantograph or "machine for setting points" or "three compass system".

The heavy work of reducing the block to the rough shape of the sculpture, removing the stone to within a few millimetres of the final surfaces was left to the point-setter and the *praticien;* the sculptor performed the final operation himself giving the work its definitive appearance, expressing his artistic sensibility through the play of the light on the surfaces.

One can well imagine the heavy expense of such methods; and it would explain why even great artists like Géricault or Daumier should have abandoned sculpture for painting, and also why what sculpture they did was often left at the fragile and perishable clay or plaster stage, for want of the means to pay the technical expenses, or of a definite commission. Another reason for the subordination of sculpture was the long apprenticeship that the student was obliged to spend in the service of successful sculptors. Contemporary accounts also all observe that their social position was mostly inferior to that of painters. Their manual dexterity with materials regarded as coarse, such as plaster or clay, made it hard for sculptors to be accepted as great masters. With the exception of a few who were regarded as being socially acceptable, they often suffered from a kind of intellectual segregation. Relying as they did on a skilled workforce, whose help was vital to them, they tended to become confused with them and failed to integrate with the artistic community. Unlike the solitary painter, the sculptor worked with his hands and in a team. Baudelaire's scornful phrase, "A unique mystery should not be fingered," was still current at the end of the century.

There was also the question of the public and the subject-matter. Who bought sculpture and what did they buy? The state and the municipalities had a policy of commissioning public monuments and official statues to honour great men. After the defeat in the Franco-Prussian war of 1870, a series of works began to appear praising bravery and patriotism in heroic and moving terms. At the same time there was a well-to-do clientele, with mainly conservative tastes, interested in other themes. Portraits were even more popular than in the eighteenth century – they took the form of busts or medallions and physical resemblance was the main priority. Drawing-room statuettes abounded thanks to new mechanical procedures which enabled a famous statue to be reduced to the size of the base of a mantelpiece clock. The technical perfection of these products concealed a painful lack of creativity and reduced the work of art to the status of mere object. But people had to earn their living. . . . Finally funerary art as it can be seen in the great Parisian cemeteries such as the Père-Lachaise, provides an accurate reflection of a society anxious to flaunt its material success and family power. Rodin, confronted with these different types of commission, brought to each one a new solution. He changed the image of patriotic sacrifice with the moving group, *The Burghers of Calais;* he often upset his models who were disconcerted by the image he had of them; and his monument to the poet Sourisseau at Amiens remains one of his most poetic creations.

It is clear that for sculptors in Rodin's time as in previous ages, the human figure is practically the only one used to symbolise the great forces of nature, passions, ideas and feelings. There was no question of Rodin challenging this tradition – on the contrary, he made it the pivotal point of his work – but his way of examining it from all sides and of obtaining his observations from life, resulted in entirely new plastic and expressive effects, with which he would refute academic tenets that were all-powerful at the time.

Academism could be defined as the authoritarian and dogmatic organisation of art-teaching; the "mandarins of the system" – in this case the members of the institute – reserved for their cronies official rewards and commissions using their control over access to the annual Salon. Its starting point was the principle whereby art must give an idealised picture of the real world; from this principle stemmed the whole system of references based chiefly on imitation of classical art which was considered the clos-

est to the idea of beauty. As a result subjects were graded and positions regulated into a kind of sign language: a seated position symbolised intellectual activity; a man of action would be standing; war was on horse-back, and the defeated were lying down. For reasons of modesty a woman must never be shown with her legs apart. Materials were classified in the same manner with marble at the top of the scale – coarse clay and plaster were reserved for the intermediary stage between creation and transposition into a noble substance. Rodin took an anti-academic line: by preserving many of his statues in plaster he was able to make use of its plastic effects and its matt, unreflecting, light-absorbing surface.

1895: "As you know I am not a clerk, and am confused by having to speak or write, my natural medium being clay or the pencil." He handled clay and pencil happily from 1854 to 1857 at the special Imperial school of drawing and mathematics, known as the Petite Ecole as opposed to the great Ecole des Beaux-Arts, predecessor of the present-day Ecole Nationale Supérieure des Arts Decoratifs. This establishment aimed mainly to turn out *ornemanistes, praticiens,* artisans rather than artists; one can imagine the resistance Rodin had to overcome in order to be allowed to go there, when his father had always extolled work and perseverance as ways of becoming "a man above the common worker".

Academic principles, favoured by uncreative and mediocre artists concerned mainly with finish and technique, easily took hold. High-flown ultra-conservatism became the norm. In the Second Empire, Carpeaux, who had a deep sense of individual life and a taste for decoration in the eighteenth-century tradition, managed to escape from academism; on the other hand the so-called "eclectic" sculpture of his time was seeped in it. Without a reviving artistic theory, they produced pastiches of previous styles – official sculptors anxious to retain the custom of their patrons withheld from them any innovation which might alter their aesthetic taste. At last came Rodin. . . .

He was born on 12 November 1840, in Paris at 3 rue de l'Arbalète, and was named François Auguste René. His father, Jean-Baptiste, originally from Normandy, had been married first to Gabrielle Cateneau, about whom nothing is known, but by whom he had a daughter, Clothilde, who seems to have disappeared from the family after Jean-Baptiste's remarriage in 1836 to a girl from Lorraine, Marie Cheffer. Can one assume from Jean-Baptiste's unremarkable career in the police Prefecture that he took part in the repressive actions of the Second Empire? In the absence of documents one must be cautious, but we do know that the family, with its modest rural origins, was conservative and deeply Christian. Auguste had a sister three years older than him whom he loved dearly. His academic career was mediocre, partly because of his short-sightedness; he went first to the school of the Brothers of the Christian Doctrine, and then, from the age of eleven to thirteen, to his uncle Hippolyte who was a teacher in Beauvais. He never improved his hopeless spelling and extravagant punctuation, and produced extraordinary letters in which clumsy improprieties lay alongside the most elegant expressions. He always regretted being unable to express himself better, although there was also a tinge of pride, as when he wrote to a friend in

The Petite Ecole continued in the pedagogic tradition of the eighteenth century, that is using old documents, sketches of monuments and costumes to familiarise the students with draperies. They benefited from the talents of an exceptional teacher, Horace Lecoq de Boisbaudran, who based his teaching on observation of life and the development of visual memory, thus retaining each pupil's individual sensibility. "The greater part of what he taught me still remains with me," Rodin was to say in 1913. Working with this master he acquired manual dexterity and suppleness of execution; this was enriched with drawing sessions among the antiquities of the Louvre, and the Italian Renaissance prints of the Bibliothèque Imperiale, and they had free run of the Gobelin manufacturing works. Because of his excellent results, on the advice of Fort, one of his teachers, and at the urging of Hippolyte Maindron, a romantic sculptor of literary themes (his *Velleda* came from Chateaubriand's *Martyrs*), Rodin tried three times in 1857, 1858, and 1859 to enter the Beaux-Arts to practise "great sculpture". He passed the drawing competition but failed the sculpture: his *fa presto* clashed with the neo-classical tradition. He was thus spared an apprenticeship to an arid and stereotyped repertoire, the substance of modern art at the time.

As a result of this setback, the need to earn his living forced him, at the age of eighteen, to begin work with a firm of bricklayers and decorators, Blanche, Garnier & Cruchet. There was plenty of work as the fashion of the time was for garlanded façades, decorative masks and balconies supported by caryatids; Paris at the time of Baron Haussmann was one great building site. Despite the gaps in his studies, Rodin had acquired a basic amount of cultural knowledge, dominated by classical art. Now, practising modelling, carving and moulding, he had mastered all aspects of his work with an ease which may explain the sheer quantity of his production. He

was, perhaps, the last sculptor with such a perfectly rounded training.

So began life as a jobbing workman. In August 1860 he was earning five francs a day and he wrote, half-joking, half-bitter to his aunt in Lorraine, "When one is a sack-carrier, one must carry one's sack." On 8 December 1862, his sister, Maria, who had become a novice with the Ursulines after being jilted by the painter Barnouvin, died at the age of twenty-five. Rodin, who had been a friend of the unfaithful suitor, may have felt responsible for his much-loved sister's tragedy. At any rate, he underwent a mystical crisis as a result, and thinking that he had a religious vocation, took refuge with the Brothers of the Holy Sacrament, an order that had been recently created by Father Eymard. This priest, recognising the novice's artistic potential, advised him to return to secular life. A sculpted portrait of a tormented Father Eymard, grimacing almost (which the latter much objected to), bears witness to the blind passion from which the young man was suffering at the time.

Several biographers have made much of restoration works at Notre-Dame, and even of religious sculptures at Strasbourg about which nothing is known, suggesting that they might be Rodin's work; if they are indeed his, they would confirm Rodin's oft-asserted taste for the Middle Ages, reaffirmed in 1914 by a book written in collaboration with Charles Morice, *Les Cathédrales de France.* In any case, he wrote two tender and intimate letters from Strasbourg, "Ah, my little Rose, I wish a good fairy would waft you through the air and bring you to me, I would very much like to . . . oh, but I was about to say silly things; anyway I kiss you with all my heart."

Rose was Rose Beuret, a young working girl he met in 1864, by whom he had a son, Auguste, whom he never legitimised. He married Rose on 29 January 1917, the year of both their deaths. Throughout their fifty-three years of life together, punctuated by crises and betrayals, the artist's career reached pinnacles of international glory, while she always remained a rough, unpolished woman of the people; she never adapted to what she called the public persona of "Monsieur Rodin"; ambassadors and monarchs visiting the master would find her bent over the washbasin with soap up to her wrists. She remained the faithful, constant model of poorer days, a sort of "Maître Jacques", looking after the studio, damping the clay to prevent it from drying out, to whom he always returned, despite all the others.

It seems that Rose was Rodin's first love. The sexual fulfilment resulting from their meeting was represented in tender maternity scenes and neo-rococo portraits such as the *Young Girl in a Flowered Hat* a brilliantly executed bust with an expression of strange yearning that hints at the atmosphere of future works. A sculpture of a very different nature was turned down by the 1864 Salon: *The Man with the Broken Nose* is the portrait of an old man from the faubourg Saint-Marcel, with a deformed face, called Bibi. Rodin tells us that it was presented as a mask because the cold in the studio had cracked the original clay separating the skull from the face. It is an attempt to combine realism with a classical reference as it also evokes the classical Greek portrait of Socrates in the Louvre. *The Man with the Broken Nose* displeased the Salon because of its realism. The period between 1865 and 1870 marks the first phase of Rodin's collaboration with Carrier-Belleuse, the fashionable Second Empire decorative sculptor. Also trained at the Petite Ecole, Albert Carrier-Belleuse (1824-87) exemplified the huge expansion of what, under the designation of "art applied to industry", was a form of mass-production, helped by constant innovations in techniques of reproduction. Faced with foreign competition, and encouraged by the notion of progress, which was deemed to be applicable to all spheres of activity, commercial interests began trying to improve the quality of the models, thus applying artistic criteria to the manufactured objects which were in such demand from the newly ascendant middle classes under Napoleon III. Besides his great talent as a sculptor, with his flexible and refined sense of composition, Carrier-Belleuse was a brilliant businessman and organiser. His highly productive workshop produced, amongst other things, the architectural decorations on the casino at Vichy, the great entrance to the Opéra, and the famous neo-Renaissance group at the Hôtel de la Païva on the Champs-Elysées, now the Travellers Club. He made light and elegant use of the human form in his models – torchères, odd busts, decorative bronzes – which were produced to a high standard with lavish use of materials.

As an anonymous member of this workshop, Rodin modelled pieces which were signed by the patron; these subordinate tasks may have been frustrating, but at least they provided him with experience in running an important studio which had a policy of active commercial distribution, eliminating the middle man. He was to remember this. For the time being, however, he earned his living by imitating historical styles: one can still see in Paris, for example, his pastiche of the Renaissance on the façade of the Gobelins theatre, now a cinema.

The 1870 war broke out. Rodin was mobilised into the National Guard but was soon discharged because of his short-sightedness. All artistic activity and building work came to a halt, interrupted by events. We do not know his reactions to the fall of Napoleon III, the rise of the republican regime, the drama of the Paris commune. It is not certain he had any. In a recent work, Pierre Daix rightly emphasises

that Rodin was never a revolutionary, and that people from his very ordinary background rarely supported republicans or demonstrators.

Without an income and needing to support his young family, he joined Carrier-Belleuse in Brussels in February 1871, leaving Rose and young Auguste in Paris. Brussels, the prosperous capital of a neutral country, where Carrier-Belleuse had installed himself at the outbreak of hostilities, was at that time a rich hive of artistic activity, with burgomasters Anspach and Brouckère engaged in huge urban building projects. Carrier-Belleuse reassembled his workforce here, and also recruited Belgian artists, such as Julien Dillens and Joseph van Rasbourg; he was commissioned by the architect Suys to embellish the Bourse – Rodin was to participate in this. Along with the affection displayed in his letters to Rose at that time, one can detect a certain secretiveness and reticence about showing his feelings: "My spirit was flying towards you . . . You see I was about to become sentimental. I am so changeable that even sentimental little thoughts can come my way . . . as long as they don't come too often, I don't like being tyrannised even by agreeable feelings."

Three months later, he and his employer had a quarrel which demonstrated the draconian conditions under which *praticiens* like himself were forced to work: he was tied by an exclusive contract with Carrier-Belleuse which forbade him from producing anything under his own signature or for his own profit. Unfortunately he needed more money to send to Rose who was supporting both her child and her parents, and he succumbed to the temptation of selling a few statuettes to the Compagnies des bronzes in Brussels, which also did the casting for Carrier-Belleuse. When the latter heard about this he sacked Rodin from his team. Misery loomed: "I have not a penny at the moment; a chemist and one of my friends have very kindly helped me, otherwise I don't know what I would have done. I asked you in my letter to take my trousers to the pawnbroker, it was free then." (To Rose, before October 1871.)

Luckily Carrier-Belleuse returned to Paris as soon as everything was calm again, leaving the Bourse work to van Rasbourg, who once again called in Rodin. From 1873 onwards the two friends formed a partnership which stipulated that their common production in Belgium would be signed only by van Rasbourg and that only the works destined for France would carry the name of Rodin. They worked together on the Bourse, the Palais des Académies, the Brussels Royal Conservatory of Music, and the monument to Burgomaster Loos in Antwerp. As well as these public commissions, Rodin managed to obtain private work which was available thanks to the current fashion for elaborate decorations on the important new buildings along the new boulevards in the centre of Brussels. He improved his financial situa-

tion by carving caryatids, and allegorical and mythological figures, and Rose was able to join him, leaving young Auguste in the care of his aunt Thérèse, his mother's younger sister, who had also been looking after Jean-Baptiste since the death of Rodin's mother in 1871. We do not know the circumstances of her death any more than we know anything of her son's grief. Despite the enormous volume of correspondence we know little of his emotional life at that time, possibly because he lived in such humble conditions that what intimate documents there may have been were thought not to be worth keeping.

There followed several happy years during which the young couple, freed from family ties, were able to enjoy their youth. Rodin experimented with an unlimited edition of fancy busts in an insipid eighteenth-century style. "Portraits" of affected, idealised young girls *(Suzon, Dosia),* typical examples of *bronze d'art* popular among his bourgeois clientele can still be found in private Belgian and Dutch collections. At the same time he showed his work regularly – at the Salons in Ghent, Antwerp and Vienna in 1874, and in London in 1875 – demonstrating his desire to escape from hack work by promoting his own art.

This preoccupation came to a head with his crucial trip to Italy at the end of the winter of 1875. Travelling in very humble conditions – part of the journey was made on foot – he discovered Turin, Sienna, Padua, Venice, Rome and, most important of all, Florence. When he set out, he was no more than an ornamental sculptor who could adapt himself easily to any requirement. When he returned, his true personality had emerged with the shock of discovering Michelangelo. His life-work as an artist had begun.

Italian art, which had been the main reference point of all artists since the Renaissance, was still, at that moment of the nineteenth century, an immensely prestigious source of inspiration. In England, the Pre-Raphaelite Brotherhood was reacting against the forces of Victorian materialism and drew new inspiration from the Italian primitives. In France, Donatello was worshipped by the so-called "Florentine" group of sculptors, which included Falguière and Paul Dubois. The critics Ruskin and Dubois fuelled the general infatuation. Rodin, understandably, needed to make direct contact with works he had hitherto only seen reproduced in the form of mouldings or engravings.

There were three moments of revelation during the journey. In Rheims he discovered the beauty of

Gothic art; his painter's eye was struck by the marvels of the Alps and the "green-purple-blue mountains" of Tuscany; and, finally, there was Michelangelo in Florence. Since he had no materials with which to model, he drew, both on the spot, and in the evening, from memory, as he had learned to do at the Petite Ecole; the idea was to dismantle and understand the different planes of this type of sculpture, with its movement of muscles that made it so different from the stability of Greek sculpture. Rodin later took his sketch-books to pieces, and stuck them together again in a curious series of collages. There are surprising gaps – the ceiling of the Sistine chapel (although we know he visited the Vatican), the Pièta, the David, the designs for the Medici tombs – although he must have examined these crucial works, which were to provide later inspiration. At any rate, it was the discovery of Michelangelo that determined his definitive move, on his return to Brussels, from statuette to life-size figure; he began to do this without commissions, just to prove that he could master that most noble form of sculpture, the large statue. A large Bacchante was destroyed during a move. In 1877 he alludes to an Ugolino thought to have been lost, but of which a plaster cast was recently rediscovered at the Musée Rodin. It is of a man sitting in a hunched position – its concentrated power seems to prefigure that of *The Thinker*.

What has been called "the Belgian period" ended with a turning point – *The Age of Bronze*, a synthesis of precise anatomical study, memories of classical statuary and the influence of Michelangelo. Its public exhibition aroused scandal and at the same time marked the true beginning of the artists personal career.

The Age of Bronze is traditionally dated 1877, but was more probably begun in mid-1875, taken up again after the journey to Italy and completed at the end of 1876, since Rodin said he spent eighteen months working on it and it was exhibited for the first time in January 1877. The model was a young Belgian soldier, Auguste Neyt – Rodin did not like using professionals who had learnt their poses from an academic repertoire. He preferred the model to adopt the required pose in a completely natural manner. Later on, he would have several models wandering freely around the studio, and he would sketch fleeting gestures and expressions to incorporate into his sculpture. He was always extremely precise about the contours of a figure, "the profiles", and, not content with being at the same level as his subject, would use a fresco-painter's step-ladder to study the planes of head and shoulders in relation to the feet. *The Age of Bronze* was a painful achievement: "I was in such despair over this figure and I worked so intensely at it, trying to achieve what I had in mind, that there are at least four figures in the one," he told Truman Bartlett in a series of interviews published in June 1889. This despair was the result of an attempt to achieve perfect fidelity to the model, and may also have stemmed from Rodin's uncertainty as to the significance of this naked masculine figure. What was it trying to express? The titles given to the statue when it was exhibited at the Cercle artistique de Bruxelles in January 1877 – *The Defeated* or *The Wounded Soldier* – and a sort of wound on the forehead, indicate some kind of unhappy heroism. The sorrowful look, the despairing gesture of the right hand, the slightly unsteady stance might therefore have been a reminder of the defeat of 1870, a shock still fresh in the national memory. The annexation of Alsace-Lorraine, which put into question the great concept of inviolability territorial implanted during the Revolution, might explain an image of a mutilated mother-country. On the other hand, when Rodin exhibited it at the Paris Salon in the spring of 1877, it carried its present title, that of one of the earliest ages of man; critics are still discussing this ambiguity. It has been thought that the choice of a less precise title than the preceding ones was intended to neutralise criticisms already made in Brussels as to the lack of props; this flouted the academic tradition by which every subject had a conventional attribute for ease of identification. *The Age of Bronze*, and its later titles, *Primitive Man, Man Walking up to Nature, The Dawn of Humanity*, might have been, as Rodin said to Frédérik Lawton in 1904, an evocation of Hesiod's *Theogony*, which told of the beginning of the world, and the cycles of man divided into the ages of gold, silver, bronze and iron; or it might have been a reminder of another myth in Ovid's *Metamorphoses*, where mankind remakes itself after a flood, with stones turning into men. We know by the contents of his library that Rodin was familiar with classical literature, but this familiarity probably came later, in which case these interpretations would be a *posteriori*. Might it also be a representation of Jean-Jacques Rousseau's primitive man, just becoming conscious? In which case the gesture would not be one of despair, but would represent the transition between the inanition of matter and the first tremor of the spirit. One might also wonder if the changes of title might not have been the result of a perspicacious political move on Rodin's part – an opportunistic illustration of evolution and progress to coincide with an imminent republican majority in parliament.

At any rate the uncertainty over the changing titles remains, giving rise to associations of ideas and private interpretations and an almost literary view of the work, linking it to symbolism. The most perceptive of the critics were in favour of this poetic view, feeling that it enhanced understanding of the work, others – the artist's detractors – were irritated by it.

The exhibition of *The Age of Bronze* at the Salon turned into a disaster, when Rodin was accused of having made the statue by moulding it from a live model. There had already been curious remarks in the *Etoile Belge* on 29 January 1877: "It will not pass unnoticed, because if the attention is attracted by its strangeness it is retained by a quality as precious as it is rare – life itself. What part *surmoulage* (moulding from life) played in this cast, it is not for us to say here." This accusation was taken up again in Paris, because of the statue's anatomical precision, so different from the academic stiffness to which the public was accustomed. The statue, unidealised, built up in subtle planes which reflected the light, seemed slavishly close to nature. Dismayed and worried, Rodin wrote to the president of the Salon: "What pain to see this statue, which could help my future – slow in arriving as I am already thirty-six years old – what pain to see it rejected because of a damaging slur." He expressed despair but also obduracy to Rose who had remained in Brussels: "I don't know what to do, I owe money everywhere, no more money. When you come you will have to help me because, my poor Rose, I will know on Friday if I have got anything, but the purchases have been made and mine has not been bought. I am rejected along with my beautiful creation. They say I have made a cast of a dead body, and revived stupid rumours that I have been swindling people. You can see how hard life is going to be as all my money will go in another try and I hope I will earn some then. The future is very bleak, only misery in store."

A group of the more official sculptors – Paul Dubois, Alexandre Falguière, Eugène Guillaume – intervened to clear Rodin of the suspicion of imposture. He sent photographs of his model, and mouldings taken on him so that the jury could see the differences of relief. It is unlikely that the comparisons were ever made, the work was badly presented and he got no compensation. It was only in 1880 that the sculpture was cast in bronze and bought by the State: the casting is today in the Musée d'Orsay.

Rodin understood from this daunting experience that his struggle against the establishment would have to take place in Paris, and Rose joined him there in August 1877. The following year, he tackled another great subject, Saint John the Baptist, and this time he decided to make it larger than life, partly to refute accusations of *surmoulage* which continued to obsess him. According to his biographers, the idea came to him when a forty-year-old

Italian, Pignatelli, not a professional model, was brought to his studio by a friend. He placed himself confidently in such a splendid position that the sculptor, modelling him, anticipated one of the major problems of twentieth-century art: how to integrate the notion of time and movement into sculpture – this was to be the subject of the researches of the Futurists with Boccioni, as well as Matisse and the Cubists. The walking movement of *Saint John the Baptist,* with the two feet on the ground, legs apart, suggests a series of steps rather than the academic *contraposto* in which the weight of the body rests on one leg, in a sense freezing the figure into a fleeting pose.

To this subject, which has been codified in traditional iconography – the ascetic emaciation, hallucinated stare, goatskin tunic, the presence of a lamb and a cross – Rodin introduced a very new physical type, which held new conviction thanks to its complete nudity, its muscular athleticism and its authoritative rather than mystical demeanour. This unleashed a new wave of criticism. *The Precursor*'s nudity was condemned: "It reaches the limits of ugliness and futility. Rodin proves with his *Saint John the Baptist* that vice can find its expression and ugliness its limit. It would be hard to find anything more repulsive than this statue." Courbet's most recent works, with their search for absolute truth, aroused the same kind of criticisms.

Another work, *The Walking Man,* subject of many commentaries, was closely related to *Saint John the Baptist.* The proportions and pose were similar, but there was no head or arms – this was Rodin's first fragmentary sculpture, the first example of his taste for the unfinished. The artist was establishing his authority over what had until then been intangible, the human form in its entirety; by mutilating it he demonstrated the expressive nature of the body alone, and the sculptor Jacques Lipchitz was to explain later how this idea influenced the Cubists: "What Rodin did instinctively was not so different from what we the Cubists did in a more intellectual way . . . He was even ahead of us." Rodin's partially complete figures soon took on a systematic aspect, perhaps under the influence of his taste for often incomplete antique sculpture and unfinished marbles. The nature of *The Walking Man* and the lack of dated information make it hard to discover whether it is a study, a variation, or a later interpretation of *Saint John the Baptist.* Presented then as a study for *Saint John the Baptist,* it was shown in public in 1900 only in half-size, and at the 1907 Salon in a larger than life-size version. Modern researchers have wondered about the sculpture's lack of cohesion, which could be the result of his having assembled two separate studies: the torso taken from an

archaeological fragment, which would explain its rough uneven surface, and the legs from a live model.

During the crucial decades of the seventies and eighties, Rodin, in the effort to earn his living as well as make himself known, tackled several different types of work. Piecework, subcontracted to him by workshops, varied from models for furniture to monumental masonry and jewellery, all the things he had been doing all along to earn his daily bread. Some of these have been identified. There are, in the Musée Rodin, full-size models and masks made for the great fountain in the gardens of the Trocadero palace, designed to spout water into a basin. This fountain disappeared when the palace was demolished and replaced in 1935-7 by the present Palais de Chaillot, but at the time it was one of the most famous spots in Paris, a favourite meeting-place for visitors to the parades and festivities at the Great Exhibition of 1878. The decorative sculptor who obtained the commission, Legrain, received a gold medal for his achievement, which included eleven masks in stone. It is hardly surprising that Rodin described the job to Truman Bartlett as an "unpleasant experience". The quality of his two surviving masks explains his regret and frustration at the enforced anonymity, for the two faces, inspired by the décor of Italian grottos and probably representing Good and Bad Weather, are particularly lively, fiercely malicious and forceful.

In 1879, another purely mercenary job came along, this time for Charles Cordier, a fashionable sculptor and pupil of Rude, famous for his busts of exotic figures in bronze and polychrome marble, such as *The Sudanese Negro* in the Louvre. For three francs an hour, Rodin made two caryatids in the shape of sirens around a large bay – this was for the Villa Neptune on the promenade des Anglais at Nice, the property of the singer Madame Schoen. These sensual, full-blown figures can now be seen in the garden of the Musée des Beaux-Arts in Nice.

Many works on Rodin attribute to him some participation in the décor of the Palais des Beaux-Arts in Marseilles. Certainly several letters to his friend, Léon Fourquet, confirm that the latter was carving stone for allegorical subjects for public buildings in Marseilles, but there is nothing to prove that Rodin worked on them. We know that he visited Marseilles from Nice and found the museum "incredibly stupidly arranged". He saw there several works by the baroque sculptor, Puget, which no doubt influenced him, but nothing more than that.

The period 1877-82 also saw several projects for public monuments, an art form which was reaching its zenith at that time. Having been, in the two pre-vious centuries, an instrument for the glorification of the monarchy, the public monument in the nineteenth century would take many different forms in order to express the new collective will of society. The development of public sculpture resulted from political changes which made it necessary for those in power to make themselves known, and their ideas more widespread. It also coincided with the Positivist thinking which held that art was a public activity and a means of educating people. Henri Jouin wrote: "A statue needs the worn ground of the big city, the noise of the public square and the street, the street which belongs to the people." A monument must make progress a solid thing, and must honour the servants of the country, exalting the nation and its great men. Baudelaire in his *Curiosités esthétiques* (1859 Salon) describes "those immobile people, towering over those who pass before them, who tell in silent words the pompous legends of glory, war, science and martyrdom".

There was, too, the fact that cities had been enriched by the industrial revolution, which led to the collective financing of statues through local taxes or public subscriptions. Finally, the inaugural ceremonies became political events, and gave rise to public celebrations during which those in power could harangue the crowd on the issues of the day.

Rodin was never very happy with public sculpture for a variety of interrelated reasons. First, because for him the subject – usually a specific concept to be developed with the help of allegorical accessories understood by all – was something he never approached in a traditional manner. People were disconcerted and shocked by his highly personal creative imagination, and the ambiguous roundabout way in which he would develop a theme. Second, he gave at least as much importance to his own aesthetic style as to the precision of the representation. Seeking a more original type of monument than those whose academic qualities had made them over-familar to the public, he increased their emotional content to such an extent that several of his works, attacked in their own time, are seen by modern critics as being introductions to modern art. All the same he continued to enter competitions, demonstrating to the end of his life that he did attach importance to that type of sculpture, and would like to have seen his ideas taking concrete form in public places. His pride when the British government bought *The Burghers of Calais* demonstrates this.

His first venture into this domain in spring 1877, at the same time therefore as the affair of *The Age of Bronze*, was a project for a monument to Byron, of which only one trace remains, a rapid sketch in a let-

ter to Rose, with the instructions for the packing of the dismantled model. It was not kept, but it was planned as being in the traditional pyramidal shape. A youthful aberration.

In 1879 the municipality of Paris held a competition for an allegorical group of two figures, to be placed at the rond-point de Courbevoie, to commemorate the defence of the capital during the siege of 1870. Rodin's composition shows a dying soldier in an attitude similar to that of Christ in Michelangelo's *Pietà*, leaning on a winged figure wearing a Phrygian cap – identifiable as the Republic rather than the city – and exhorting him to battle. Rodin may have been inspired by two works on the theme of modern war: *Le Départ des volontaires* on the Arc de Triomphe at the Etoile, but also Mercié's *Gloria Victis* (which won the Medal of Honour at the 1874 Salon), which places a female winged figure next to a weakened warrior. Despite these prestigious references, the jury turned down the project on the grounds of a faulty stylistic approach and treatment of the subject: a tendency towards generalisation, substituting the warrior nation for the city, and the violent expressions and rough modelling, which went against the current trends. He suffered another setback in the same year at the public competition for a bust of the Republic for the newly built town hall in the 13th arrondissement. Out of the fifty-four projects put forward, Rodin's attracted press attention, but again the powerful expression and aggressive face – Rose's, no doubt – on top of a massive neck, were too far from a traditional interpretation. The final irritant was Rodin's replacement of the traditional cap with a helmet – like the one Michelangelo put on Lorenzo de Medici – accentuating the bust's bellicose demeanour. The sculpture did not embody the theme, and the dramatic impression it made was at opposite poles to the general climate of yearning for peace, and the serenely reassuring image which the regime wished to project. The bust had a different fate and later came to be exhibited under the title of *Bellona, goddess of war*.

There were many other unpursued projects in the years that followed. In 1881, a very lively maquette presented to the town of Nolay for a monument to Lazare Carnot was turned down. In 1844, although judged "full of spirit – a charming composition of unrestrained originality", the model of Diderot for Paris was rejected on the grounds that it lacked monumentality and resemblance. There was a setback, too, at the double competition organised for a statue of General Margueritte, mortally wounded at Sedan leading the Chasseurs d'Afrique, one for his native village in Lorraine and the other for Algeria. The only completed commission was a statue of Alembert, still to be seen in one of the niches of the exterior façade of the Hôtel de Ville in Paris, rebuilt by Ballu after the fire which destroyed the previous building during the Commune. Rodin did not like to remember this one, which, in any case, he received only through the recommendation of Carrier-Belleuse.

This brings us to the third of Rodin's activities during these years preceding his major works – his work at the national ceramics factory at Sèvres, under the direction of the same Carrier-Belleuse. Created in the previous century to manufacture procelain in France to compete with the imports from the East and from Saxony which were upsetting the trade balance, the Sèvres works, whatever the regime, were always part of the State budget. Models of shapes and patterns were supplied by artists either brought in from outside or attached to the establishment. In 1875, when Carrier-Belleuse was made director of art works, the factory was being attacked on all sides as a stagnating workplace. Irregular production, fake stamps, routine and lack of originality, all cried out for reform. Carrier-Belleuse's personality, his role in the promotion of industrial art, his capacity for leading large teams and his prestige as a sculptor made him the ideal candidate for new leadership. Wanting to surround himself with artists whose talent he admired, he called on Rodin, who, in June 1879, joined the special, contracted staff. Although Carrier-Belleuse wanted to attach him permanently to Sèvres, his collaboration ceased in 1882 when he embarked on the plans for *The Gates of Hell*. But that was another story.

It is difficult to identify what was actually designed by him at the factory at Sèvres. Book-keeping and records were so inaccurate that it is hard to find any definite attributions. Sometimes a vase decoration seems to resemble one of his drawings, but that is because the artist exploring such and such a theme – motherhood, fauns, centaurs – tried it out in different techniques; one cannot therefore see in the drawing a definitive preparation for the decoration of a vase. The accounts enable one to attribute to him work in 1879 on the *Chasses* centrepiece (initiated by Carrier-Belleuse and therefore not a personal creation) and about ten known vases to which one must add several with a more anonymous type of decoration, as well as a few plaques and samples. Whether they are of the "Saigon" or "Shanghai" types, or the pair of great Pompeian urns – *Day* at the Musée de Sèvres, and *Night* at the Musée Rodin – the ceramics are decorated with figures traced by hand in the soft clay with the fine sense of mass you would expect in a sculptor adept at every sort of technique. His understanding of the constraints placed by this type of

work on the distribution of mass lends a particular quality to his work. It was wrongly supposed that these minor works were later disclaimed by Rodin. This is not true; his Sèvres pieces appeared regularly in his exhibitions: at the Union Centrale des Arts Decoratifs in 1884, at the Great Exhibition of 1889, at Galliera, and at the Salon des Indépendants in 1907. Because of his interest in ceramics, he allowed several famous potters at the end of the century to produce some of his most famous sculptures in clay. Paul Jeanneney transposed the head of Balzac into glazed earthenware, and also made the spectacular *Burgher with the Key*. Chaplet and Lachenal made other powerful pieces out of Rodin's work, such as *La Pleureuse* and *La Faunesse*. So he found himself associated with the great movement which, with the new craze for all things Japanese, brought about a renewal of interest in earthenware techniques practised in the Far East, and can be seen in objects of the art nouveau period, and the decorative repertoire of the 1900s. He always remained, until the end of his life, curious about new methods of expression and unusual materials such as glass paste which had been used in antiquity and was rediscovered by Henri Cros. This complex procedure involves melting down powdered glass with oxidescolorants: the pieces often appear insufficiently vitrified, so that it can be used only on small-sized subjects, mainly portraits, such as those of Camille Claudel, Madame de Nostitz and the Japanese lady Hanako, in all of which the strange material appears both luminous and waxy at the same time, giving it a morbid, almost funerary aspect.

From this period between 1879 and 1882, when, besides Sèvres, Rodin also worked directly for Carrier-Belleuse, probably dates a work known as *The Titan's Basin*, really the support for a jardinière, the base divided by figures whose powerful muscles foreshadow those of *The Thinker*. However, the terracotta version in the Musée Rodin is signed by Carrier-Belleuse.

At the same time the sculptor, although still short of money, was becoming famous. His association with Carrier-Belleuse, always a generous man, helped him make contact with influential people in the world of politics, journalism and literature. He frequented the salon of Madame Adam, founder of the *Nouvelle Revue,* he met Richepin, Mallarmé, Henri Becque, Léon Cladel, father of Judith, whose lectures and writings, verging on hagiography, were the basis of his first biographies. His early relationship with journalists dates from this time, and his correspondence shows the care with which he always thanked them eagerly for the slightest word of praise, the most passing mention of his name. His friend, Dalou, introduced him to Séverine (Caroline Rémy), a literary figure of the far left, whose portrait he both drew and sculpted. Most importantly, he got to know, at Sèvres, Maurice Haquette, photographer and art expert, brother-in-law of the Under-Secretary of State at the Beaux-Arts, Edmond Turquet. These friendships, along with his own tact and almost crafty diplomacy, and the need to be rid of the false accusation over *The Age of Bronze,* resulted in the all-important commission for *The Gates of Hell,* the great turning point of his career. It must be noted that among the artists who intervened on his behalf were Dubois, Chapu and Falguière, all official sculptors and all defenders of *The Age of Bronze*. Rodin's image as a solitary, cursed artist must be modified since, although he was quite detached from academicism, he could not entirely neglect the normal channels. How could he do otherwise?

On 16 August 1880, Rodin received the order for a monumental gate of the planned Musée des Arts Decoratifs on the Left Bank, on the site of the Cours des Comptes, which had been burned down during the Commune. In the initial order and ensuing documents the actual title does not appear, and official accounts mention only bas-reliefs illustrating *The Divine Comedy*. The price, eight thousand francs, was raised to twenty-five thousand by 1884, and the three-year delay eventually forgotten. Like most sculptors working on a public monument, Rodin was given a studio at the State Dépôt des Marbres at 182 rue de l'Université.

At his request, and bearing in mind the size of the door (6 metres high, 4.35 metres wide and 1 metre thick), he moved in 1882, having obtained the use of a second workshop, which, thanks to his eventual fame, he retained permanently. On 21 October 1881, Rodin indicated his intention of adding two "colossal" statues on either side of the doors: *Adam* and *Eve*. On 3 January 1883, Roger Ballu, the Beaux-Arts inspector, checking the progress of the work, found its complexity baffling but interesting: "I could only see small isolated groups having their cloths removed as I examined them one after the other. I cannot tell what effect these reliefs will make on the huge scale of the great door. This young sculptor has truly amazing originality and power of expression. He conceals his disdain for cold architectural style beneath the energy and vehement movement of the poses." By 1884, the work had progressed a great deal but the casting had to be deferred because of the cost. It was set aside to make way for other commissions, taken up again in 1888, then slowed down again because of the *Balzac* – Rodin always had several works going simultaneously which interconnected and enriched his imaginative world.

The original contract was not honoured. Perhaps Rodin realised a certain wildness in the original concept? The first drawings planned for a precise geometrical door inspired by those of the Italian Renaissance, but the high relief figures commented on by Ballu stem from a completely different concept. Bourdelle, employed by Rodin from 1893 onwards, humorously criticised the lack of rigour: "It is neither a wall nor a door, there are too many holes and I should be afraid of putting out my eye if I tried to open it." Several groups and figures were therefore removed from the panel surface, and the structure which appeared in Rodin's one-man exhibition at the Pavillon de l'Alma in 1900 had only the bottom bas-reliefs left. At the end of his life he replaced the figures on the panels, but never saw it in bronze, as the transposition was made only in 1926 by the banker Jules Mastbaum, founder of the Rodin Museum in Philadelphia. Almost simultaneously a casting was made for the Musée Rodin in Paris, and a third one for the Japanese collector, Matsukata. The German authorities ordered a casting during the Second World War, but it remained unfinished and now belongs to the Kunsthaus in Zurich; a fifth one was made between 1978 and 1981 for an American patron of the arts who gave it to the Stanford University Museum. The groups of individual figures created for the ensemble representing universal destiny, *The Thinker, The Kiss, The Prodigal Son,* to name only the most famous, were therefore exhibited on their own, out of the framework for which they were designed, and *The Gates of Hell* thus became a field of incessant experimentation in sculpture.

T he real theme of this swarm of mingled figures was that of Hell, the *Inferno section of The Divine Comedy* which was entirely Rodin's own choice. Why? First, because his recent reading of Dante had greatly impressed him, as had several other great texts; he largely ignored the literature of his own time with the exception of Hugo, Balzac, Lamartine and Baudelaire. Dante's *Inferno* is an epic which combines great knowledge with myths and historical events. This great allegorical poem, in which one glimpses the drama of religion tearing the human soul apart, this journey through the different circles of Hell, is a sort of progressive purification leading to the contemplation of God; the journey is conducted by Virgil, symbol of the wisdom which makes man understand evil without saving him from it. Rodin, naturally pessimistic and secretive, his personal life full of conflict, passion and anguish, could not fail to respond to it. *The Gates of Hell* expressed his distress and inner confusion. One must remember that several episodes of Dante's *Inferno* formed part of a familiar repertoire for nineteenth-century artists, at a time when several new translations had appeared. It haunted Hugo, de Musset and Baudelaire – Delacroix painted *Dante's Ship,* and Ingres, *Paolo and Francesca;* Carpeaux sculped *Ugolino and his Children.* Confronted with a text imbued with the idea of God and sin, Rodin was inspired by its tragic and violent atmosphere, but did not produce a literal and entire rendering. On the contrary, he avoided a Christian interpretation and centred the work on man, with, as focal point, *The Thinker,* who, identified at first as Minos, judge of souls, passed into posterity as the great symbol of reflection. Similarly, the two figures of *Adam* and *Eve* framing the doorway with their Michelangelesque silhouettes, suggest that the theme is a general illustration of man and his destiny. Instead of creating a composition in zones corresponding to the nine circles of Hell, he broke with all the narrative traditions in order to create a totally new sculptural space.

T hese profound differences lead one to wonder – at least in the case of the sculpture, since the drawings refer precisely to Dante's text – about what other sources he drew on, and one thinks of Baudelaire.

As well as the critic Gustave Geoffroy, Rainer-Maria Rilke, who was Rodin's secretary in 1906, wrote as a poet about Baudelaire's role in the sculptor's work: "From Dante he came to Baudelaire . . . In the poet's writing there are passages which appear to have been sculpted rather than written . . . He recognised Baudelaire as his artistic predcecessor . . . in the search for characters who were larger than life, crueller, more fevered." In 1887 Rodin did some drawings for Paul Gallimard to illustrate a copy of the original edition of *Les Fleurs du Mal;* they provide precise information as to what most appealed to him in the poems. Besides the general pessimism, the sense of sin, the solitude of man, feminine perversity, all the elements lacking in Dante were common to both artists. But although several drawings in *Les Fleurs du Mal* correspond with figures in *The Gates of Hell – The Thinker, Eve, La Toilette de Vénus, Je suis belle* – they were done after the sculptures. One must assume that there was a moral affinity rather than any direct influence, and one must not forget either that a pure *plasticien* like Rodin was less influenced by language and ideas than one might be tempted to think. The search for "solid" sources is just as hazardous, although monumental, historically decorated gates are scattered throughout Western history: the doors of the Pantheon in Rome, the St Sabine gate at Hildesheim in Lower Saxony; closer in time the doors of the church of the Madeleine in Paris, of the Vanderbilt Memorial and St Bartholomew in New York, of the Capitol in Washington, and, most important of all, the doorways of Renaissance Florence, such as that of "Paradise" by Ghiberti at the

Baptistery in Florence. Several drawings and a small wax model show that the last, in which each leaf contains five bas-reliefs surrounded by a border, was Rodin's main reference point. What other influences pushed aside such a serenely balanced prototype, and replaced it with this strange sculpted universe, peopled by 200 highly expressive, animated figures? Was it *The Last Judgement* in the Sistine Chapel? To the extent to which baroque art represents vitality, the play of light and shadow, tension between shapes, one can say that *The Gates of Hell* is baroque in nature, but it is personal to Rodin and does not allude to any particular works.

The structure he chose was his own creation but also pertained to the atmosphere of the time. Complicated compositions were popular at the end of the nineteenth century. The art nouveau movement had repudiated academic traditionalism, and introduced a new taste for natural freedom – hence the attraction of sinuous lines, and decorations overflowing from their frames. Architecture was seen as an entirely individual activity, with no link to the immediate neighbourhood or the urban environment. There existed therefore a form of 1900 baroque which came close to symbolism, and towards which Rodin felt strongly attracted. *The Gates of Hell,* quite unsuitable for the building for which they were supposed to denote the triumphal entry, belonged to this current of European art nouveau; the work had been much publicised in reviews such as *La Plume, l'Art Moderne, La Revue Blanche,* which all contained many articles on Rodin, and by exhibitions in which his work was shown such as the Libre Esthétique in Brussels or the Vienna Secession.

The Gates of Hell was the receptacle for several wonderful pieces of sculpture: the upper part with its three layers of dramatic figures, the lateral pilasters juxtaposing terrible images of old age with delicate figures of women surrounded by children; the higher parts, almost invisible from the ground, where the crouching *Caryatid* and the crushed *Danaïde* hide their superb forms.

As the unending gestation of this fascinating work continued, Rodin began, with *The Burghers of Calais,* a new type of municipal commission which brought him into conflict with particular local circumstances, perhaps even more testing than the

problems involved in central government work. The history of the monument is well known, thanks to the detailed correspondence between Rodin and the Mayor of Calais between 1884 and 1895. In 1884, Calais demolished its seventeenth-century ramparts in order to link the old city with the industrial suburb of St Pierre, where lace and net were manufactured; with this industrial and demographic modernisation the city felt it had lost some of its historical identity, and the town councillors decided to erect a statue which would personify the theme of the past faced with modernity. They chose a famous episode in the Hundred Years War when the town, besieged by Edward III of England, was spared, thanks to the courage of six leading citizens who presented themselves as voluntary hostages. This story, on which Voltaire had already commented in his *Essai sur Le Moeurs,* inspired numerous paintings and engravings in the nineteenth century, as well as plans for statues by Cortot, David of Angers, Clesinger and Rochet. All had the same iconography, representing only Eustache de Saint-Pierre, the best-known of the six burgers, in an academic form - the traditional statue of a famous person up on a pedestal.

Once the decision had been made to have a public subscription managed by a special committee, the motivating spirit behind the project, Mayor Omer Dewavrin, a moderately cultured lawyer, asked a Calaisien living in Paris, Paul Isaac, to help choose a sculptor. He suggested Rodin, quoting the works bought by the state, the order for *The Gates of Hell* and the fame of those that Rodin had already sculpted – Carrier-Belleuse, Victor Hugo, Rochefort, Antonin Proust. This was effective as, particularly in the provinces, the main criteria for judging art were an artist's reputation with the Salon, and the resulting prizes, medals and commissions. All this corresponded to a certain extent with the realities of Rodin's career – he had reached forty and sought a minimum level of financial security; he also considered that the main purpose of sculpture was to teach, and in this respect the drama of *The Burghers of Calais* appealed to him, particularly as it took place in the Middle Ages, a period that had always attracted him. The Calais monument, one of the greatest works of sculpture inspired by a precious historical fact, gave him the chance to express his patriotism: he saw it as an artist's duty to inspire love of one's country. The final result was to be one of his most personal works, and it demonstrated, in view of the controversy it aroused, his perseverance at justifying and imposing his views . . .

In October 1884 he decided to abandon the initial brief, which was limited to the figure of Eustache de Saint-Pierre, and decided on a group of six, breaking with the sacrosanct tradition of the hero alone in glory. Here the group itself became the subject and the notion of collective sacrifice took shape. The

committee accepted the increase in numbers when it saw the first model, but it entailed a financial problem, which Rodin tried to minimise, but of which his potential competitors, Marqueste and Chartrousse, made much. As soon as the commission for 15,000 francs was confirmed in 1885, Rodin began trying to obtain more: "I hope your influence, which is indispensable to me, will allow me to add on the costs of plaster moulding, models, adjustments, framework etc," he asked the mayor, alluding at the same time to his relationship with Waldeck Rousseau, then Minister of the Interior . . . We see here the modern idea that the artist should be able to separate the creative work itself from the cost of materials.

The second model aroused intense controversy in Calais; *Le Patriote,* on 2 August 1885, said, after some ironic remarks about the heart-rending appearance of the protagonists: "We would like to have found more ideas in it, and, particularly, we would like to have seen in Eustache some resignation and satisfaction in the service rendered to his fellow citizens, and some pride in self-sacrifice." Dewavrin wrote to Rodin: "We are embarrassed, public opinion is vigorously opposed to the position of Eustache de Saint-Pierre, and we dare not continue with the subscription unless we know that you will change it." Rodin did not bother to answer. But an important point had been raised about the constraints imposed at the time by patrons over artists: the work is dependant on the financing, and to the extent to which it is determined by public subscription, the subscribers' wishes must be borne in mind, even though they might be based on class or chauvinistic feelings. Letters accompanying gifts of money expressed the wish "to take part in an enterprise which would remind dissenters of the services that the bourgeoisie had provided in the past and could still provide". There was here a political element which those in charge of the funds had to bear in mind, and the conflict between Rodin and the city of Calais lay as much here as in the aesthetic sphere, in which he was also straying from official dogma. With no concessions from Rodin, and the committee's evident anxiety, we do not know how the situation would have resolved itself if the bank holding the subscription fund had not crashed. The committee broke up and Dewavrin was voted out of office. And, final paradox, Rodin, free now from all obligation, pursued his preparations for a statue he thought would never be erected.

After making the bodies in clay first at half their eventual size, then life size, in order to fix the position of each figure, he experimented with endless permutations of expression for the faces and hands, particularly the latter, with their important relationship to the rest of the body, conveying poetry or power by gesture, and making emotion perceptible. The Goncourts' diary that year described "the sculptor's studio with its walls splashed with plaster, its miserable cast iron stove, the icy damp oozing from great wet clay shapes wrapped in rags, all the mouldings of heads, arms and legs . . ."

In 1889, a completed model of the statue appeared in the Monet-Rodin exhibition at the Galerie Georges Petit, but it was hidden away in a studio specially hired to hold it. There was always the problem of the space necessary to hold these cumbersome phantoms. In 1892, a new local group relaunched the subscription and the casting in bronze was completed in six months by the Leblanc-Barbedienne foundry. New difficulties arose, relating to the plinth and the placing of the group; the two problems were connected, and Rodin envisaged two separate solutions: either to have a high pedestal in an open space so that the silhouettes against the sky would not be confused with trees or buildings, or a low one in the centre of the town so that the statue would be at the same level and in the midst of the passers-by. An uneasy compromise was reached at the inauguration in June 1895, combining a medium height pedestal with a neo-gothic railing. After the upheavals caused by two world wars a simple base was finally chosen, but the monument's situation in an open space reduces its impact.

After the installation at Calais, there remained much confusion about how the statue should have been presented, betraying Rodin's own uncertainty on the subject. Rilke refers to a two-storey tower beside the sea, but there is no trace anywhere else of such a romantic fantasy. There are photographs taken after 1900 of the plaster model perched on very high scaffolding. At any rate, what Rodin wanted to express through each of the six burghers locked in his own private drama, was the approach of individual death, breaking with straight realism and leaving aside the usual anecdotal approach. The agony of death, so perceptible in the sculpture of the Middle Ages, is certainly present in the group, but although he compared it with a "church entombment", there is present too the search for the integrity of the individual; the modern installation without any pedestal makes it the first public sculpture to rely for its impact solely on the modelling itself.

The statue of *The Burghers of Calais* was the only public commission out of which Rodin made any appreciable financial gain. This was thanks to orders for more editions: in 1903 for the Danish collector Jacobsen, in 1905 for the Belgians Warocque at the Château de Mariemont, and in 1907 for another Belgian collector, Wouters Durstin, who gave it to the British Government who installed it in the public gardens next to the Houses of Parliament.

Other monuments brought only disappointment and incomprehension, except perhaps for a rather dull one at Damvillers on the tomb of Bastien-Lep-

age, a painter of rural scenes and friend of Marie Barsckitcheff, who died in 1884.

Things were different at Nancy, where, in 1886, a group organised a competition for a monument to the painter Claude Lorrain. The secretary of the Parisian committee supporting the group was none other than the writer, Roger Marx, a friend and admirer of Rodin. There is no doubt that his articles in the local press proclaiming Rodin as "the leading contemporary sculptor" helped to ensure his selection from amongst fourteen competitors. His idea was to render as tangible as possible the genius of the great master of light, whilst respecting the harmony of the Jardins de la Pépinière, close to Place Stanislas, where the statue was to be placed. To this end, the pedestal took as its theme Apollo driving the sun's chariot above which stood Lorrain himself, an intimate and immediate portrait of the artist at work, with his palette in his hand. The statue, not inaugurated until 1892 in the presence of Sidi Carnot, reflects Rodin's interest in baroque sculpture, all movement and effects of light and shade; he was trying to evoke the unattainable moving beauty of light as Lorrain had caught it. But the local reception was hostile. The horses of the sun appeared unfinished, with their rumps disappearing into the clouds, and the figure itself was criticised for being too life-like "like a frog in sewerman's boots". As with *The Burghers of Calais*, where people expected an idealised person, Rodin produced somebody devoid of all pomp and a long way from the sublime.

Another complicated scheme which generated many misunderstandings was that, or rather those, for the monuments to Victor Hugo. He was given the first commission in 1885 for a fee of 75,000 francs. He had to adapt his plan to the scheme decided on in 1885, when the old church of Sainte-Geneviève was transformed into a French Pantheon containing memorials to illustrious citizens. Hugo was to stand opposite a statue of Mirabeau haranguing the crowd, inspired by "Eloquence", surrounded by the new France and the three estates of the nation – a daunting confrontation. There was no problem about physical resemblance, as he had already made a bust of the great man, and he chose as his theme Victor Hugo opposing the Second Empire, sitting on his rock of exile in Guernsey. There followed several versions in which the seated poet (this went against the instructions which were for him to be standing) was surrounded by female figures symbolising *The Legend of the Centuries*, *The Punishments*, and *The Inner Voices*. In 1890, the works committee judged the whole thing to be too small and too confused. Rodin then agreed to alter his plan, and conceived of a deified Hugo, standing crowned by the spirit of the century, and attended by a group of Nereids already used in *The Gates of Hell*. Connected to this idea was a surprisingly heroic Victor Hugo in portly nudity,

which derived directly from *The Walking Man*. The use of conventional allegory to glorify the poet's epic qualities was bound to give the whole project a bizarre aspect, and because of all the criticisms and changes of mind it was never carried through. In the end they returned to the original idea. Rodin's reputation and connections inspired the suggestion in 1881 that a sitting Victor Hugo should be installed in the Luxembourg Gardens. The new commission was fixed at 40,000 francs and then reduced to 30,000 in 1907, when Rodin decided to leave out the figures of *The Tragic Muse* and *The Inner Voices*, which can be seen in the plaster model. The venue was then changed to the gardens of the Palais Royal, and the monument was unveiled in 1909, to coincide with the fiftieth anniversary of *The Legend of the Centuries*. Unfortunately the heap of marble blocks on which it was perched was destroyed, and one can see only in photos the extraordinary modernity of Rodin's presentation.

Other statues contained superb pieces but showed that Rodin found some difficulty in thinking in monumental terms when the subject did not fire his imagination. Hence the monument to the Argentinian president, Sarmiento, or the composite project for an equestrian statue of General Lynch. Others were no more than busts, such as those of Henri Becque or Barbey d'Aurevilly, or bas-reliefs like the highly symbolic one representing the highly strung sensibility of the poet Maurice Rollinat at Fresselines.

From 1894 to 1899, he worked on a project for *The Tower of Labour*, the plaster maquette of which can be seen in the Musée Rodin. Although Rodin had no highly developed political ideas he respected work. Labour was a popular theme in the second half of the century, as illustrated in sculpture by Dalou and Constantin Meunier, in painting by Roll and Lhermitte, in literature by Zola. They were all artists whose work was susceptible to contemporary ideas on the subject, notably Leon XIII's encyclical *Rerum Novarum*, on reciprocal obligations between labour and capital, and legal arrangements to protect children and limit the amount of work they could be allowed to do. Rodin's huge, visionary idea was to have a tower 50 metres high based on the famous spiral staircase at Blois, with a central column carved with a bas-relief illustrating the material and spiritual hierarchy of labour: at the base the miner and the diver, then higher up, artisans, and at the top poets, artists and philosophers, the whole thing crowned by benevolent winged spirits. *The Tower of Labour*, extravagant and gradiose, puts into question the whole notion of monumental sculpture.

Alongside all these various works and projects was *Balzac*, which became the subject of at least as much controversy as Manet's *Olympia*. For some it represented the beginning of modern sculpture, for others it was a dead end; for all it was a contentious

work, and Rodin regarded it as the one in which he had made the most innovations. We must pause to consider this critical disaster and artistic triumph.

Prior to Rodin's commission, received in 1891 from the Society of Literature, several attempts to put up a statue in Paris to the author of the *Comédie Humaine* had failed, in particular that of Alexandre Dumas, who organised several fund-raising gala evenings, but came into conflict with Madame Balzac, who, because the idea had not come from her, felt humiliated at being thought indifferent, and attacked the scheme in court. The project was restarted in 1883, with a subscription by the Society of Literature, which was anxious to honour its second president and his efforts to protect literary properties against pirate editions. The sculptor Henry Chapu was chosen in 1888, but died in 1891, leaving a maquette which his colleagues thought precise enough to execute in marble. Emile Zola, then president of the Society, refused to proceed with this. He was an eminent figure in the naturalist movement, a friend of Cladel and Mirbeau and an admirer of Rodin's; several letters to the architect Franz Jourdain, who was in charge of the pedestal, show that he had already decided in his favour even before the vote, arousing the anger of a group of artists opposed to naturalism. Members of the Rosicrucian movement, a sort of radical wing of symbolism that veered with the Sar Peladan towards mysticism, fought fiercely against contemporary materialism as personnified by Zola. One of them, an unknown sculptor called Marquet de Vasselot, exhibited several ideas for the Balzac statue at the Rosicrucian Salon; one of them showed Balzac as a sphinx, demonstrating the complicated aesthetics of the group – it made the novelist into a sort of hybrid, with the strength of a lion's body, human intelligence, and a strong will represented by eagle's wings.

Rodin was selected in 1891 to make a bronze statue of Balzac 3 metres high. Excited by the subject, he began, as a naturalist would, by amassing iconographic information, to compensate as much as possible for the lack of a living model, since Balzac had died in 1850. A series of studies emerged from this phase which demonstrate Rodin's anxiety to establish physical credibility. From 1893 to 1895, Rodin was "imprisoned by a sick man's fancies", and was passing through a moral crisis caused by his relationship with Camille Claudel, the extremely gifted young sculptress with whom he had formed a liaison. The Society of Literature was pressing him to deliver the work; their impatience was certainly justified by the continual delays, but it reached absurdity at one point, when they asked him to deliver it within twenty-four hours. Personality conflicts arose alongside financial problems – he was being asked to pay back his advances – when Jean Aicard, and then the humorist Aurélien Scholl, succeeded Zola. Needless

to say, he delivered nothing, as he was working simultaneously on *Victor Hugo, Sarmiento* and *The Tower of Labour.*

After 1896, he probably abandoned his original model; he no longer sought verisimilitude, and set aside realism in favour of a figure symbolising the depth of Balzac's genius. The same search for an overall view of the man applied to his clothing, which changed from a contemporary frock-coat to the famous monk's habit that the novelist wore to write in, ending up with a sort of timeless coat which concealed the ungainly body, and concentrated attention on the head. It is the head that shows the genius, with its defiant and proud expression, rather than the attitude, which, with the massive head of hair, the hollow eye-sockets, the soft fat flesh, conveys to us all of Balzac's belligerent character.

At last, in May 1898, the statue was exhibited in plaster at the Salon of the Société Nationale des Beaux-Arts, opposite a marble version of *The Kiss,* commissioned by the State. Even in a period accustomed to artistic controversy, the scandal created was unprecedented, amongst the public, artists, and in the Society of Literature. The Society rejected a motion calling on Rodin "to complete" the statue, and refused to recognise its commission in the "rough-hew" at the Salon. Jean Aicard resigned in support of the sculptor. Rodin withdrew the plaster cast and went to live at Meudon, where, in 1895, he had bought the Villa des Brillants, which became both his home and his main workshop. Artists and intellectuals reacted: Léon Dierx called the work "an unnameable hoax", and Bourdelle affirmed that it was "a hundred times more powerful than *The Kiss*". A petition was circulated to raise money to buy the statue; the greatest names encouraged Rodin – Monet, Cézanne, Toulouse-Lautrec, Pissarro, Renoir, Mallarmé, Anatole France, Lugné-Poe, Clemenceau – but he refused with dignity: "I firmly wish to remain in possession of my statue. My interrupted work, my thoughts, everything now demands it." The public was openly hostile; the statue was described variously as a larva, a foetus, and a sack of flour; satirical statuettes were made with Balzac in the shape of a seal, and the cartoonists had a field day.

This reception was not merely a show of incomprehension in the face of something ahead of its time. Rodinists and anti-Rodinists more or less corresponded to Dreyfusards and anti-Dreyfusards. For many critics in the contemporary press *Balzac* was not merely a controversial work – it was a political gesture as well. The quarrel within the Society of Literature between "naturalists" and Rosicrucians was connected with other conflicts – between left and right, republicans and royalists, anti-clericals and supporters of the Church; and it raised the whole question of nationalism, as we can see in Marquet de Vasselot's invective: "Rodin's *Balzac* is anti-patriotic.

The spirit of France cannot exist within this Germanic larva, this beer-filled object at the Salon." A connection was made between the revolutionary nature of the work and the social and political climate of the time, with two opposed groups roughly representing conservatism versus progressive ideas. This happened, of course, in other circumstances and within other disciplines as well, when impressionist painters, or poets who wrote in blank verse, were automatically considered to be *agents provocateurs,* and therefore anti-patriotic.

Rodin was simply an admirer of Balzac's genius and was quite indifferent to his political or religious beliefs; but his refusal to take sides still caused misunderstandings. Bearing in mind his relationship with Zola, who published *J'accuse* in that same year, 1898, and the sort of people the Dreyfusards were, he tried to avoid being included amongst them. His native caution and patriotism were alarmed by them, and what might have appeared as opportunism was in fact an absolute wish to remain aloof from political debate and to be judged on artistic rather than political grounds. The main problem for him was whether the portrait of a great man should be a faithful reproduction of his appearance, or whether it should attempt to express his personality as well, even at the cost of breaking with the tradition of polished perfection and completeness. He settled the question when he said of his *Balzac*: "Nothing I ever did satisfied me so much, because nothing cost me so much, nothing sums up so profoundly what I believe to be the inner secret of my art."

Whatever its importance, he was not solely occupied with public statuary. His first creations were busts, and he remained a portrait maker throughout his career, beginning in 1860 with a cold hard image of his father, executed in the antique manner. Before 1900, the busts were done out of personal choice: either he was interested by the sensitivity of the model's expression, or the person in question could be helpful to him in obtaining a commission, or keeping him on good terms with some section of the artistic community. It was at his express request that Victor Hugo, unwilling to have himself represented in old age, agreed to have his portrait done in 1883. He did not pose for it and the bust, done almost from memory, is more an image of Hugo as the public knew him than a reflection of the inner man. Rodin sculpted a large section of the artistic community with busts of Carrier-Belleuse, Dalou, and Puvis de Chavannes, whose vigour, restraint and dignity he admired. In the political sphere, he produced a portrait bust of Rochefort, an incisive and irritable man who did not care for Rodin's habit of walking round and round his model for a long time before starting work; Clemenceau reacted similarly in 1911, and, displeased with the result, insisted that the finished work could be entitled *Portrait of an Unknown Man,* because, he said, "Rodin made me into an oriental, a Tamburlaine or a Genghis Khan." Bernard Shaw, on the other hand, to whom, when Rodin said: "Do you know that you look like the devil?" answered: "Sir, I am the devil", dropped the irony and wrote in 1914: "The work is yours, the honour is mine. I will always be very proud to be known as your model, you are the only man beside whom I feel truly humble." For reasons indicated earlier, there are fewer busts of women and, until 1900, when his one-man exhibition made him internationally famous and brought him clients from all over the world, the portraits of women are mostly of those with whom he had some romantic attachment, or who attracted him by their beauty, character or sexuality. The features of Rose Beuret, Camille Claudel and the duchesse de Choiseul – the three women, who, at different levels, shared his life – were struck in clay, plaster, bronze, marble and glass paste.

Camille was born in 1864, the year in which Rodin met Rose, whom he was to marry after spending fifty-three years of their life together during which she lived in constant dread of abandonment. Several publications and exhibitions in recent years have enabled the public to rediscover Camille's talent as a sculptress and the details of her liaison with Rodin are too well known to need repetition. She was, for Rodin, pupil, helper, mistress and muse. The passionate affair which took place from 1883 to 1892 between the beautiful young woman and the middle-aged sculptor at the height of his powers was unfortunately perceived by each from a totally different point of view. In reply to the carnal love expressed in Rodin's *The Kiss* and *The Eternal Idol* came Camille's *Sakountala,* a work of total love "where the spirit was all", according to her brother Paul. The prevailing climate of the nineteenth century, the difference in the lovers' ages and backgrounds, Rodin's growing fame – he was made Chevalier de la Légion d'honneur in 1887, a member of the jury for the great Paris exhibition of the same year, a founding member of the Société Nationale des Beaux-Arts in 1889 – all caused great pain to Camille, who, as the Master's intelligent and demanding partner, could not bear to be neglected. Rodin, for his part, faced great inner anxiety. Although engaged on large-scale commissions which his search for perfection prevented him from completing, he often left the studio for weeks at a time, with or without Camille, who went away several times to Touraine, possibly to hide a pregnancy which never came to term. It is possible that the women with children on the pilasters of *The Gates of Hell* were inspired by this drama. He dithered between Rose and Camille, two jealous and possessive women whom he loved in different ways. Was it the memory of his

sister Maria, who died of despair after being jilted, that prevented him from leaving Rose, or was it just natural indecisiveness? Was he trying to remove Rose from Paris when he moved to Bellevue, and to another part of Meudon? Whatever it was, there was a semi-separation in 1892 between Auguste and Camille, although the two artists continued to go out together and see friends they had in common. The beautiful marbles *La Pensée* and *L'Adieu,* inspired by the young woman's melancholic expression, date from this period. The final break probably took place in 1895, not 1898, as has long been supposed; it was Camille's decision, and, during the following eighteen years she gradually withdrew from society, before being finally locked up in a lunatic asylum at her family's request in 1913, where she remained until her death in 1943.

Rodin never stopped loving her. Certainly he had many, sometimes long-lasting liaisons, notably with the duchesse de Choiseul, who, with the consent of a complaisant husband, took on the role of a vigilant Egeria; her greed drove away his old friends – it was said that she stole drawings . . . Camille's caster, Eugène Blot, bore witness to their love: "Truly, he only ever loved you, Camille . . . All the rest, those wretched adventures, that ridiculous society life, for somebody who was basically a man of the people, it was all just an outlet for his excessive energy . . . You have suffered too much for him. But I will not withdraw anything I have just written. Time will put everything in its proper place."

There remains some confusion about the works of art and Camille's role in Rodin's production. We know that the *praticiens* in the studios went beyond simple craftsmanship, as the young Rodin's example shows us. One can assume that Camille, linked to him sexually and romantically, as well as intellectually, must have played a more important part than most of his other helpers. Mathias Morhardt, critic, friend and first biographer of Camille Claudel wrote: "He consulted her personally about everything. Whenever there was a decision to take, he deliberated with her, and it was only after they had agreed that he would decide definitely." We must not assume from these remarks that Rodin plagiarised Camille, or that his genius came from her. A look at the chronology puts paid to such ideas, but it is all the same true that their years together were by far his most prolific, and that the image of the couple, vivid in his mind at that time, gave him the opportunity of exploring, under cover of legend and mythology, every nuance of sexual passion.

He portrayed his erotic feelings in truncated female figures, often without heads, and with incomplete limbs, powerfully modelled. The most startling, *Iris, messagère des dieux,* with its pose of hitherto unheard-of daring, is the incarnation of sexual vigour.

Rodin, possibly inspired by his taste for the archaeological fragments which he collected, pushed further and further towards the elimination of parts which were not necessary to the desired movement or gesture, simplifying the anatomy to the stage where he ended up with simple shapes at the outer limits of stylisation. The energy embodied within these shapes placed them at the very edge of the great leap into abstraction.

Another aspect of his modernism was the way in which he assembled different mouldings which were cluttering up his studios. He was in the habit of making several plaster casts of a same moulding, and then fragmenting it into sections in order to change its final shape. From this reserve of torsos, limbs, heads and hands, described by the Goncourts, he reconstituted new works such as *Je suis belle,* made two figures for *The Gates of Hell, The Falling Man,* and *The Crouching Woman.* Other more hybrid creations resulted from uniting a plaster cast with a vase from his collection of antiques; the odd, somewhat surrealistic effect almost prefigures "instant" sculpture.

From 1 June until the end of November 1900, 168 sculptures and drawings were put on display in a specially built pavilion on the Place de l'Alma, as part of the Great Exhibition. This expensive enterprise was made possible thanks to the help of the bankers Albert Kahn and Joanny Peytel, and of Louis Dorizon. It was not the immediate public success they expected but the prestigious catalogue, the poster engraved by Carrière, the lectures, public relations activities, and Rodin's almost constant presence, all produced long-term results, ensuring the permanence of Rodin's reputation, and confirming him as the greatest sculptor of his time. The following years saw success after success. He became a member of the royal academies of sculpture in Dresden and Munich, of the Beaux-Arts academy of Berlin, received honorary degrees from the universities of Jena, Glasgow and Oxford. He presided over celebrations and banquets, and travelled to England and Moravia for dedication ceremonies. In 1910, he was made a grand officer of the Légion d'honneur; exhibitions of his work were in demand all over the world, including the New World; in 1908, fifty-three drawings were show at the gallery of the famous photographer Alfred Stieglitz in New York, on Fifth Avenue – most of them are now in the great American collections. There are more than 7000 other drawings in the collection of the Musée Rodin, providing the abundance and diversity of this aspect of his work which, with a few rare exceptions, remains completely separate from the sculpture; unlike most sculptors, Rodin did not draw as a preparation for modelling, but, more often, made

sketches of the finished sculptures. The public often mistook these independent drawings for studies. Throughout Rodin's life, his graphic work was autonomous, and it became bolder and freer as he grew older. In the general introduction to the inventory of the Musée Rodin collection, Claude Judrin analyses the difficulties in dating the drawings, with the exception of those of Cambodian women drawn in July 1906. In his youth, he drew plaster casts, draperies, and Belgian landscapes; from Italy he brought back sketches of antiquities, Roman monuments, and the sculptures of Michelangelo and Donatello; later he juxtaposed them in collages, the purpose of which remains obscure. A group of "black" drawings, powerfully executed in pen and ink wash, often enhanced with gouache, corresponds with *The Gates of Hell,* and therefore dates from the 1880s. The accusation that his art was too literary could have come in part from the importance of the illustrations he supplied for several of the century's masterpieces; the best of these are the twenty-seven drawings for *Les Fleurs du Mal,* done in 1887-8, followed, seventeen years later, by drawings for *Le Jardin des Supplices,* by Octave Mirbeau. Up until the end of his creative life he produced an uninterrupted series of feminine images, with blurred shadows and features placed on either side of the wash, as if to accentuate the relief. A whole set of myths and symbols, inspired by his penchant for universality, made him name these figures Nausicaa, Sappho, Psyche or Constellation; to draw their voluptuous shapes he let models roam freely, suggesting their own pose, and he would say later: "I did everything to adapt my mind to that of those creatures."

He squandered his life with endless worldly activity, held on course by a few faithful and compatible friends; he carried on an important correspondence with Hélène de Nostitz, the niece of Chancellor von Hindenburg, writing slightly precious letters revealing his very conventional musical tastes. With Edmond Bigand-Kaire, the master of a foreign trading ship and a friend of the Provençal poet Mistral, there was a friendly exchange of presents – statuettes in return for raisins from Smyrna and wine from Provence. To close friends he always wrote by hand. But, for the international correspondence engendered by his success, he needed a cohort of secretaries to knock the master's thoughts into shape and to improve his faulty spelling. It was a hard task in which patience and devotion were often met with mistrust, and the confusion and excessive demands of an over-stretched old man. Twenty-two secretaries came and went in the first decade of the century, amongst them Rainer-Maria Rilke, "sacked like a valet" for having, in Rodin's absence, sent, without permission, a routine reply to a letter.

As I have already pointed out, nineteenth-century sculpture was an art form weighed down with constraints, and a large part of the achievement was manual rather than conceptual. It is estimated that during his active life Rodin employed at least fifty assistants, some completely unknown and others – Halou, Bourdelle, Despiau, Schnegg, Pompon – who would become the most important sculptors of the succeeding generation, Indeed, clients, warned of the division of labour, would ask for their marble to be cut by such or such an assistant. The presence of these assistants caused it to be said that Rodin himself did not touch the marbles. In fact, documents show that having learnt his job as an artisan, and being technically able to do it, he exercised precise control over the *praticiens,* showing them with a pencil which contours to follow, which shadows to strive for, which planes to soften in order to better reflect the light. And they would write to him for instructions if, held up by his official engagements, he was unable to check the progress of the carving.

His attitude towards bronze sculpture was quite different and complex, and it was influenced by the obligation he felt to respond to the needs of different clients. For the more enlightened ones he made single bronzes, cast by foundries of varying reputation. From 1875 to 1917, he used twenty-eight different ones. Some, like Gruet, Gonon, Hébrard and Rudier were renowned firms, others more obscure, whose bills look like laundry lists. Often it was the polisher rather than the caster who gave the piece its final tone. And since one of the most loyal of these, Limet, lived more than a hundred kilometres from Paris, received the pieces directly from the foundry, and, after putting on the patina, sent them straight to the clients, one must admit that the idea that Rodin had personal control over every phase of production was slightly fanciful, at least after his success in 1900. For the general public, he had no hesitation in disseminating, as was the custom of the time, his most famous sculptures – *The Kiss, The Thinker, The Eternal Spring* – in the form of mechanical reductions which specialist foundries would sell directly, the sculptor who supplied the model merely receiving an agreed percentage.

Most of the bronzes are stamped with the artist's signature (copied from an example supplied by him) and also with the stamp of the foundry. Some, although perfectly authentic, are unsigned. But there is no question of any of them being numbered or dated; these are modern methods, linked with the notion of rarity and speculation in art.

Rodin was now supremely confident, and was in control of a real production line. The time for monumental sculpture was past, but his ability to communicate life to inert matter remained, the triumph of his lifelong devotion to his art. His swan song was a small series of sculptures on the theme of the dance, which he made from about 1910 onwards. He did not understand the type of ballet inserted into opera in the nineteenth century, with its formal poses and traditional costumes, which appeared as artificial interludes interrupting the musical drama; he never reproduced any of the steps or poses of classical ballet, but what did inspire him were the more modern forms introduced by Isadora Duncan, Loïe Fuller, and, most of all, the Ballets russes. It is instructive to compare these statuettes, which capture in an instant a limbering-up exercise or balancing effort, with ballet as represented by Degas. Like Rodin, Degas did not pose his models, and looked for spontaneous movements, but he showed dancers in intimate everyday positions, devoid of any emotional content. Disregarding the deliberate contortions with which he increases the intensity of a gesture, Rodin focused his attention passionately on the human body itself. Thus his *Nijinsky* is impressive despite its modest size. Rodin had removed all intellectual intention to concentrate on the energy of a body gathered on itself ready to leap into space. It is painful to learn that this great challenge to gravity and symmetry, the great taboo of the previous century, this pure essence of movement, was the result of an episode from which Rodin did not emerge well. We know that Diaghilev had allowed Nijinsky to adapt the choreography of *L'Après-midi d'un Faune* to new steps which were to become the basis for modern dancing. The performance of May 1912 aroused violent criticism in *Le Figaro* by Calmette, who found the ballet bestial and unseemly. Rodin had been enthusiastic about it, and said as much to Roger Marx, who, to defend Nijinsky, quoted the sculptor on the perfect harmony between the mime, and the grace and quality of the bodily expression. But when challenged by Calmette, Rodin, afraid that a public controversy might put in jeopardy his dreamt-of plans for a museum, disowned the faithful Roger Marx, who had always been an unconditional champion of his work.

This plan for a museum to house his work had been brewing for several years. The place chosen for this project was the Hôtel Biron in the faubourg St Germain, a very fine example of baroque architecture, named after the duc de Biron, Louis XV's marshal; in 1804 it had become a boarding school for young girls, as famous for its pupils' social standing as for the quality of the teaching given by the nuns of the Society of the Sacred Heart. The laws separating Church and State, which resulted in the expulsion of the nuns, meant that the house was in the hands of the liquidator of the Society, and was due for demolition. Artists, notably Rainer-Maria Rilke, were attracted by the beauty of the architecture and the charm of the overgrown garden. Rilke, now reconciled with Rodin, encouraged him to move in, which

he did in 1908. He proved to be an expansionist tenant, extending his domain bit by bit; every day he went to the rue de Varenne to receive and lay out his collections, hanging pictures, mingling the excellent with the less good, while retaining his home and studio at the Villa des Brillants where Rose lived. It was at the Hôtel Biron that the duchesse de Choiseul made her attempts to obtain publishing rights over his works. It was there, after the break in 1912, that this doyenne of beautiful, greedy women continued to circle round the old man, who, after his first stroke, had entered a phase which with its intermittent remissions, was described by Pierre Daix as "the senility of a God".

The state finally bought the property in 1911, but hesitated between using it as an administrative office or as a house for the distinguished guests of the Republic. With the prospect of complete destruction of the character of the place, a campaign was started to create "a unique and special museum to preserve Rodin's work in perpetuity"; it was orchestrated by Judith Cladel, who hoped to be the first curator of the establishment, and organised a petition. There is no doubt, however, that it was Rodin's political connections which settled the matter, with the support of Clemenceau, Dalimier, Poincaré and, most of all, Etienne Clémentel. He was the creator of the International Chamber of Commerce, and Minister of Commerce, as well as being Rodin's executor. (What is less well known is that he was a keen photographer, and it is to him that we owe the only pictures of Rodin in colour.) The museum plan met with opposition from conservative artistic circles, and disapproval from Catholics indignant at the presence of what they regarded as sacrilegious works in a former convent; there was also a reluctance to publicly fund a museum to a living artist. The First World War interrupted the whole enterprise. After a hurried departure to England with Rose and Judith Cladel, Rodin returned to Paris and then went to Rome in 1915, where his attempt to make a portrait of Benedict XV was cut short when the Pope grew impatient with Rodin's methods and his "political" remarks.

The wartime winters were hard. The old man's spirits sank; he was weak and ill, and upset by the intrigues among his rapacious "friends". Thanks to the

persistence of his supporters, and after long hard debates in Parliament, all his personal works with attached rights of reproduction, his own collection of works of art, his furniture, his manuscripts and all his documents, the Villa des Brillants (with a life interest for him and Rose) were all made over to the State in three successive donations on 1 April, and 13 and 20 September 1916. The gift was ratified on 22 December 1916. This was the origin of the present-day Musée Rodin; the State had ensured the preservation and dissemination of this great patrimony by a statute establishing its civic nature and financial autonomy.

At last came the strange, almost comical end, in the cold house in Meudon where the two old people were running short of coal. On 29 January 1917, Rodin – almost absentmindedly – married Rose in the studio adjoining the villa; she died sixteen days later. He joined her, on 17 November of the same year, in a grave dug in their garden. They still lie there, beneath a bronze statue of *The Thinker*. Death fortunately spared Rodin from a scandalous plan for unsought admission to the Institute, which would have been a betrayal of his whole life's work.

Posthumous fame did not come immediately, partly because of all the disagreements, partly because of the fake Rodins which discredited his own productions. Of the sculptors who had been his assistants, Bourdelle turned to monumental archaism, Despiau to eurhythmy and immobility, and Pompon to smooth, calm shapes. Rodin's modernity would emerge only when his methods were revived in the new perspective of a completely twentieth-century sculpture.

MONIQUE LAURENT

Conservateur en chef
des Musées Nationaux de France
Ancien Conservateur
du Musée Rodin

Rue de l'Arbalète in about 1840. Auguste Rodin was born here, on the fifth floor of the last house on the left.

Maria

Daguerreotype, probably 1849, of
the sculptor on his mother's knee.

Auguste Rodin was a child of eleven at the time of Louis-Bonaparte's coup d'état, on 2 December 1851, when 400 people were killed, shot on the boulevards – was he even aware of it?

In that same year, Manet met Baudelaire, a young man called Whistler entered West Point, Turner died, and Victor Hugo went into exile. But in Paris, in the working-class district of the Montagne Sainte-Geneviève, young Auguste was having trouble with his spelling. His life was made even more difficult by his red hair, considered at the time to be a sign of bad character, and his short-sightedness. He was the son of Jean-Baptiste Rodin, a police inspector at the time of the 1851 events, and himself the son of carters from Normandy, originally from Yvetot. He had received enough of an education to enter the police force during the reign of Charles X. He retired in 1861, in Napoleon III's reign. He had one daughter from his first marriage, who was thought to lead an "unseemly" life, and who became estranged from the rest of the family.

"I was poor;
I might have become a teacher perhaps."

Rodin had one sister, Maria, three years older than himself; she very soon realised the extent of his genius, and it was she who obtained concessions from her parents on behalf of her brother. At the age of ten, he was sent to his uncle's boarding school in Beauvais, where he was not a great academic success. His myopia prevented him from joining in with the rest of the class, and he shut himself away in a world where drawing became his only outlet. To draw, and thus be able to communicate at last with others, was all the easier for him as he could decide himself how close to get to his subject. Drawing was his link with reality: "Even when I was very young," he explains, "I drew. The grocer, where my mother shopped, used to wrap the prunes in paper bags with pictures on them. I would copy them, they were my first models."

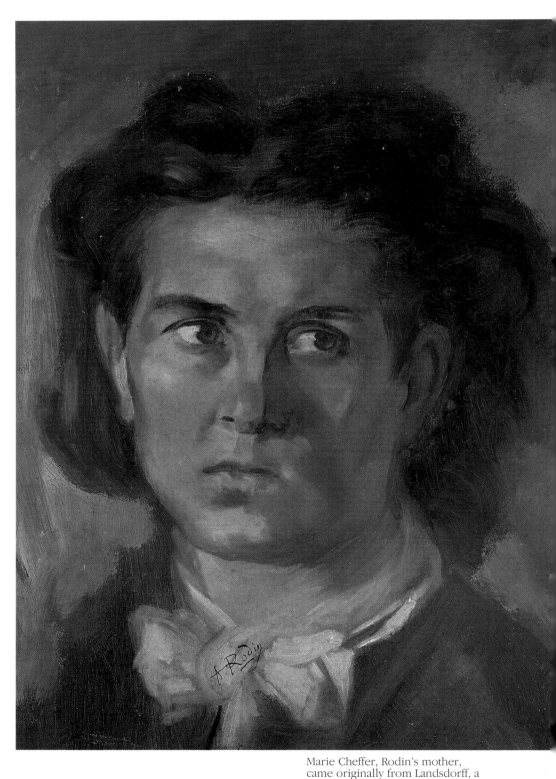

1. *Portrait of Marie Cheffer*, 1860. Oil on canvas. 46×38 cm. Musée Rodin. P.7237.

2. *Portrait of J.-B. Rodin*, 1860. Oil on canvas. 47×41 cm. P.7235.

Marie Cheffer, Rodin's mother, came originally from Landsdorff, a small village in Lorraine which became German in 1870. This portrait was painted by Rodin in 1860, when he was twenty. Jean-Baptiste Rodin, the sculptor's father was a police inspector. What role did he play during the revolutionary times of 1848? Did he zealously enforce the censorship and repressive police system of the monarchy and the empire? He was certainly the sort of functionary who respected "law and order", and he had doubts about his son's vocation.

"If you want something, you can get it, but you must really want it, with a man's will. I think that you are a bit of a limp rag at home . . ."
(Jean-Baptiste Rodin to his son.)

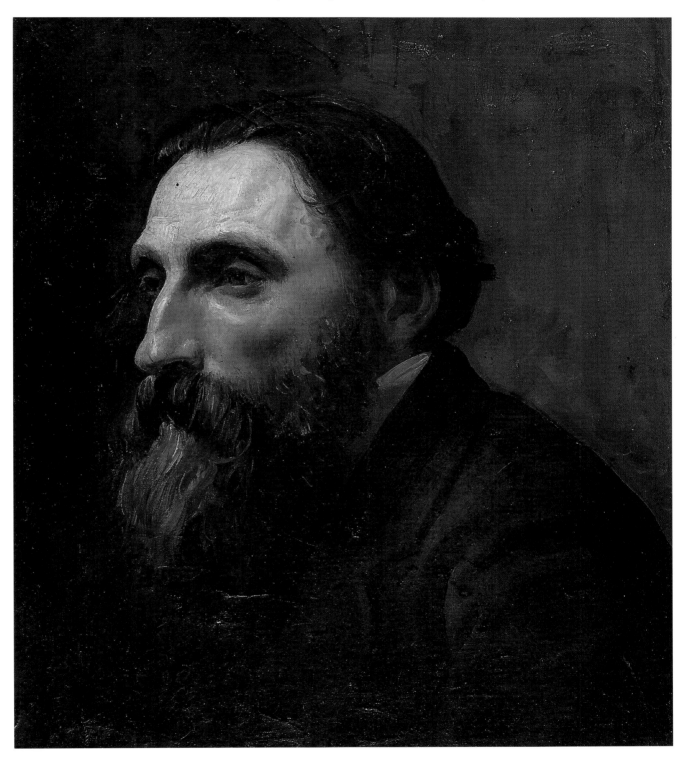

"I went to the horse market, and drew everything."

"We worked there relentlessly, we were like wild animals."

1. *Horse in harness,* about 1864. Graphite, pen, black ink on paper. 7.4×10.7 cm. Musée Rodin. D.120.

2. *Skeleton of dog,* before 1870? Graphite on paper. 24.3×31 cm. Musée Rodin. D.245.

Probably taken after Maria's death, this photograph shows Rodin *(r)* with a friend, Léon Fourquet. At twenty-two, he had started studying again at the horse market.

1
Study from the horse market on the boulevard Saint-Marcel.

2
At a time when academicism was entrenched at the Ecole des Beaux-Arts, Rodin's studies of animal skeletons at the Natural History Museum were a way of escaping from the demands of traditionalism.

A famous animal sculptor during the Second Empire, Antonin Barye gave generous advice to Rodin, for which he remained grateful all his life.

After the setbacks in the entrance exams for the Ecole des Beaux-Arts, Rodin found a new workplace at the horse market on the boulevard Saint-Marcel. "How I was pushed and trampled upon!" He installed himself in a basement of the Natural History Museum, with a few friends, and they studied animal skeletons. Antonin Barye, who gave a course at the museum, used to come down and visit them from time to time. "He used to look at what we had done and then go away, mostly without saying anything. But all the same it is from him that I have learned the most." He had been a famous sculptor under Louis Philippe, responsible for promoting animal sculpture from its secondary position. "He was a very simple man. In his shabby suit he looked like an assistant in one of the schools of the time. I never knew such a powerful man who could look so sad."

Rodin entered the Petite Ecole in 1854 or 1855, no doubt thanks to his mother, and the powers of persuasion of his sister Maria. "At last", wrote Rodin, "my parents realised that they must help me towards a career, and, knowing my taste for drawing, entered me at the drawing school in the rue de l'Ecole-de-Médecine." Known then as now as the Petite Ecole, to distinguish it from the Grande Ecole, that is to say the Ecole des Beaux-Arts, it was founded by Bachelor under Louis XV.

"I received an eighteenth-century education."

Rodin ran his own life from the age of fourteen onwards, meeting "brothers in vocation": Alphonse Legros, and Jules Dalou. They spoke the same language, and discovered the world of art, with forerunners such as Courbet among others, whose-*Baigneuses* caused a scandal at the 1853 Salon, and which Rodin probably saw for the first time at the Great Exhibition of 1855, where Courbet's work was shown in his own pavilion. Maria, his gentle and sensitive sister, was eventually drawn into this world. She had been educated by nuns with the aim of becoming a Catholic teacher, but she succumbed to the charms of a friend of Auguste's, the painter Barnouvin, while he was painting her portrait. But the painter married another girl, and Maria, unable to face life without him, entered the Ursuline convent which had taken her in as a child; she died at home of peritonitis in 1862. Auguste was shattered by her death, and he too took refuge in religion. He entered the monastery of the fathers of the Holy Sacrament, an order founded by Father Eymard. There he chastised himself, but the perceptive Father Eymard soon recognised the young novice's talent; first he installed a studio for him in the monastery garden, but eventually he returned him to secular life to continue his studies.

4 September 1860
"My dear sister, we have been very sad since your departure . . . we are very lonely, even though there are still two of us."

Rodin, photographed here in 1862, was devastated by his sister's death, and, feeling responsible, put side his artist's smock for the white robe of the monks of the Holy Sacrament, an order headed by Father Eymard. The latter soon realised what the novice's true vocation was, and installed a studio for him in the community's garden.

1. *Portrait of Maria Rodin*, Barnouvin. Oil. 46×38 cm. Musée Rodin. P.7264.

Maria was Auguste's elder sister.
She adored her brother, and
supported him against their father,
working to help pay for his
lessons. She was attracted by the
artistic milieu, and met Barnouvin,
a painter friend of Auguste's; she
fell passionately in love with him,
or so she thought, but he
abandoned her. She then entered
the convent of the Ursulines, and
died at the age of twenty-five.

The teaching at the Petite Ecole was far less stifled by academicism than that at the Beaux-Arts. This relative freedom enabled Rodin to escape from rigid paternal authority, and to experience life on his own. At fifteen he was his own master. As well as the Petite Ecole, he attended the free classes at the Collège de France, and studied at the Louvre and the Bibliothèque Imperiale. The Petite Ecole trained *ornemanistes* and *praticiens,* in other words artisans rather than artists. It might seem therefore that Rodin was not yet aware of his artistic potential. But the Petite Ecole was also a gateway to the Beaux-Arts entrance examinations, and this was why Rodin, working harder than ever, used to go to the Gobelins works to perfect his drawing – they offered free courses where he could draw from a live nude model.

"Remain devoted to the masters who came before you."

The Petite Ecole was dominated by the powerful personality of the painter Horace Lecoq de Boisbaudran. He made his pupils study an engraving, painting or sculpture minutely, and then reproduce it from memory, sometimes several days after seeing it. He never hesitated to take them out of the studio, to work on the new buildings. Rodin was to write in 1913: "Despite the originality of his teaching, he maintained traditions, and his studio was, one might say, a studio of the eighteenth century. At the time, Legros, myself and the others did not realise, as I do now, what luck we had to be with such a teacher." Rodin led a life of hard labour at the Petite Ecole, where drawing was soon replaced by sculpture: "In drawing, we drew in the round. Some pupils modelled from antiques. For the first time, I saw separate pieces, arms, legs or heads, and then I attacked the whole figure. I suddenly saw the whole thing . . ."

Rodin entered the Petite Ecole in 1854. "It had kept a few traces of the teaching of the eighteenth century: life, feeling and grace were not forbidden, you could see that clearly in my drawings."

The *Bust of Father Eymard* marked Rodin's return to secular life. Thanks to Father Eymard, his confessor at the Holy Sacrament monastery, Rodin returned to his family. It was at home, then, that Charles Aubry photographed him, posing in front of the plaster bust, in his sculptor's smock. Father Eymard refused to let the bust be cast in bronze, saying that Rodin had given him horns.

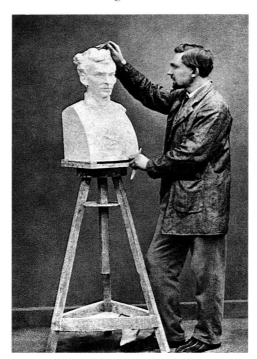

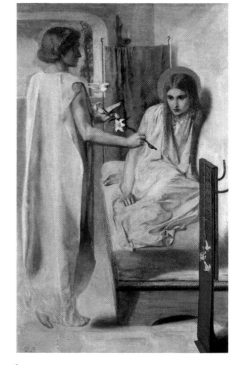

1
In 1855, the Great Exhibition celebrated the triumph of Corot, Ingres and Delacroix. But most of all it introduced the British Pre-Raphaelites (whose name stemmed from their aesthetic theories based on Raphael's predecessors); their leader was Dante Gabriel Rossetti.

2
This study by Rodin, in whch the model is frozen in a stylised pose, is typical of the sort of exercise practised at the Petite Ecole and at the Gobelins school. But equally the teacher, Lecoq de Boisbaudran, was in the habit of taking his pupils outside, and giving his classes in the open air.

1. *Ecce ancilla Domini*, D. G. Rosetti. 1850. Tate Gallery, London.

2. *Académie d'homme vu de face, c.* 1857. Oil. 78×35.5 cm. Musée Rodin. P.7231.

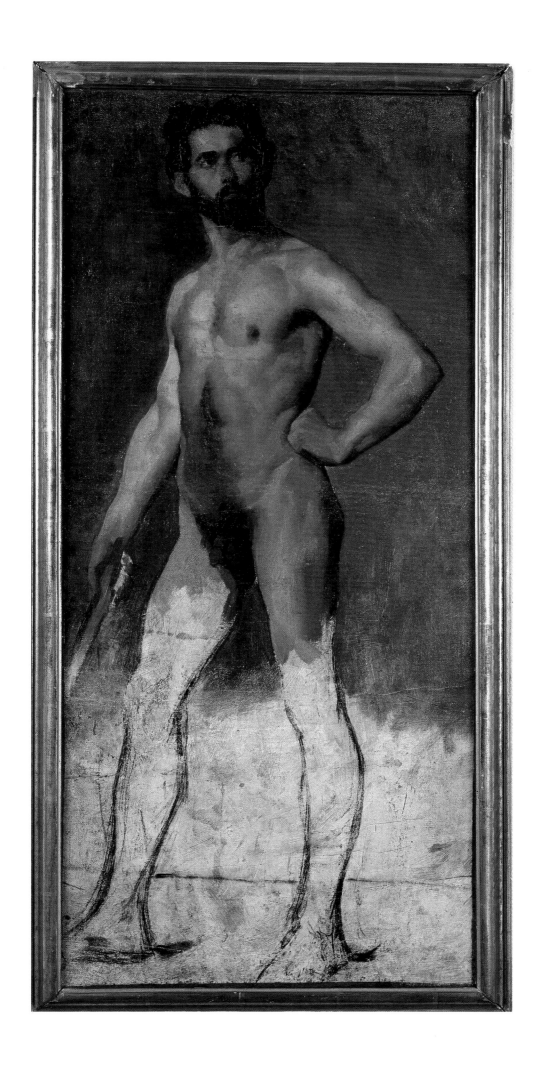

"In the meantime, avoid
imitating your elders."

Maria died in 1862, and her death tragically marked the end of Rodin's adolescence. In 1864, he entered Carrier-Belleuse's workshop – he was the best *ornemaniste* of the time. Quantities of fountains and statues destined for ceilings and fireplaces were produced by his studios. It represented security of employment for Rodin, and an avenue to new experiences. Working as a *praticien,* he would hack away marble, or prepare plaster-casts, to which Carrier-Belleuse would affix the final touch, and his own signature. This was common practice at the time, and later on Rodin would use *praticiens* in his own studios. He read a lot, and followed Michelet's courses at the Collège de France. He rented a studio, the scene of his first amorous encounters with a young laundry girl called Rose: "Not being able to afford anything better, I rented a stable near the Gobelins, rue Le Brun, for 120 francs a year; it had enough light, and space enough to get a proper perspective between the clay and the model, always an essential priority from which I have never departed. Cold air came in from every crack . . . It was icy cold, and a well in one of the angles of the wall, full of water, maintained a penetrating damp in all seasons . . ."

"As I could not afford to have everything I made moulded in plaster, I wasted precious time each day covering the clay with damp cloths."

Here he worked on the bust of an odd-job man called Bibi, who worked up and down the boulevard Saint-Marcel. "A fine head, full of nobility." *The Man with the Broken Nose,* finished in the middle of the winter of 1864, cracked in the frost. Rodin was undeterred by the broken face, and showed it as it was at the 1864 Salon, under the title of *Mask,* without pedestal or stand. The entry was, of course, rejected, the first of a long series. But, for Rodin a new era had begun; he had met Rose.

Rodin worked in Carrier-Belleuse's studio from 1864 to 1870. Carrier-Belleuse provided work in Brussels for the young Rodin during the Commune, and then at the Sèvres factory. "He had in him something of the fine blood of the eighteenth century. His sketches were admirable; the final product was less good, but he had a noble nature."

1
The Man with the Broken Nose was turned down at the 1864 Salon: not only was it just a mask, as the frost in the studio had broken the back part of the head, but also it took an opposite course to the mainstream of academic sculpture. It marked the beginning of Rodin's innovative genius. Picasso, in 1905, took up the same idea with his Picador with a broken nose.

"I worked as much as I could, I thought only of that."

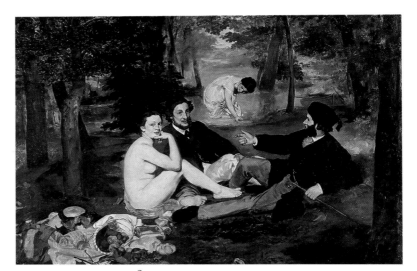

2
Manet's *Le Déjeuner sur l'herbe* was the scandal of the Salon des Refusés in 1863: "M. Manet wants to achieve celebrity by shocking the bourgeois." Passions were unleashed by the naked young woman amongst the fully clothed young men. The emperor declared that it "offended modesty". Rodin was twenty-two years old. The following year, *The Man with the Broken Nose* was turned down by the Salon.

1. *The Man with the Broken Nose,* 1864. Bronze. 31.8×18.9×16 cm. Musée Rodin. S.755.

2. *Le Déjeuner sur l'herbe,* E. Manet, 1863. Oil on canvas. 208×264.5 cm. Musée du Louvre.

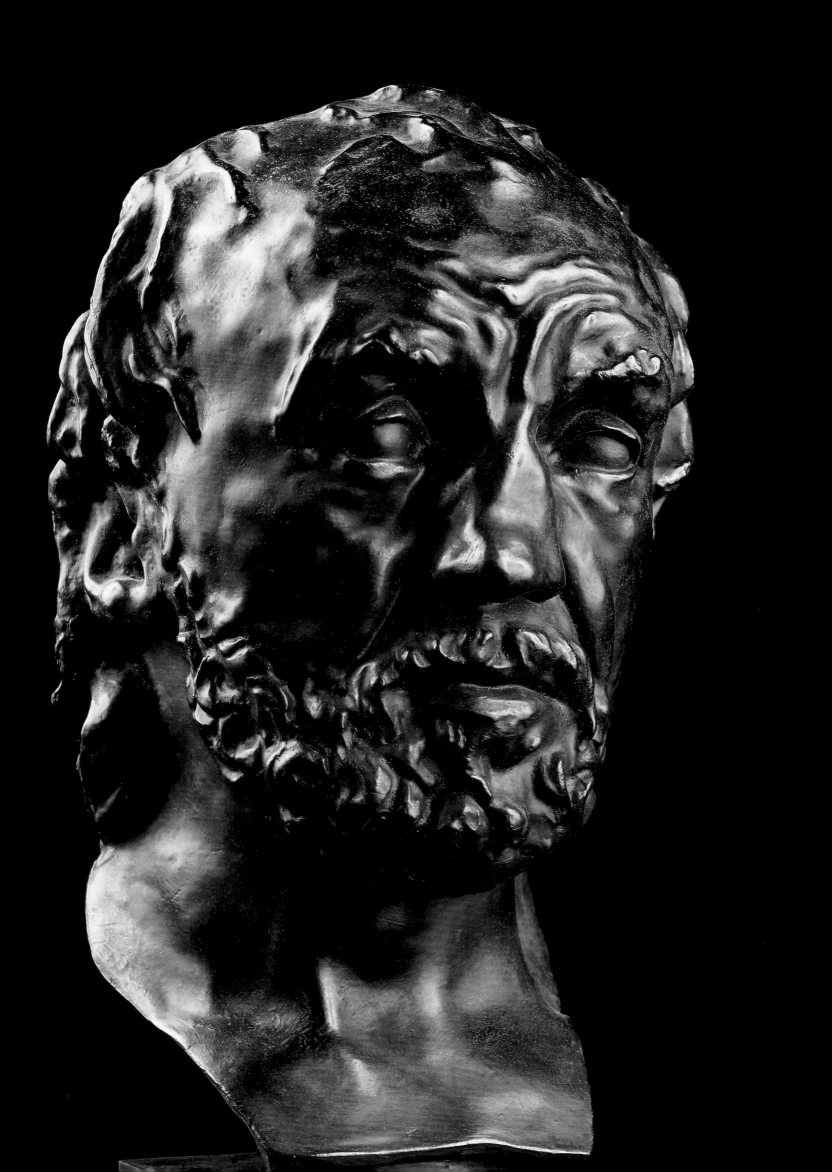

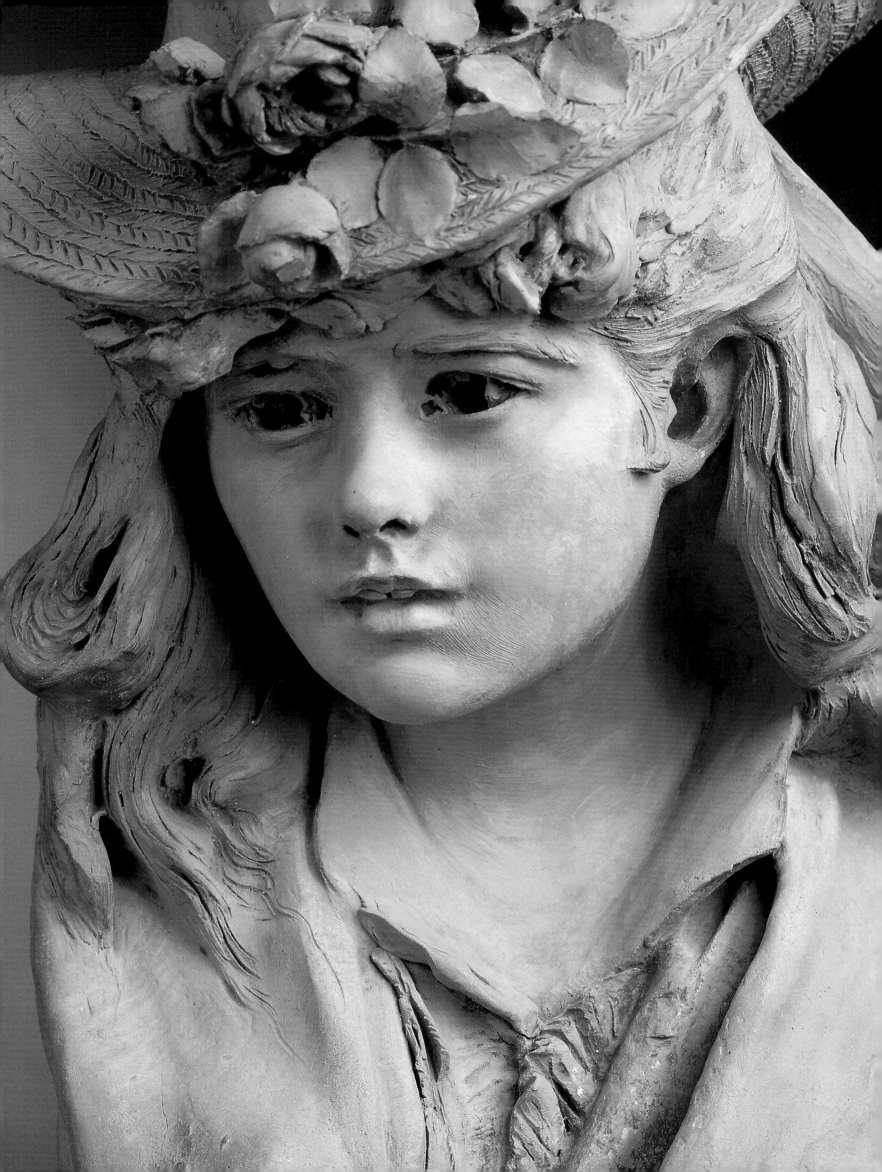

Rose

When Rodin first met Rose, she was a very pretty young girl. Unfortunately, her gentle features hardened and she became prematurely old. The last bust, in 1890, showed the aggressive face of somebody who had lost their illusions.

1
Jeune femme au chapeau fleuri. Rodin made this bust in 1865, with Rose as a model. One sees here the charming style of the eighteenth century, with which Rodin was impregnated. Rose was twenty-one at the time.

2
La Source, or *La Maternité,* 1867, was a theme Rodin was fond of, out of his affection for the gracious style of the eighteenth century, and more especially, its best representative, Clodion. Little Auguste, Rodin's son, was two, and inspired several maternity scenes at that time.

*"I am happy
that you are looking after
my plasters and clays."*

1. *Jeune femme au chapeau fleuri,* around 1865. Terracotta. 69×34.4×29.5 cm. Musée Rodin. S.1056.

2. *La Source,* 1867. Terracotta. 37.5×32.7×32.8 cm. Musée Rodin. S.1193.

Rodin met Rose in 1864. She was just twenty and worked as a linen girl with a dressmaker. This more or less illiterate young woman was probably the sculptor's first sexual partner. The studio at the rue Le Brun, an old stable, was also their home. It was completely filled with work in the course of completion; "I had accidents the whole time, either because of the frost or the heat, whole blocks would come away, heads, arms, knees, pieces of torso would fall off; I would find them in pieces on the floor tiles. Sometimes I could save the pieces." Rose took in sewing work to pay for the housekeeping, posed for Rodin, cooked and cleaned. But her main job was to maintain the humidity of the cloths wrapping the plasters, a full-time job. Throughout their life together, Rodin never ceased to nag her about this: "When you damp my figure, don't wet it too much or the legs will get too soft."

> "How beautiful she is!
> It is sculpture,
> pure sculpture."

Rose gave birth to a child, officially by an unknown father, but named Auguste-Eugène. Rodin asked his aunt Thérèse to tell his parents that they had a grandson and only then did he introduce Rose to his parents. All this shows how afraid he must have been of his father. He never legally recognised the child, and when the young Auguste turned out to be mentally handicapped, he gave up the idea of teaching him his skills. Meanwhile his art became more sensual, still full of the gracefulness of the eighteenth century, as can be seen in a group modelled in 1865, *Young Girl in a Flowered Hat.*

Despite Rodin's many amorous adventures, Rose was always considered as his wife. He waited fifty-three years, however, before legalising their relationship; he did this for reasons of inheritance, and also, perhaps, to thank his old friend of so many years for her support and loyalty.

Rodin had to support his family. There were plenty of great construction works going on in Paris at the time, so, setting aside his personal ambitions, he set to work to earn his living. Baron Haussmann had begun to change the whole face of Paris: already slums had been cleared, great avenues opened up, and new blocks built. The Opéra and the Châtelet had been built, the Tuileries and the Louvre restored, and 355 sculptors hired, one of whom was Rodin. He worked on the decoration of the house built by La Païva on the Champs-Elysées. He was also the *praticien* for Charles Cordier, who decorated the grand drawing-room of the château that the Rothschilds were building at Ferrière. In 1866, Carrier-Belleuse obtained the commission for the caryatids in the grand foyer of the Opéra. Rodin no doubt worked on one or the other. The Opéra was opened in 1875, when Rodin was in Belgium, but he had certainly already admired the stone groups on

"I hunt for truth and I track life."

"He [the artist] *has only to look at a human face to decipher the soul; no feature can deceive him, hypocrisy is for him as transparent as sincerity; the inclination of a forehead, the slightest frown, the movement of the eyes, can reveal to him the secrets of the heart."*

1
The Balcony, by Manet was presented to the 1869 Salon. Berthe Morisot and the violinist Fanny Claus had posed for the painting. The public was amazed, the critics silenced by the picture's realism.

2
La Danse by Carpeaux was destined for the façade of the Paris Opera, whose construction began in 1861. The decorative groups were unveiled in 1869 and greeted with cries and sneers. The naturalism of *La Danse* shocked bourgeois conventions and was labelled "an ignoble saturnalia" and "an insult to public morality".

3
Rose was twenty-four in 1869 and *Mignon* was the second bust that Rodin did of her. His art had matured in the four years that separated this bust from the 1865 one. On his return from Brussels, Rodin sculptured Rose again, creating *Bellone.*

the façade, such as Carpeaux's *La Danse,* which had been shown to the public a few years previously. Like Carpeaux, Rodin was a member of the Union Centrale des Beaux-Arts, and, at their meetings, had encountered Delacroix, Ingres, and Théophile Gautier. Rodin continued his personal artistic development, alone and ignored, alongside his work on the great monuments of Paris, and from this aspect of his work emerged a bust which represented a turning-point: *Mignon.* This portrait of Rose marked the end of the elegant eighteenth-century phase, and the beginning of a much more modern style, that of the mask of *The Man with the Broken Nose.*

1. *The Balcony,* E. Manet. 1869. Oil on canvas. 170×124.5 cm. Musée d'Orsay.

2. *La Danse,* J.-B. Carpeaux, 1869. Sculpture for the façade of the Opera. 330×297 cm. Musée du Louvre.

3. *Mignon,* 1869. Bronze. 40×30×26 cm. Musée Rodin. S.503.

The Franco-Prussian war was declared on 19 July 1870. The Prussians were at the gates of Paris. The fall of Napoleon the Small – Victor Hugo's nickname – was imminent. The Empire collapsed on 2 September. Belgium became a place of refuge, as it had been for David in 1815 and Victor Hugo in 1851. Rodin, invalided out because of his eyesight, and without work, was sinking into penury. With the help of Carrier-Belleuse, who had already been recruited by Belgian architects, he took refuge in Brussels, leaving Rose in Paris.

Brussels was being entirely rebuilt: new boulevards were being cut, new houses built. Rodin worked alongside Carrier-Belleuse, sculpting for the "boss". Driven by the need for money, Rodin signed some bronzes to sell for his own profit to the Compagnie des Bronzes; Carrier-Belleuse could not forgive him for this. . . . "My little Rose, I have had many worries; I have not worked for nearly three months. You see how tough it's been; we have quarrelled with Monsieur Carrier . . . You will have to wait a bit, Rose, I haven't a penny at the moment."

"I have not a penny at the moment."

But the starving Parisians had risen – it was the revolutionary Commune. The national assembly was installed at Versailles, while the barricades went up in Paris. "I wish I knew what you did during those dreadful days," wrote Rodin to Rose. Actually, he appeared to more worried about the works he had left in Rose's care. During these moments of enforced leisure, he used to visit museums where he would copy the Flemish masters as he had done in his youth. When the Commune ended, Carrier-Belleuse returned to Paris; Rodin joined forces with his successor, Van Rasbourg, and began to earn some money: "Everything comes to an end, my angel, even misfortune." He brought Rose to Brussels, and on Sundays he painted the Belgian countryside.

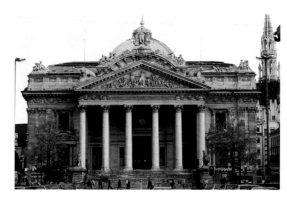

In Brussels, at the request of Carrier-Belleuse, and then in collaboration with Van Rasbourg, Rodin worked on the decoration of the Bourse.

1
Life remained simple and hard-working. Rodin continued to draw and the forest at Soignes, on the outskirts of Brussels, offered plenty of subject matter. He often used red chalk, which gave him freedom of line, and speed of execution. But he also painted true landscapes in a manner which resembled Corot.

Barricades in front of the Town Hall (May 1871). The Paris Commune, the revolutionary government during the siege of Paris, ended in a "bloody week": 20,000 federates killed, 38,000 arrests. Courbet, Corot, Daumier, Millet and Dalou had supported the Commune; Monet took refuge in London and Renoir returned to Paris. Rodin was in Brussels.

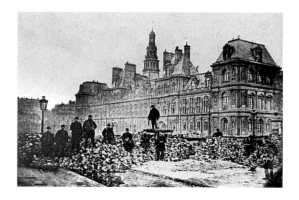

2
This drawing after Rubens is one of many studies Rodin did from the Flemish masters.

1. *Belgian Landscape*, 1871-7? Detail. Red Chalk. 15.8×22.8 cm. Musée Rodin. D.35.

2. *Crucifixion*. Pen and sepia wash. c. 1870. 10.2×14.5 cm. Musée Rodin. D.133.

At the beginning of 1875, Rodin set off for Italy, leaving Rose in Brussels. "Only thinking of my stomach when there is nothing more to see," he reported dutifully to Rose. "It won't surprise you to hear that I have been studying Michelangelo from my very first hour in Florence, and I think that the great magician is yielding up a few of his secrets. All the same, none of his pupils or his masters can do what he does, the secret is in him, and him alone."

1
"When I was working on *The Age of Bronze*, I obtained those ladders that painters use for large canvases. I would climb up, and, as much as I could, match my model with my clay in the foreshortenings, and I would examine the profiles from above. I had more or less the same profiles becoming 'tighter' as they came closer together, as profiles never look alike unless they are very accurately drawn in relation to one another. It is important to examine them from above and from beneath and from the top and the bottom (. . .)"

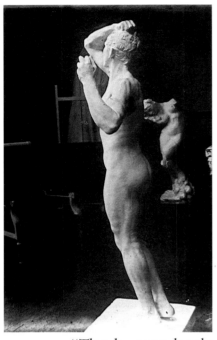
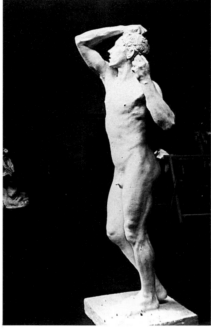
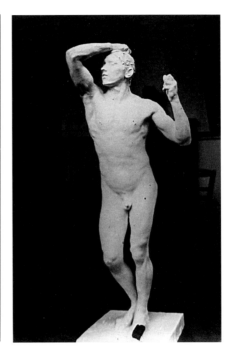

"The human body
has infinite profiles."

Back in Brussels, Rodin continued his researches. He planned a statue that would symbolise defeat, but also rebirth, which would be called *Le Vaincu*. At first the figure held a spear, which he was leaning on; then it was removed and the statue was renamed *The Age of Bronze*. When it was exhibited at the Cercle Artistique in Brussels, everybody was amazed and exclaimed at the artist's skill. But what began as a compliment soon became an insult. *L'Etoile Belge* said: "If the attention is attracted by its strangeness, it is retained by a quality as precious as it is rare – life itself. What part *surmoulage* (moulding from life) has played in this cast, it is not for us to say here." Rodin took up the challenge, and quickly replied: "If any connoisseur would do me the pleasure of finding out for himself, I will introduce him to my model, and he will be able to observe how far an artistic interpretation is from a slavish copy."

The department stores did not only represent a commercial revolution: they held art exhibitions, as the ones in Tokyo do today.

2
The bust of *Suzon* is one of the charming "bread and butter" figurines which sold for between 50 and 80 francs to the commercial bronze makers.

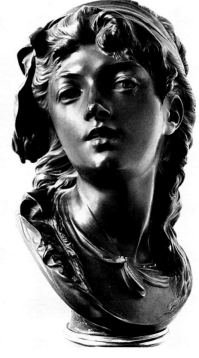

1. *The Age of Bronze*, 1876. Bronze. 180×80×60 cm. Musée Rodin. S.465.

2. *Suzon*, 1875. Bronze. 44×22×22 cm. Musée Rodin. S.961.

42

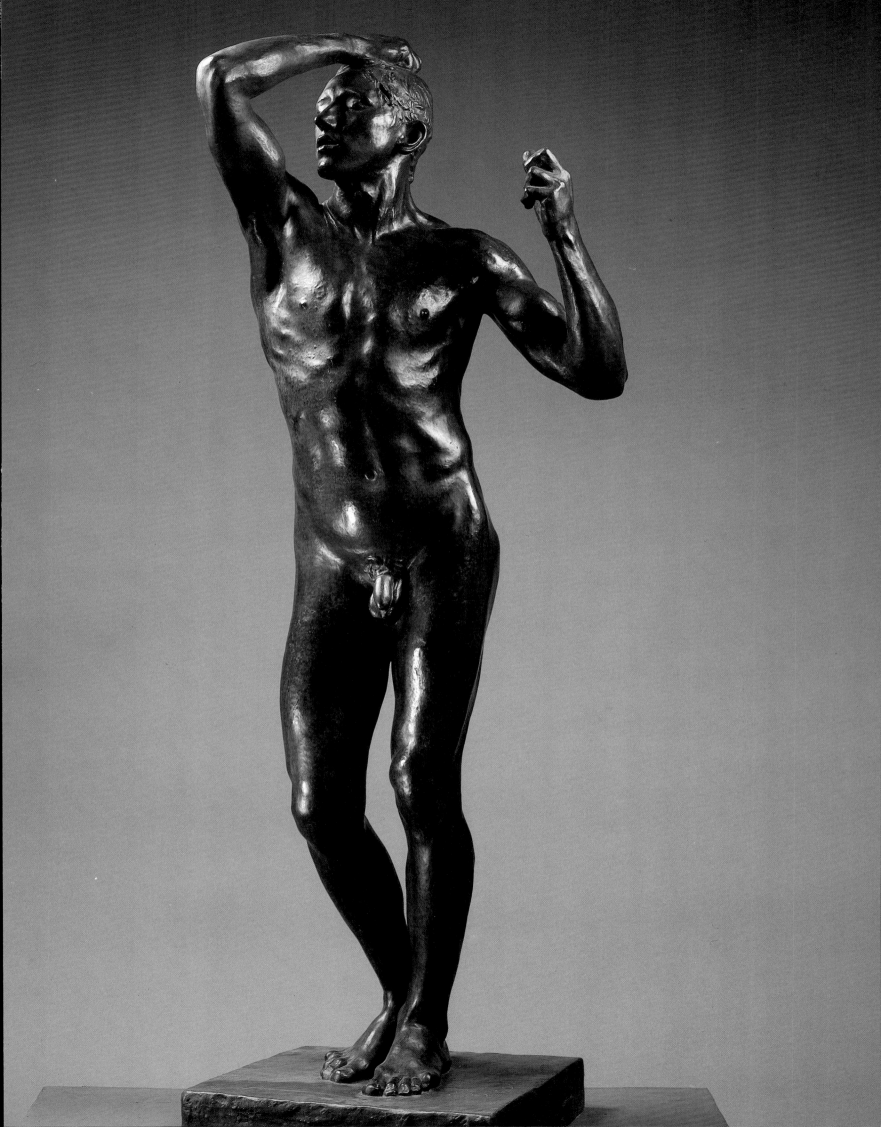

He had been accused of practising *surmoulage,* that is to say, taking plaster casts from the model himself. However the sculptor Boucher one day found Rodin working on a group without even having the model before him. Convinced then that the accusation was unfounded, he organised a petition in support of Rodin. All this publicity placed him in the forefront of the artistic scene. *The Age of Bronze* was cast in bronze in 1888, and it was bought by the State for 2200 francs, the cost of the moulding. At the same Salon of 1880, Rodin showed a plaster of *Saint John the Baptist* and, this time, it was a meeting with the model in 1858 that inspired the work. Rodin told the story to the American sculptor Truman Bartlett: "I saw an Italian coming in with one of his compatriots, who had previously posed for me. He was a peasant from the Abruzzi, who had arrived the day before, and wanted to work as a model. I was struck with admiration as soon as I saw him: this rough, shaggy man expressed through his attitude and features, and his violence, all the mystical nature of his race."

So, when Rodin saw the man posing, standing on both feet, with one arm flung forward, he is said to have exclaimed:

"But it is a man walking!"

Several studies led him to attempt a larger-than-life statue. The too perfect model of Auguste Neyt had to be counterbalanced by the *Saint John the Baptist,* so that Rodin could get his revenge for the accusation of moulding from a live model. The statue echoed the contemporary perception of its Greek and Roman ancestors because of its mutilated state, and also looked forward in its modernity to the twentieth century. Pure movement is demonstrated, without arms or face, as they might have shown the feelings of the person. A photograph, wrote Rodin, "would show the back foot already lifted and moving towards the other. Or, on the contrary, the front foot would have not yet reached the ground if the back one was in the position it is in my statue. It is just for that reason that if the model had been photographed, it would present a strange picture of someone suddenly paralysed and petrified in this pose."

"It is the artist who tells the truth and photography that lies, because, in real life, time does not stop."

1
In 1876, that is to say between *The Age of Bronze* and *The Walking Man,* Renoir showed *Le Moulin de la Galette* at the Impressionist Salon. Unlike *The Age of Bronze,* unjustly accused of *surmoulage,* Renoir's work was criticised for its confusion of shapes and figures in favour of too much boldness of colour and shade.

2
The Walking Man, a preliminary study for *Saint John the Baptist.*

3
The face of *Saint John the Baptist* is that of Rodin's friend, Danieli. The theme of this 1878 bronze is the same as that of *The Walking Man.*

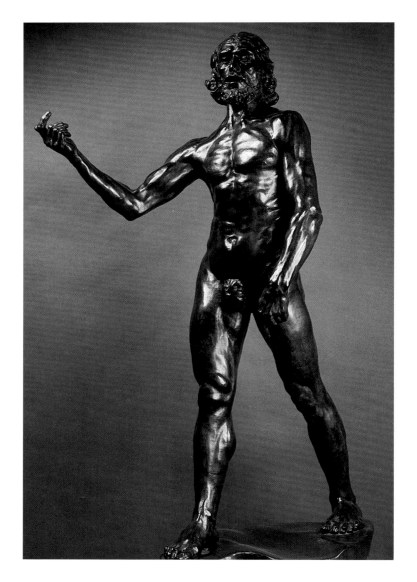

1. *Le Moulin de la Galette,* A. Renoir. 1876. Oil on canvas. 131×175 cm. Musée du Louvre.

2. *L'homme qui marche,* 1877. Study for the *Saint Jean-Baptiste.* Bronze. 85×28×58 cm. Musée Rodin. S.495.

3. *Saint Jean-Baptiste prêchant,* 1878. Bronze. 200×77.6×110.5 cm. Musée Rodin. S.999.

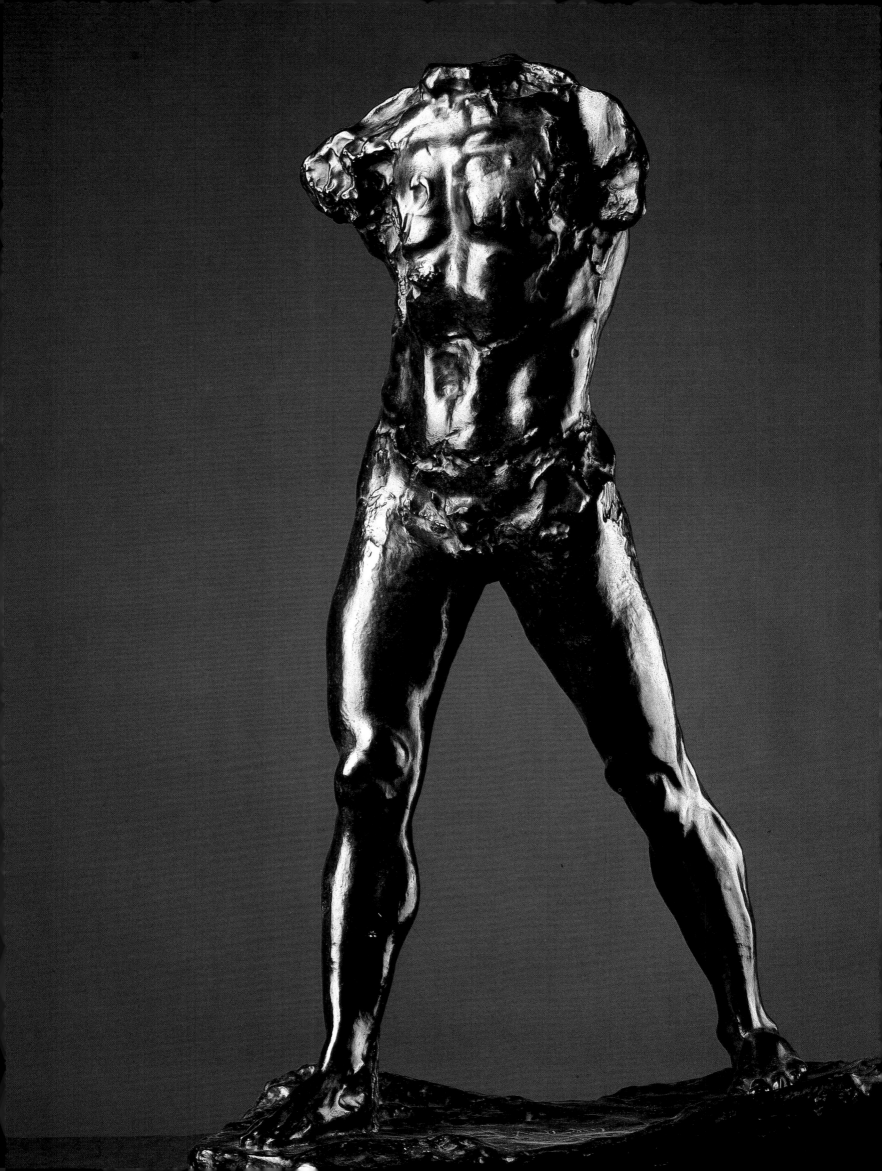

In 1879, he won a gold medal for *The Age of Bronze*. This prize helped his reputation, and he joined the Sèvres works where Carrier-Belleuse was now director of art works – their quarrel appears to have been forgotten. At the factory, he met the Haquette brothers, who were to be a constant support to him. Georges Haquette arranged for the inspectors from the Beaux-Arts to visit his studio. Their report was unfavourable, but the petition which ensued, signed by, among others, Dubois, Falguière and Carrier-Belleuse, put an end to the controversy about the *surmoulage* of *The Age of Bronze*. Rodin wrote to Georges Haquette: "You have played a great part in all this, and you have truly helped the sculptor out of his troubles. I will always be grateful and indebted to you." At the factory, Rodin received "a monthly wage of 170 francs, plus 3 francs an hour," and he gradually became a "decorative mason". After that time, the factory exported vases and decorative objects all over Europe; they were usually inspired by the Far East, or at any rate, by the Far East of the imagination.

"Any spectacle would provoke in Rodin a profusion of notes and sketches." (Roger Marx)

1
Woman holding her child. This porcelain plaquette is one of the many illustrations of the theme of mother and child carried out by Rodin at Sèvres between 1879 and 1882. The theme could be seen on vases, but was also the inspiration for *Je suis belle*.

2
The composition of this motif on the Saigon vase is by Rodin, but it was executed by Jules Desbois, his most faithful collaborator, and his best interpreter in porcelain. One can see, in this motif, the same grace and inspiration as in the *Faunesse à genoux* in 1884 and 1885.

However, despite the excellent atmosphere in the workshops, the permanent staff did not take the work of the "modern" artists seriously, especially as it interrupted a routine that suited them well. The technicians who dealt with the final stages of the porcelain manufacturing, often took a liberal interpretation of the artist's idea: "Under the pretext of a highlight", according to Roger Marx, "a totally ill-judged piece of gilding has filled up the deep rut surrounding the features . . . Elsewhere, Rodin's drawing has been changed to the point of being unrecognisable . . ." Despite such travesties, Rodin's researches and innovations were effective; the technique of engraving on paste, similar to copper engraving, was a preparation for future engraving work.

Sèvres was famous at that time for its vases and diverse ornamental objects inspired by Clodion, and equally for its Far Eastern art as it was imagined at the end of the nineteenth century.

1. *Woman holding her child,* 1880. Porcelain plaquette. 18.8×6.7 cm. Musée Rodin. S.2417

2.3. *Saigon vase, c.* 1880. Porcelain. 24.7×12.7×12.7 cm. Musée Rodin. S.2415.

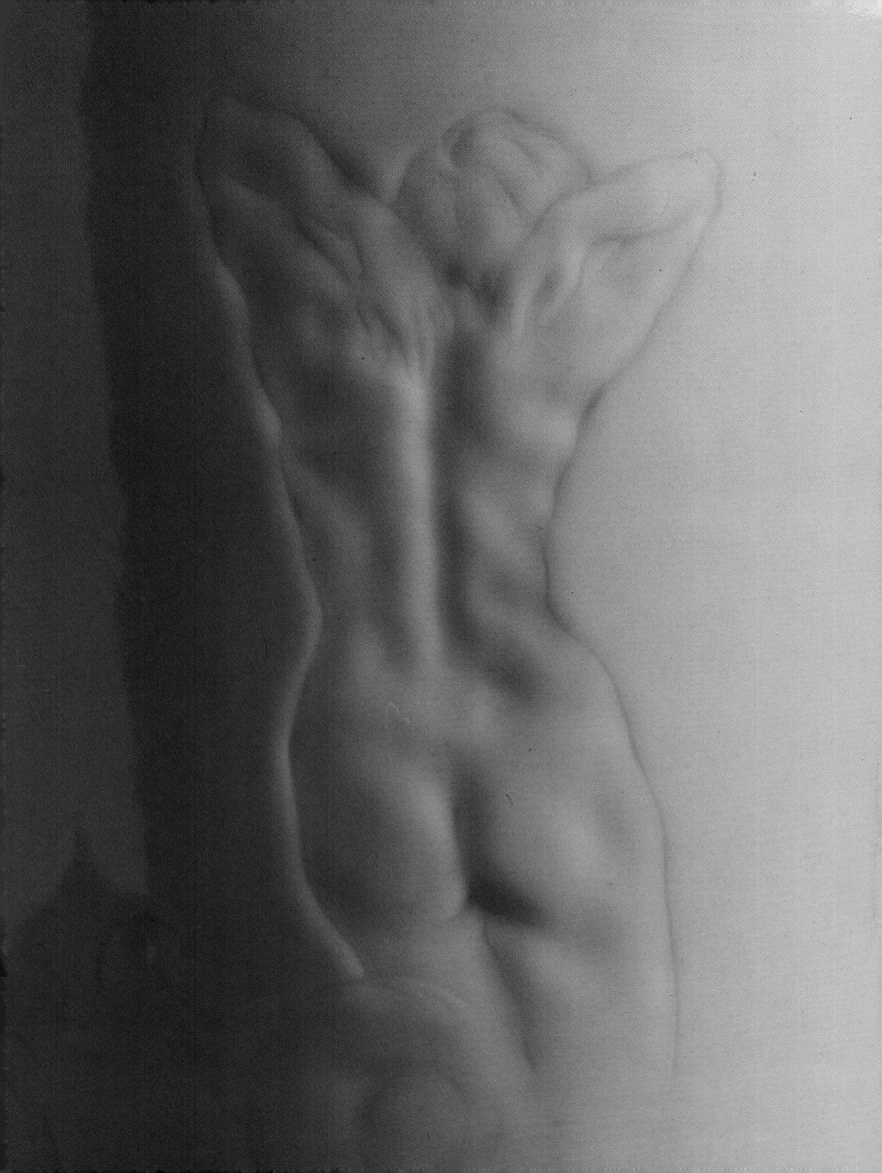

The Gates of Hell

Rodin was illustrating here the passage from Dante's *Divine Comedy* in which Count Donoratico, the tyrant of Pisa, is the victim of a conspiracy and condemned to die of hunger, locked in a cell with his sons and grandsons. According to the legend, Ugolino ate his children. Rodin probably began his study of Ugolino in 1875, on his return from Italy.

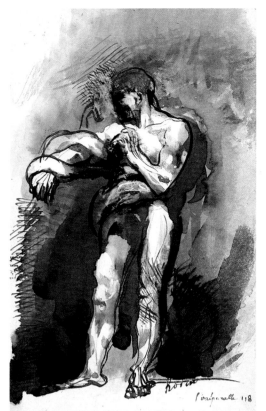

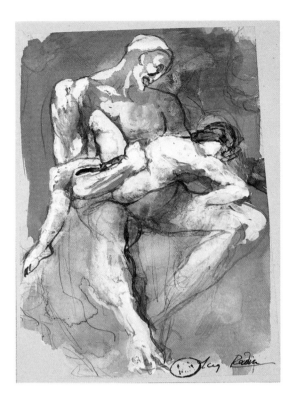

"Art can instigate thought."

Struck at first by the *Belvedere Torso* in the Vatican Museum, he had made a replica of it, symbolising the arts, for the balustrade of the Palais des Académies in Brussels. This torso was similar to studies made for *The Thinker,* proving that Rodin already had in mind several themes which would re-appear throughout his career. He worked on this torso, also known as *Ugolino's Torso,* and transformed it. In 1882, Rodin sculpted a group, apparently independent, but which would be included in *The Gates of Hell.* He was returning to Carpeaux's interpretation of it; because of the right angle formed by Ugolino's legs and thighs, it looks as though he had worked earlier on a group in which Ugolino was seated. And so one comes to the original study, *The Seated Torso of Ugolino.* This Rodin showed at the Great Exhibition in 1900.

1
Pouvons-nous étouffer le vieux, le long remords
Qui vit, s'agite, se tortille,
Et se nourrit de nous comme le ver des morts;
Comme du chêne la chenille
Pouvons-nous étouffer l'irréparable remords?
Baudelaire. Illustration for *Les Fleurs du Mal,* 1888.

2
Study for the first version of the Ugolino theme, in which he is seated. This position echoes the work of Carpeaux.

The Trocadero was built in Paris on the Chaillot hill for the Great Exhibition of 1878. Bourdais and Davioud were the architects. The latter's eclectic tastes inspired him to use every sort of style and material. Rodin, working as a decorative mason, took part in the building of the fountains. The palace was destroyed, making way, in 1937, for the present palais de Chaillot.

3
The photograph of this second version of *Ugolino* was probably taken between 1880 and 1887. The first version, *Ugolino seated* dates from 1877. Here, in this dramatic version, Rodin shows us the Count of Donoratico, dying, his stomach contracted with hunger, falling on his knees before his children.

1. *L'Irréparable, c.* 1888. Illustration for *Les Fleurs du Mal.* in 16. 7174/N.

2. *Ugolino in his prison.* Pencil, ink wash and gouache. 14.8×10.5 cm. *Musée Rodin.* D.7208.

3. *Ugolino and his children.* Plaster. Anonymous photograph *c.* 1880-1. Musée Rodin. Ph.294.

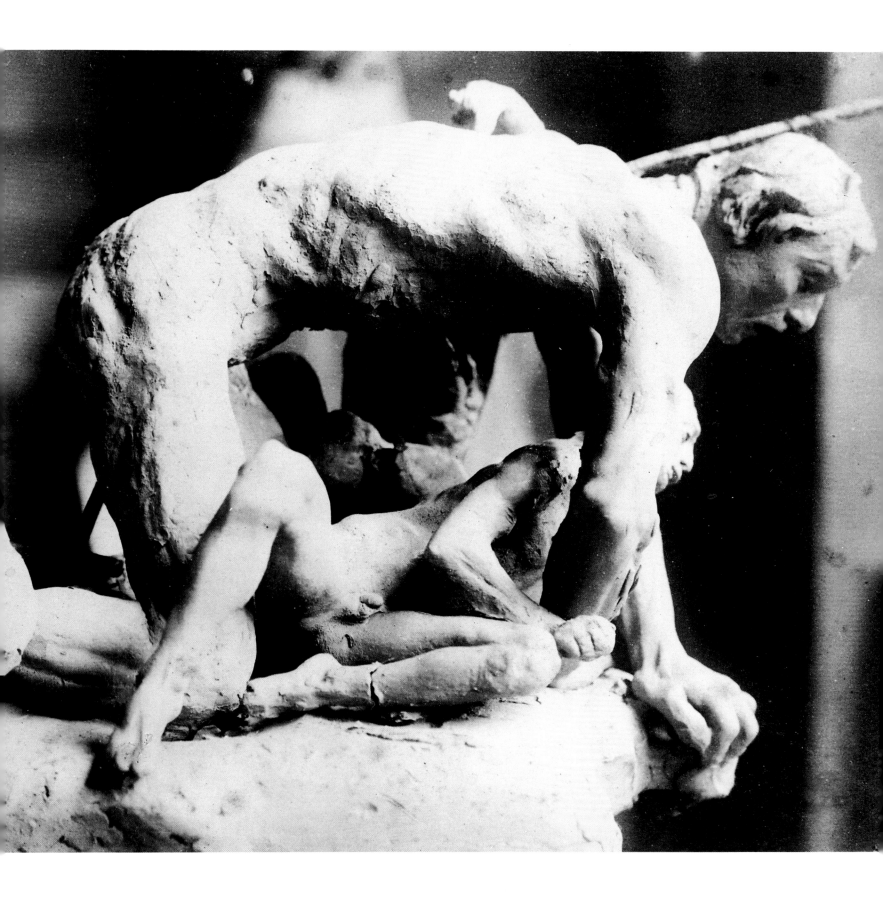

*"Already blind, I crawled amongst them,
calling them throughout three days,
whilst they were already dead."*

"Abandon hope
all ye who enter here."

1
In London, in 1881, Rodin discovered William Blake's engravings for *The Divine Comedy,* which caused him to modify his design for *The Gates of Hell.*

The rehabilitation of *The Age of Bronze* made Rodin something of a celebrity. He became worldly, frequented the *salons,* and was known and recognised. He wanted to obtain a commission from the State that was in some way linked to the construction of the Musée des Arts Decoratifs, on the site of the old Cour des Comptes, which had been destroyed by fire in 1871. Rodin's imagination was fired by the idea of "something from Dante". He told Turquet, Under-Secretary of State at the Beaux-Arts of his project: "I will make a mass of small figures, then they won't be able to accuse me of moulding from nature." Turquet was swayed, especially as Falguière and Carrier-Belleuse had intervened on Rodin's behalf, assuring Turquet of his talent. On 16 August 1880, Rodin knew he had won: "M. Rodin, artist in sculpture, is charged with executing, for the sum of 8000 francs, a model for a decorative door in bas-relief, representing Dante's *Divine Comedy,* for the Musée des Arts Decoratifs; the sum allocated will be charged to the account of the Travaux d'Art et de Décoration des Edifices Publics." To enable him to complete his work he was also allocated Studio "M" at the Dépôt des Marbres, 182 rue de l'Université, which he shared for the time with another sculptor, Osbach; because of the scale of the work, he also obtained the use of Studio "J". The museum was never built; the Gare d'Orsay was built on the proposed site – it is now a national museum. The State, having made Rodin an official sculptor, bought *Saint John the Baptist* for 6000 francs. The money enabled Rodin to travel to London to visit his friend Legros, then teaching at the Slade School of Art. Here Rodin discovered a different art world. With his friend, he learned to master the etching needle, a technique

"Whilst with the ancients the generalised lines represent the total, the summing-up of all the details, academic simplification is an impoverishment, an empty swelling. The quivering muscles of the Greek statues are warmed and animated with life, whereas the insubstantial dolls of academic art are as though frozen in death."

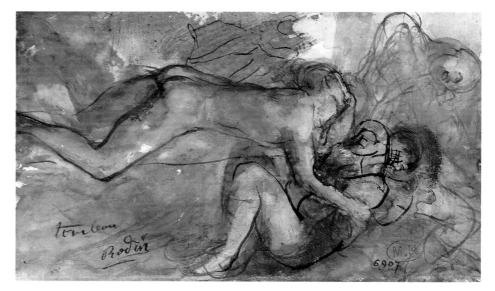

2
The Tomb, a drawing that can be dated from about 1881, is probably part of an important series of studies relating to *The Gates of Hell.* It is similar to the marble group *The Dream* or *La Jeune Fille embrassée par un fantôme.*

3
The Thinker is placed above *The Gates of Hell.* He is an integral part of them, and yet remains an autonomous work. In 1914, *The Thinker* was installed in front of the Panthéon, and then removed in 1922.

1. *The Divine Comedy,* W. Blake, 1824-7. Engraving. 24×34 cm. Tate Gallery, London.

2. *The Tomb, c.* 1881. Gouache, pen, wash. 10×16.6 cm. Musée Rodin. D.6907.

3. *The Thinker,* 1880. Painted plaster. 182.3×108×141.3 cm. Musée Rodin. S.161.

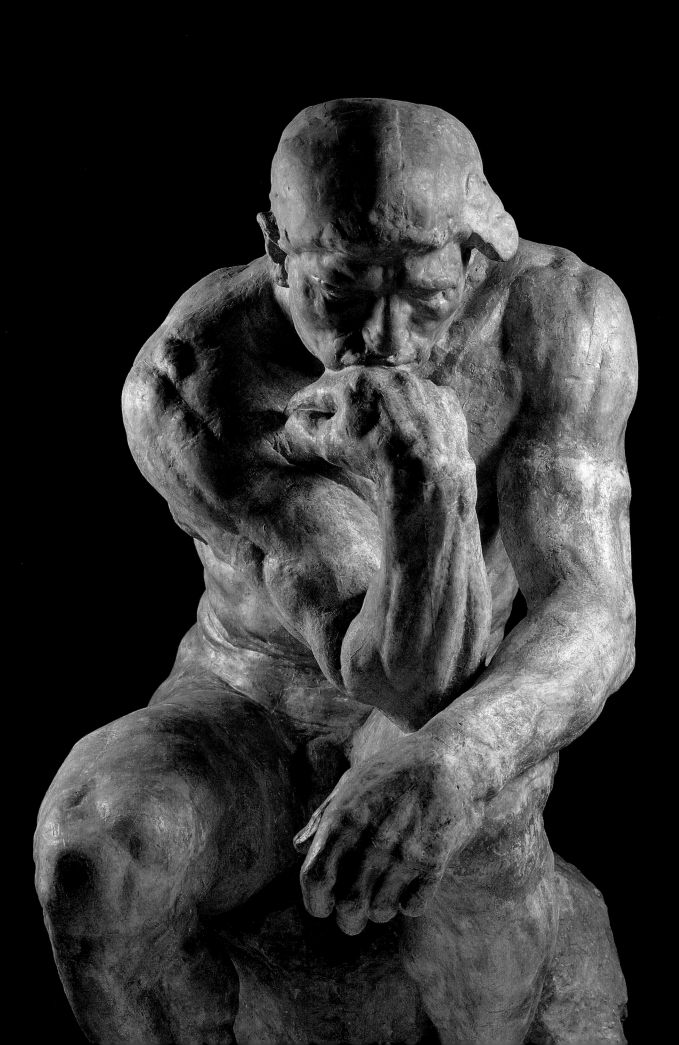

which brilliantly suited his lively, nervy style of drawing. He admired an engraving by Blake, inspired by the *Divine Comedy*, and met W. E. Henley, editor of *The Magazine of Art*, and Robert Louis Stevenson, who had not yet written *Treasure Island*. But above all he was struck by the Parthenon friezes, which had been brought back from Greece by Lord Elgin in 1822. Seeing them, he was able to confirm that his work was on the same track as that of the ancients, and that his rejection of academicism was justified.

"Something from Dante"

Back in Paris, Rodin set to work. *The Gates*, which he never finished, became the receptacle for all his ideas and fantasies. He tossed in all his creations, reassembling them in one huge entity. It was inspired by *The Gates of Paradise* by Ghiberti on the Baptistery in Florence, and by Dante's *Divine Comedy*, and it gradually took on a Baudelairian accent as well. By 1880-1, he had conceived of *The Thinker*, who he imagined sitting above the door, overlooking it. Was it supposed to be Dante himself, gazing at his work, or Rodin, guarding it?

Conceived as an infernal echo to Ghiberti's *Gates*, this one told the story of the Old Testament on ten panels. But in contrast to the Florence gates which are orderly and structured, Rodin's *Gates* are chaotic and disorderly. Ghiberti had installed, on the lintel of the gates, three statues representing Saint John baptising Christ, watched by an angel. To echo this, Rodin had the idea of the three ghostly shades of the kingdom of Hades. These *Three Shades* were in fact one, multiplied. He used this idea of duplication for his *Three Fauns* or *Three Dancing Graces*. *The Three Shades* represent Adam cast out of Paradise. The model who had posed for Adam, and therefore for the *Three Shades*, was a giant from a circus; Rodin had been attracted by this man, with his relaxed, weary poses. The statues of *Adam* and *Eve* were to be installed on either side of the

London in 1880. The purchase by the State of *Saint John the Baptist* enabled Rodin to travel to London. There he found Legros, his old friend from the Petite Ecole, who was now teaching at the Slade School of Art.

1

In *Les Trois Faunesses* dance appears for the first time in Rodin's work. The three little figurines hanging on to each other, with their heads thrown back, might very well have been intended as a pedestal for a bowl, or some other decorative object. But this trio, which resembles those of the archaic periods, is also similar to the groups Rodin based on the theme of Pan and pagan eroticism.

1. *Les Trois Faunesses*, 1882. Plaster. 24×25.7×13.6 cm. Musée Rodin. S.1163.

2. *Les Trois Ombres*, 1880. Bronze. 96.6×92×54.1 cm. Musée Rodin. S.1191.

2
The *Trois Ombres* group, placed above *The Gates of Hell*, is a triple version of *Adam*, who was going to stand, with *Eve*, on either side of *The Gates*. The *Trois Ombres* are an echo of Ghiberti's statues, on his *Gates* at the Baptistery in Florence.

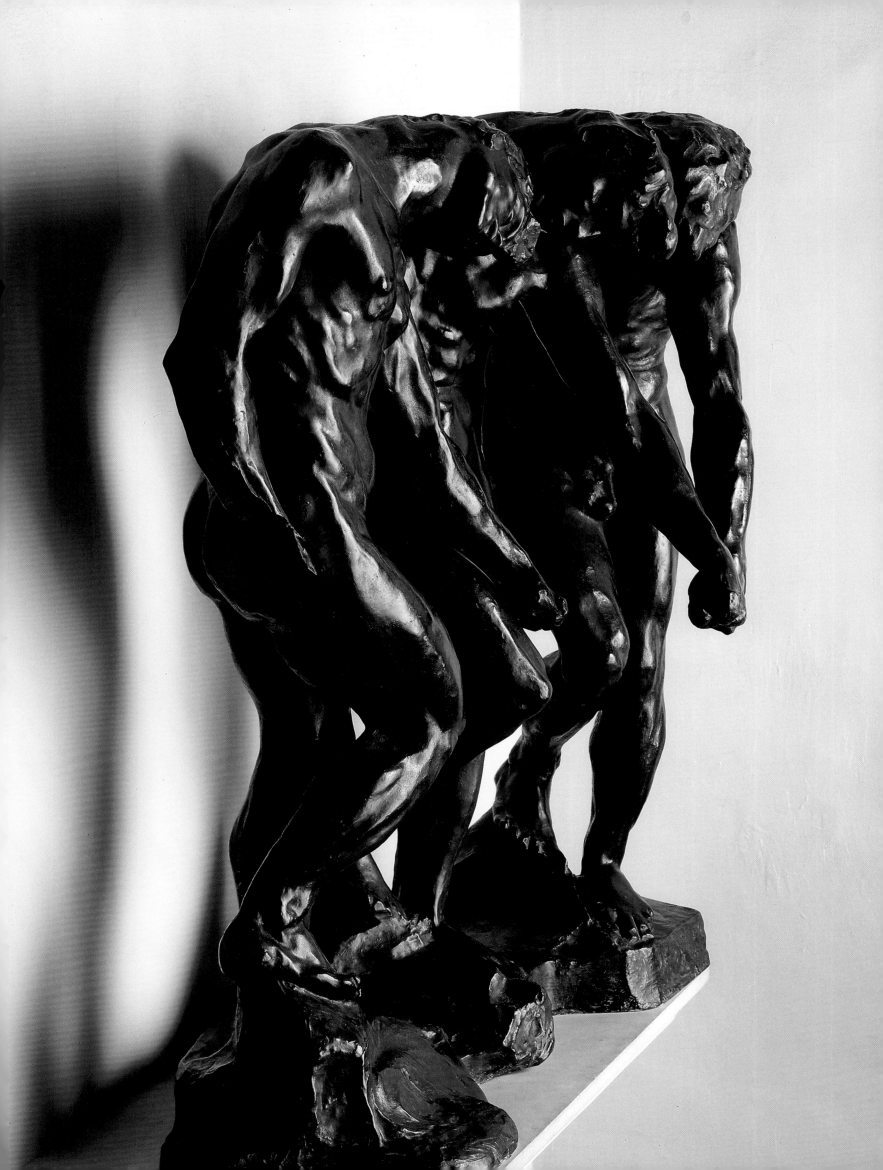

gate. *Eve* is a real masterpiece; her face is veiled, as she carries within her original sin. According to Judith Cladel, Rodin's biographer, he was very much taken with the model, an Italian girl: "As he was sculpting *Eve,* he noticed that her figure was growing ampler by the day. He made the necessary adjustments, until she confessed that her approaching confinement would have to interrupt the posing." Nonetheless, Rodin made use of her new shape, so that his big-bellied, wide-hipped *Eve* amply represents the original mother. The sculptor Truman Bartlett said: "An artist who can produce such robust work must really, as they say, have something in his gut." And Rodin, indeed, following the example of the Old Masters, was pursuing his researches into flesh and muscle: "Full of respect and love for Nature, they always represented her as they saw her. And they would always enthusiastically display their love of flesh. It is folly to think they despised it. In no other people did fleshly beauty excite more tender sensuality. An ecstasy of delight seems to play over all the shapes they created." But Rodin went further, adding to the folds and creases of the human extrior. He repudiated the idealisation of Greek statuary, giving his characters *(Adam, Eve, The Three Shades)* a lively and expressive nature. On the other hand, his *Three Little Dancers* holding on to each other belong almost to an archaic phase. Here Rodin does not bother with anatomical detail, because he is describing a movement rather than any emotion or feeling. Therefore the features are merely suggested, and the dance movement is the most important element.

"Art is only feeling."

1
This bold group, *Je suis belle,* is the illustration to a poem by Baudelaire: "Je suis belle, ô mortels, comme un rêve de pierre". Rodin, here, uses his assembly technique, joining *The Falling Man* with *The Crouching Woman.* In the two separate works, Rodin had made figures of extreme sadness. The faces are contracted, no doubt by the pain of such an effort, such a contortion of the body. Together the group can be differently interpreted. It becomes a tragic passion, without any future, into which the two figures are hurling themselves.

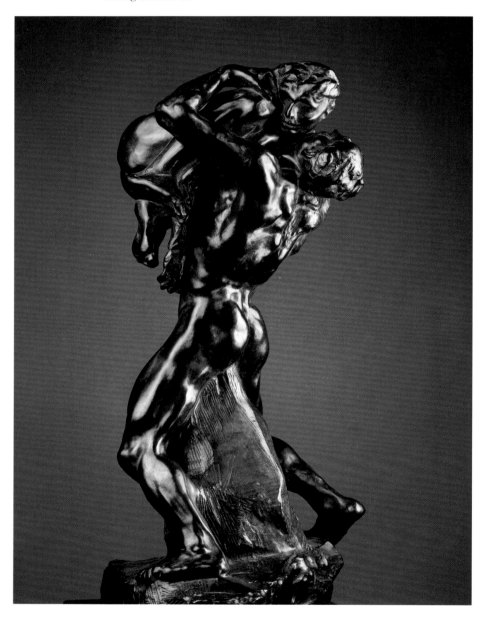

Rodin was almost forty. He had known poverty in his youth, and the injustice of the Salon juries. Now, he was beginning to enjoy a more agreeable life. His work reflects this; groups appear, mostly couples, entwined in audacious poses. Thus he added

1. *Je suis belle,* 1882. Bronze. 69×30.8×31.9 cm. Musée Rodin. S.1151.

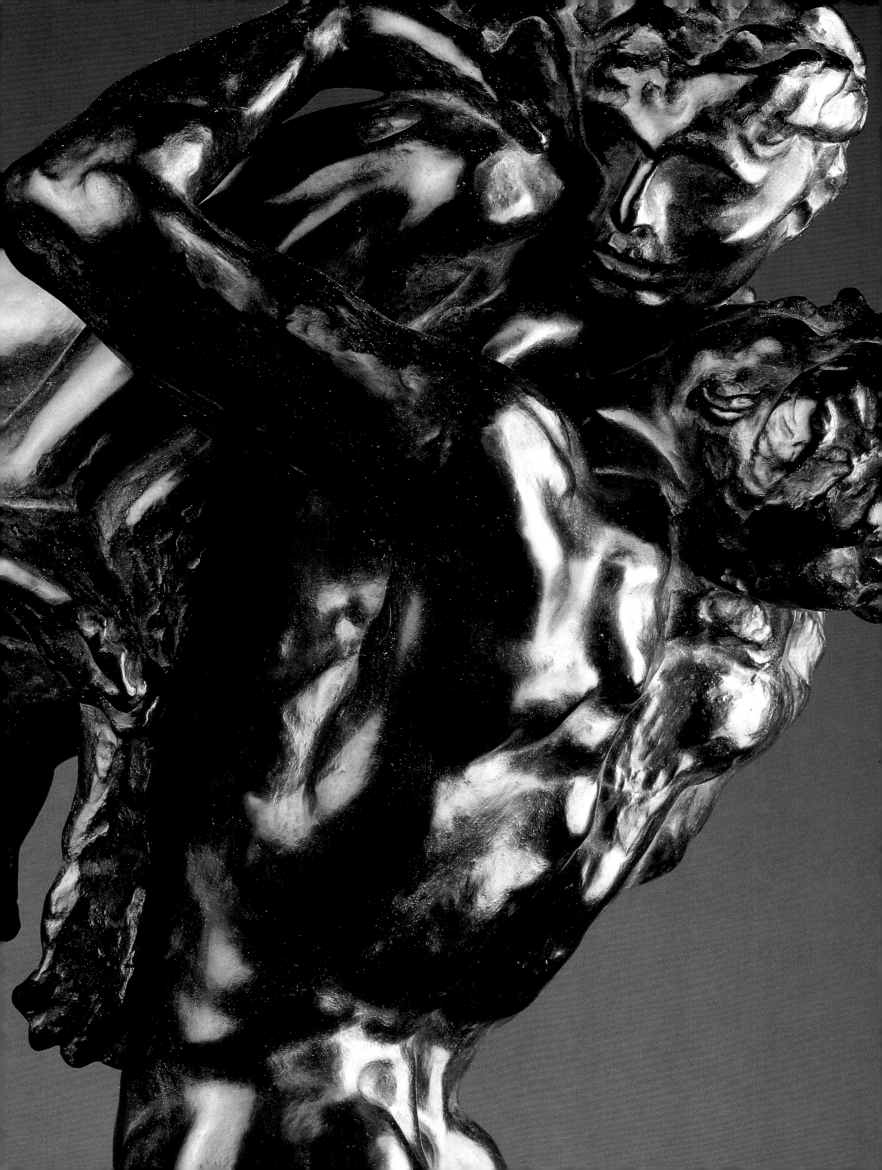

to *The Gates* a group entitled *Je suis belle*, illustrating a poem of Baudelaire's.

He formed this group out of two independent works which were in *The Gates of Hell: The Falling Man* and *The Crouching Woman*. The woman's sensual and provocative position, and the man's wild pose give a sense of madness to this particular couple, one of Rodin's first. After Camille came into his life, a few years later, his lovers became more serene, as in *The Eternal Idol* or *The Kiss*.

"May all your forms and colours express feelings."

1
This is one of several studies for *L'homme qui tombe*. One can recognise the freedom of movement which appears in the sculpture of the same name.

"There are no lines, only volumes."

Rodin worked on numerous sketches for his next work, giving it its guiding line, its movement. The drawing of *The Falling Man* is without any doubt linked to the final sculpture. Above all, established clearly the main surfaces of the figures you are sculpting. Accentuate strongly the position you are giving to each part of the body, the head, the shoulders, the pelvis, the legs. Art requires decision. With strong lines you can plunge into space, and acquire depth. When you have fixed your planes, you have got everything. Your statue will already be alive. Details appear and arrange themselves . . . Remember this: there are no lines, there are only volumes. When you draw, do not worry about the contours, think only of the relief. It is the relief that determines the contours." Rodin saw all drawing as flat sculpture. Once the sculpture was made, it became a starting point for new groups and new interpretations of the figure. So *The Falling Man* became in *Je suis belle* the passionate lover lifting up the body of his beloved, and crouching sensual woman becomes, in the arms of the strong man with his arched back, a fragile person, carried away by passion. The two individual beings, each with its own destiny, become, together, a tragically passionate, deeply sensual couple.

'In fine sculpture, one can always detect a powerful inner impulsion."

1. *Mercure, homme nu se dressant sur la pointe d'un pied,* 1880? Pen and wash. 9.8×5.4 cm. Musée Rodin. D.447.

2. *L'Homme qui tombe,* 1882. Bronze. 59×37×29 cm. Musée Rodin. S.963.

2
L'homme qui tombe is above the leaf of the Gate, about to crash down into Hell. This is a single work, but it gave rise to the *Je suis belle* group, on the right hand pilaster, above *The Gates*.

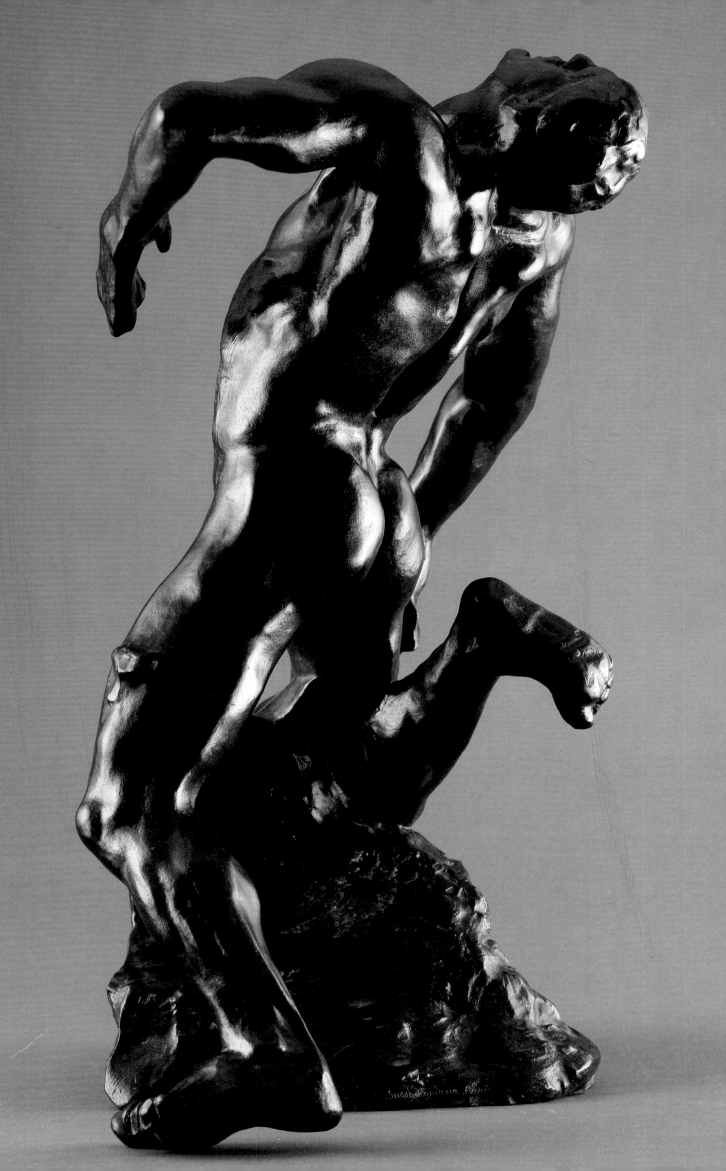

On 10 January 1883, Rodin asked for an advance payment from the director of the Beaux-Arts. The inspector, Roger Ballu, was despatched to the studio, charged with giving an account of the work to date – so Rodin found himself once again face to face with the administration. Luckily, Roger Ballu was a perceptive man. He immediately saw genius in Rodin's *Gates,* and sent an enthusiastic report back to the director of the Beaux-Arts. Apparently, he had not seen much, but "at any rate M. Rodin's work is highly interesting. This young sculptor has truly amazing originality and tormented power of expression . . . He is haunted by Michelangelo-like visions, he will surprise people, and will certainly never leave them indifferent. As I say, then, the work shows considerable interest, and, although I have reservations about the ensemble, I can only praise the finished pieces." So Roger Ballu, without really seeing Rodin's art, knew how to judge it. He returned ten months later for a new report, which justified another advance.

"And cathedrals, are they finished?"

This time Ballu was truly enthusiastic. He watched the artist working, "modelling piece by piece the little figures, which he added to his ensemble". *The Gates* "would impose itself as an original creation, it might be criticised according to established principles and current rules. But it will be accepted because of its deliberate energy, and the style of execution. It will be truly, in the real sense of the word, a work of art." In 1885, *The Gates* was already taking final shape, if one can judge by the words of Octave Mirbeau in *La France* on 18 February 1885. The journalist was as enthusiastic as the inspector Roger Ballu, who had, two years previously, understood Rodin's intentions and seen in the rough sketch the chef-d'oeuvre to come. "Each of the bodies is totally subject to the passion that animates it, every muscle ruled by the spirit. Even the strangest positions and the

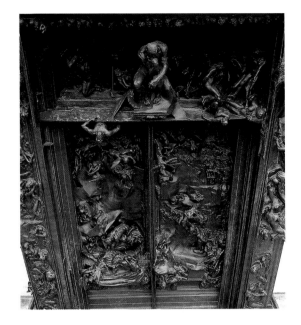

In the studio of the Depôt des Marbres in the rue de l'Université, Rodin assembled a life-size maquette of *The Gates of Hell,* which was appreciably different from the final work, cast in bronze only ten years after the sculptor's death.

1
Detail of *The Gates of Hell* as they can be seen today. In this picture one can see *The Thinker* seated on the lintel, with *L'homme qui tombe* at his feet.

2 (Page 59)
This sculpture is an individual work, but it is inspired by one of the sons of Ugolino, a group in the middle of the left-hand leaf of *The Gates.*

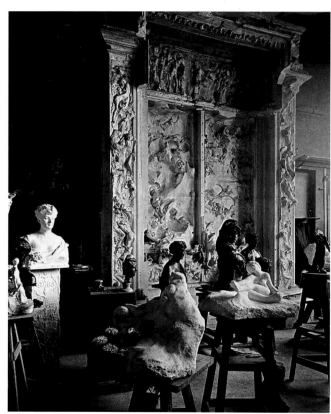

3 (Page 60)
Left-hand detail of the lintel of *The Gates of Hell,* in which can be seen in the foreground a faun on her knees.

4 (Page 61)
Detail of one of the many damned couples in the *The Gates of Hell.* This one is at the bottom of the right hand pillar.

5 (Page 62)
Detail of the right-hand leaf, showing a damned woman.

6 (Page 63)
Right-hand section of the lintel, showing several small figures of the damned.

1 to 8. *The Gates of Hell,* details. Bronze. 635×400×85 cm. Musée Rodin. S.1304.

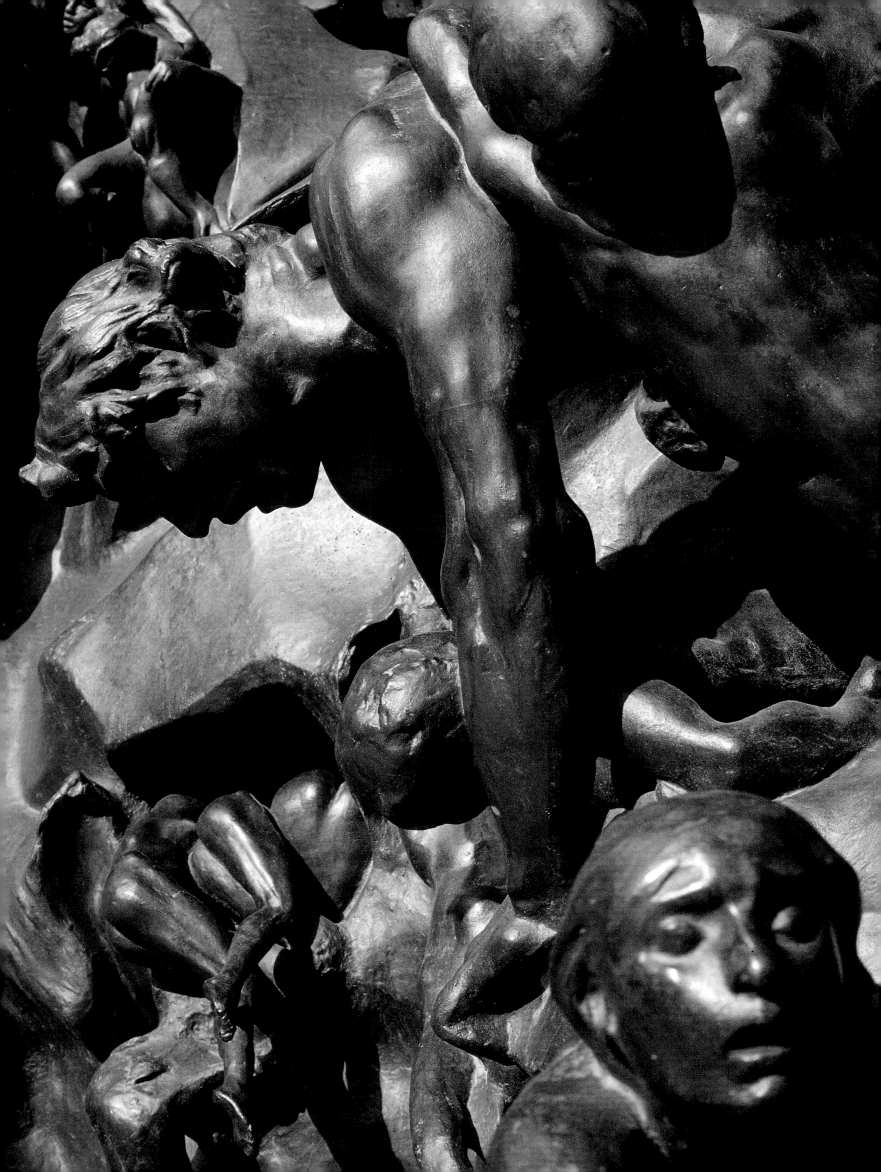

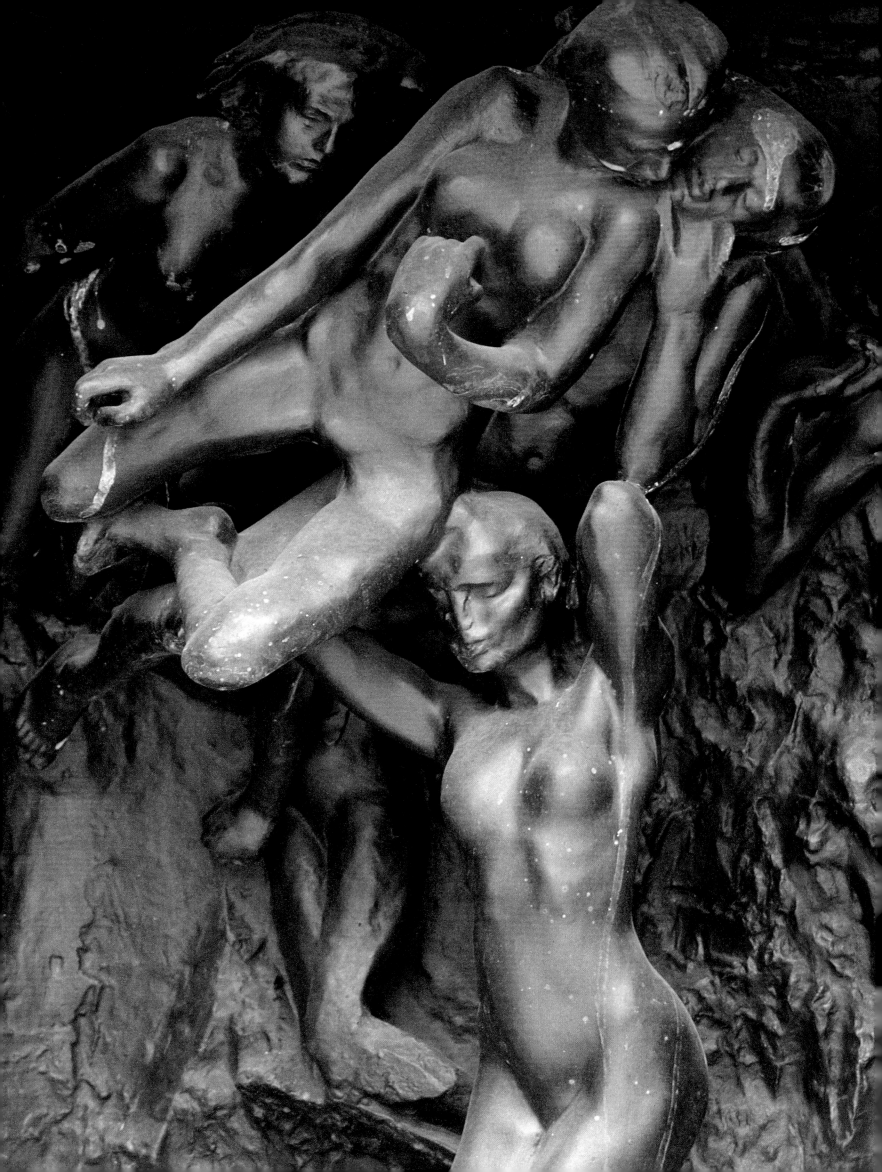

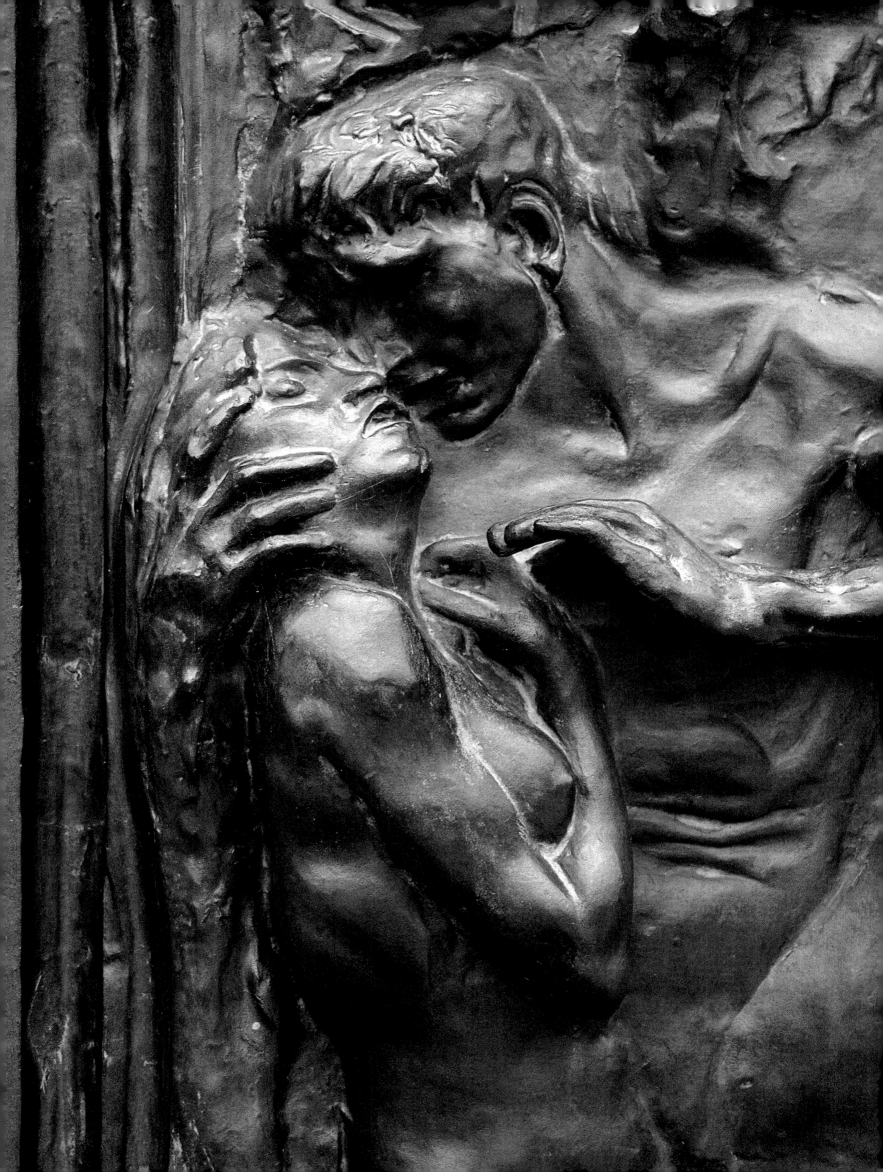

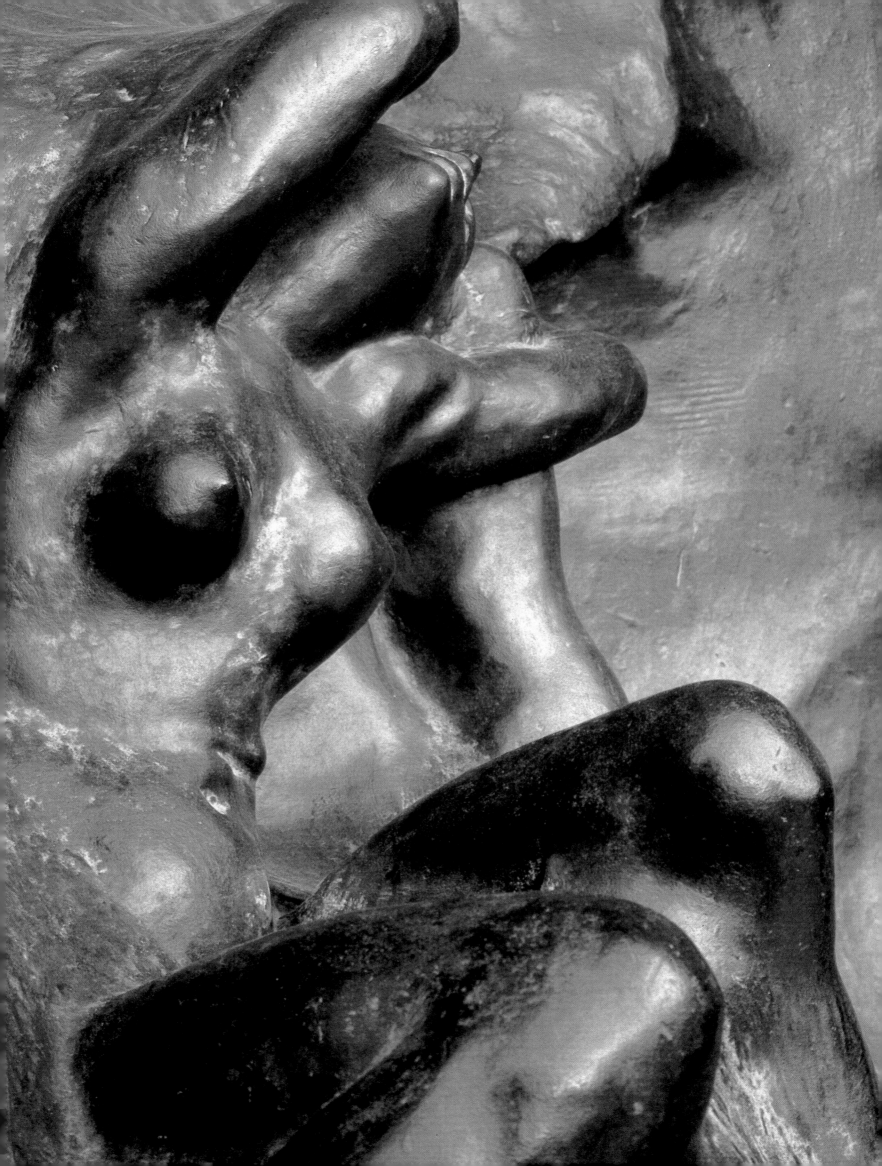

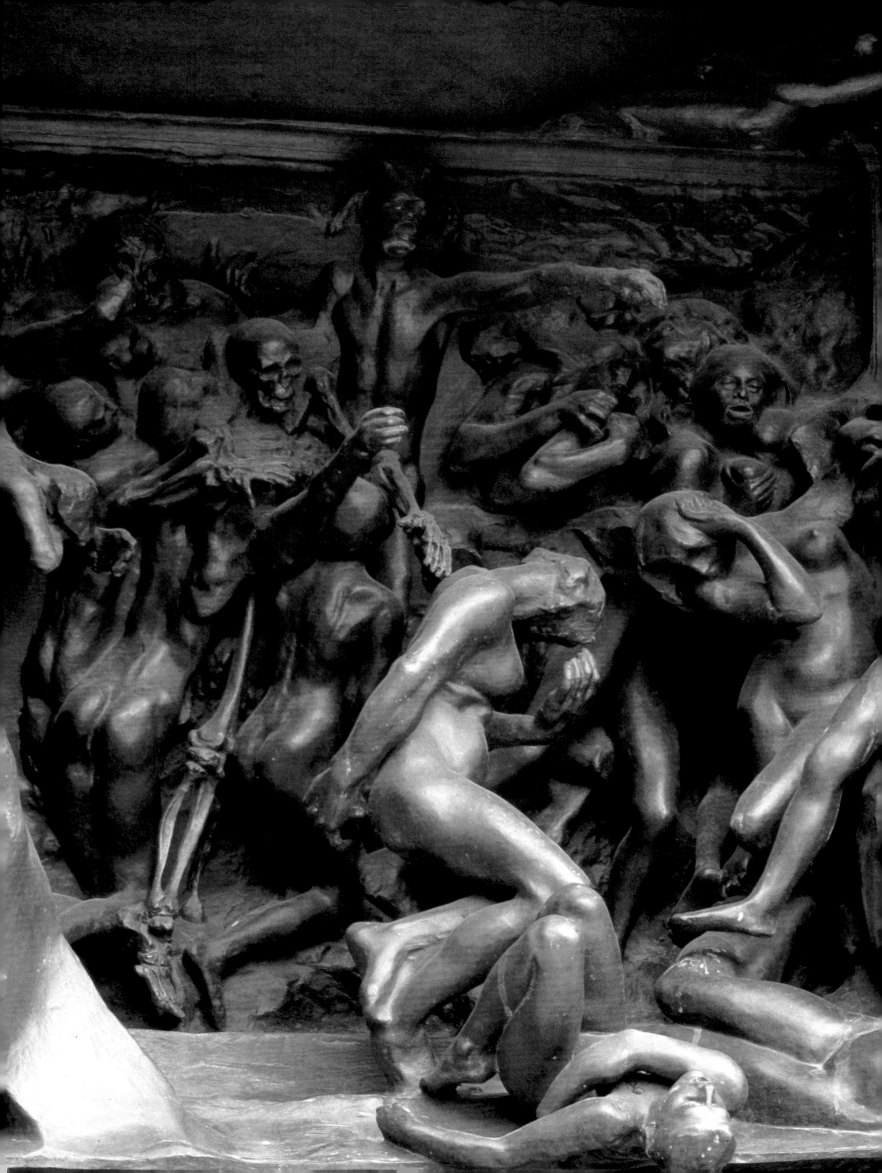

most twisted forms reflect precisely the fate and punishment of rebellious humanity. Rodin makes us sense tragedy in an atmosphere aflame with his genius." All Rodin's artistic intentions are fulfilled, with these passionate and tragic bodies. The tympanum can be read from left to right, as a descent into Hell. The entrance is at the top on the left, where one can see the *Torse d'Adèle,* followed by a procession of the damned, among whom can be recognised several version of *The Martyr* and a *Venus Kneeling.* On the right of *The Thinker* is the entrance to Hell.

"Be fiercely, profoundly truthful. Never hesitate to express what you feel, even when you find yourself in opposition to received ideas."

Skeletons embrace and entwine themselves with the damned, bodies are disarticulated, and the procession ends, at the bottom right with the body of a young girl, momentarily in balance, but about to fall into the pit. The continuity of the falling action is ensured by *The Falling Man,* plunging into Hell. He symbolises a theme which appears frequently in *The Gates* – that of failed ambition. He is Icarus, the mortal who tried to fly close to the sun, and crashed into the sea when his wings melted. Octave Mirbeau placed Rodin amongst the great artists, supporting him in his struggle against academicism: "He has broken away from anatomical balance – stupid, feeble conventional beauty, as taught by the schools, has vanished. That is what they cannot forgive Auguste Rodin – he has given beauty and true voice of humanity." Rodin "has projected his own anxieties into a huge and brilliant dustbin, where all the coinage of human suffering is gathered" according to Professor Hegueburr. Octave Mirbeau concludes: "Ignorance and envy have not once halted his progress, and will never prevail against him when it comes to posterity."

7 (Pages 66-7)
This *Prodigal Son* appears in the group *Fugit Amor* in *The Gates of Hell,* at the bottom right of the right-hand leaf.

8 (Pages 68-9)
This *Torse d'Adèle* was introduced into *The Gates of Hell,* and appears at the top left-hand side of the lintel showing the entrance to Hell.

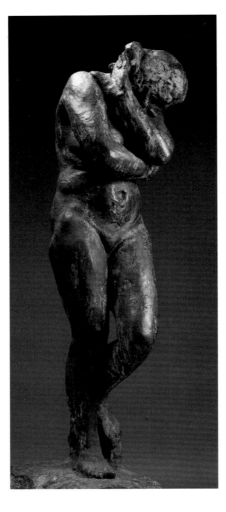

1
The model for *Eve* was an Italian girl with fine muscles, whom Rodin found very attractive. However he did not hesitate to dismiss her when she turned out to be pregnant, and he finished the sculpture from memory.

2
Celle qui fut la belle heaulmière is the only representation of an old woman in Rodin's work. This dignified and respectful sculpture, which emanates great sadness, shows a marked contrast to old age as conceived by Camille Claudel in the *Clotho* of 1893. The story is that the woman had come from Italy on foot, in order to see her son, who was one of Rodin's models, for the last time. The son took her to see Rodin, who was fascinated and made this extraordinary sculpture.

3
La Martyre can be found several times in *The Gates of Hell.* Rodin took pleasure in reproducing this bony figure, so out of step with the times.

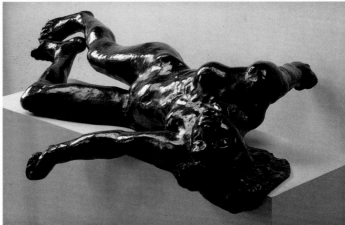

1. *Eve,* 1881. Bronze. 173.5×59.9×64.5 cm. Musée Rodin. S.1029.

2. *Celle qui fut la belle heaulmière,* 1880-3. Bronze. 50×30×26.5 cm. Musée Rodin. S.1148.

3. *La Martyre,* 1885. Bronze. 42.4×149.5×100.5 cm. Musée Rodin. S.1160.

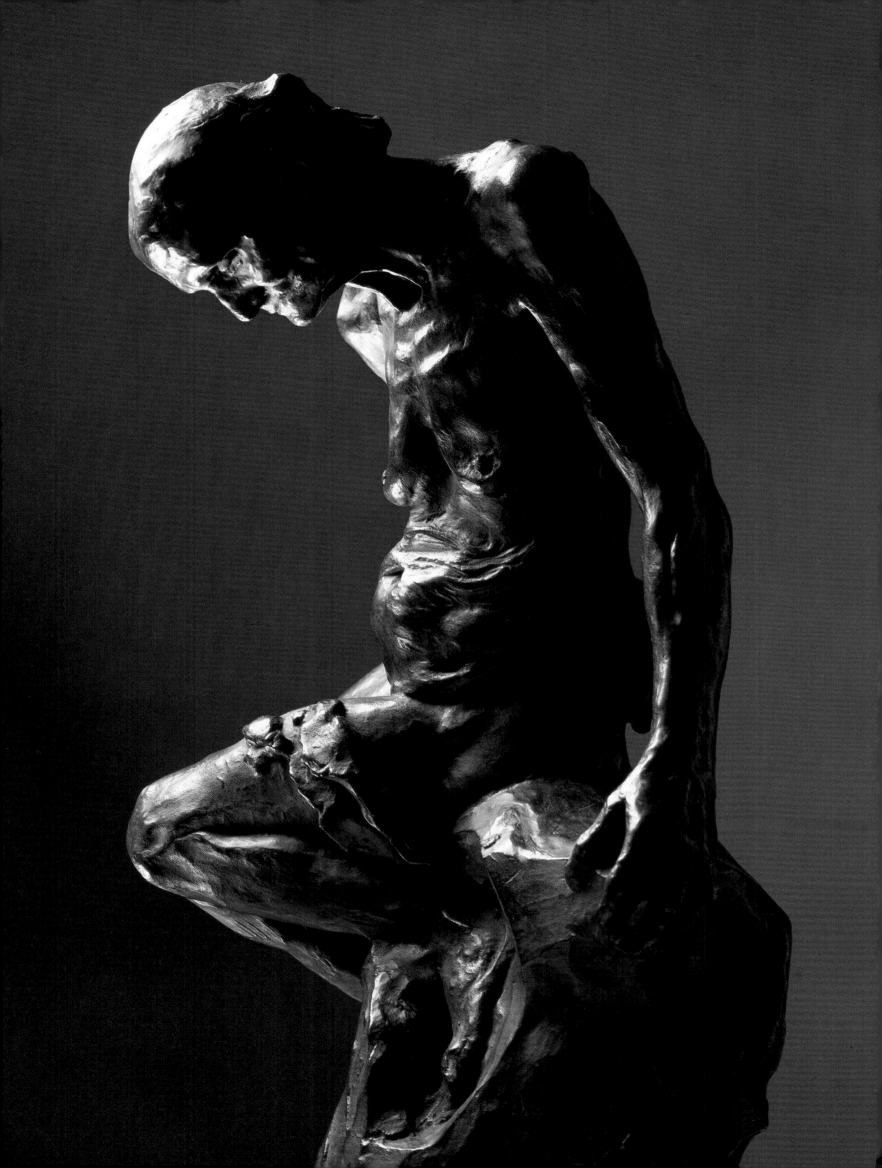

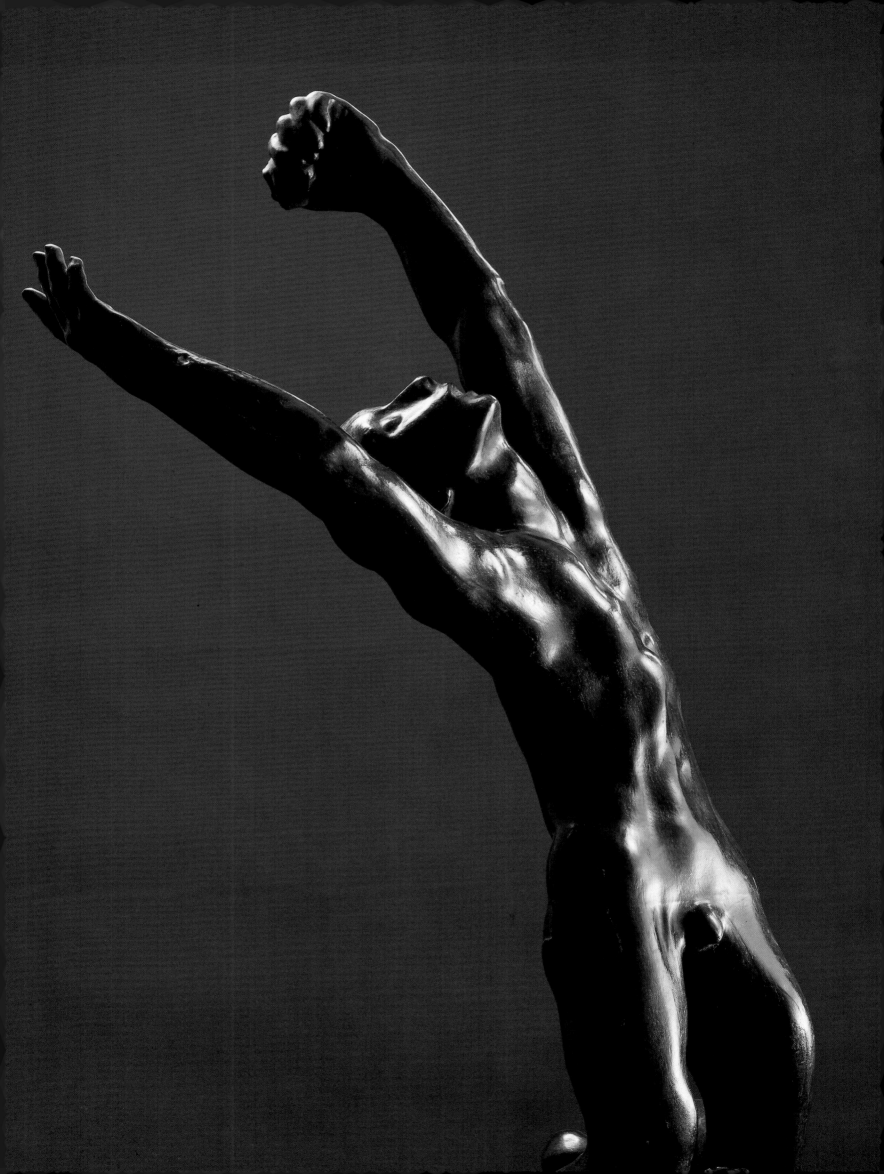

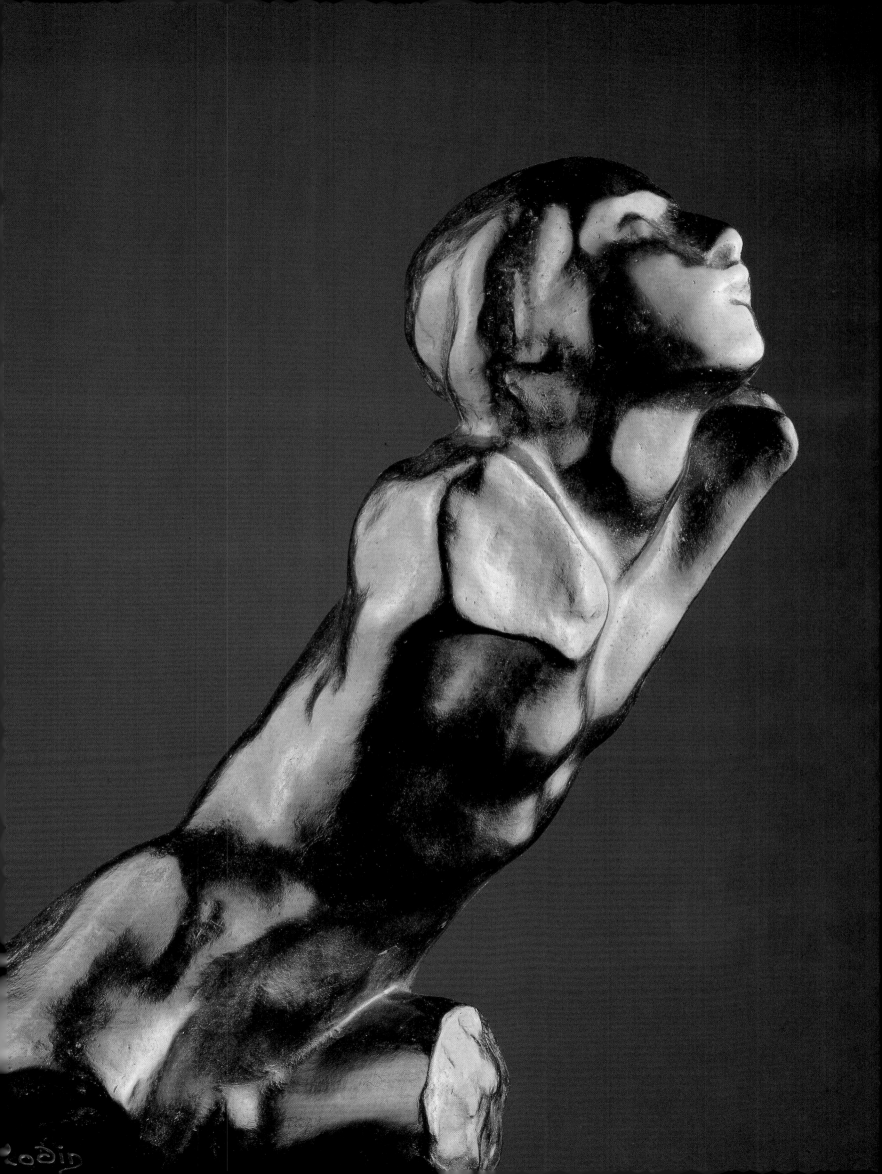

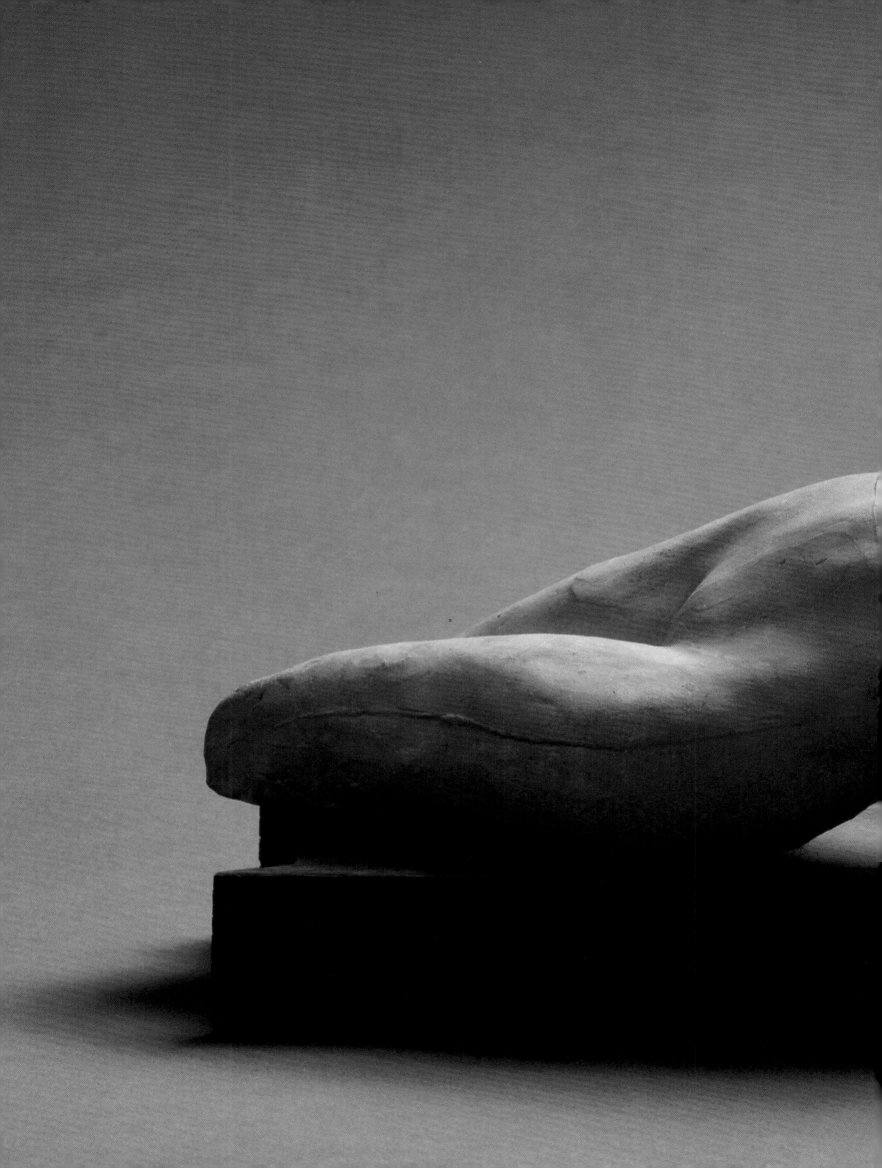

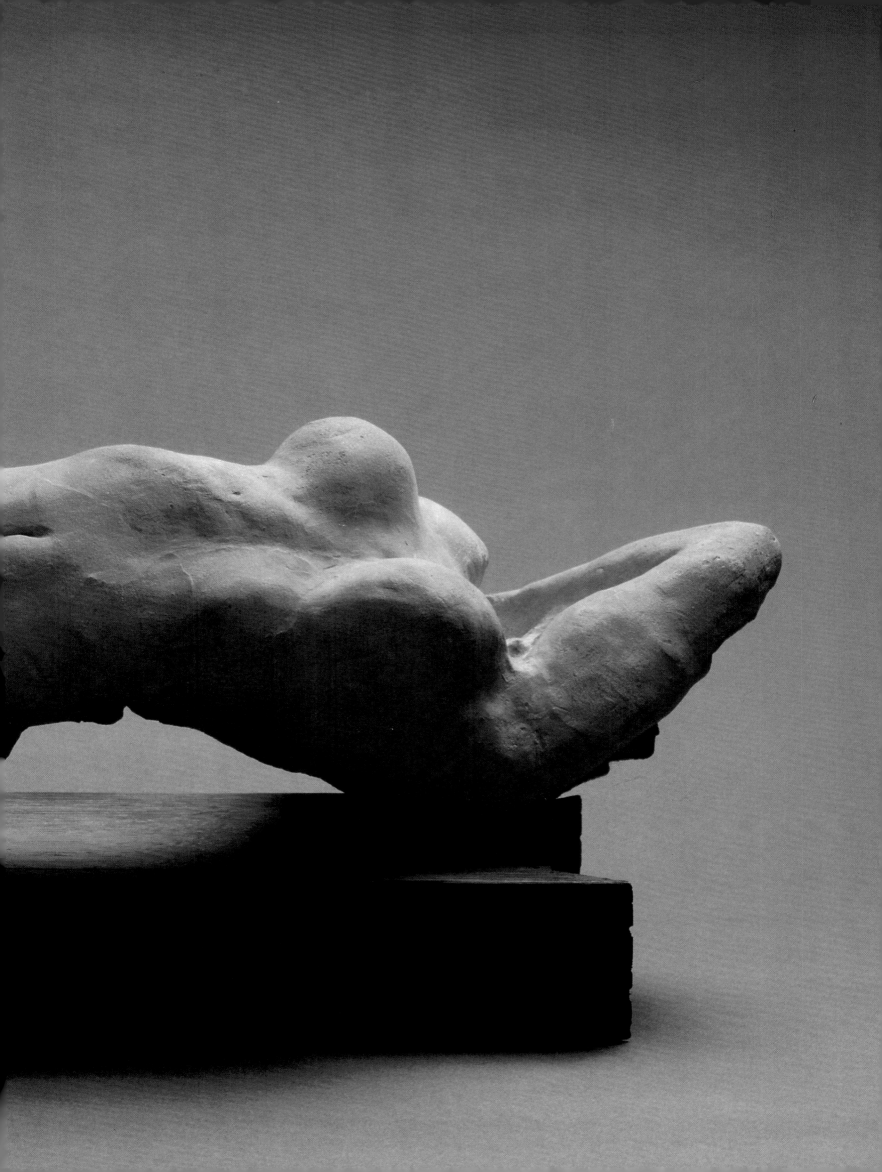

Camille

*"Sculpture was for her a violent passion,
which completely possessed her,
and which she imposed despotically
on all those around her,
her family, her neighbours, even the servants."*
(Mathias Morhardt)

2
This bust by Camille bears the
marks of Rodin's teaching, with
the emphasis on the profile. But
one must not discount Camille's
own genius, which shows Rodin
as sculptor and searcher, with
furrowed brow and eyes fixed on
his model.

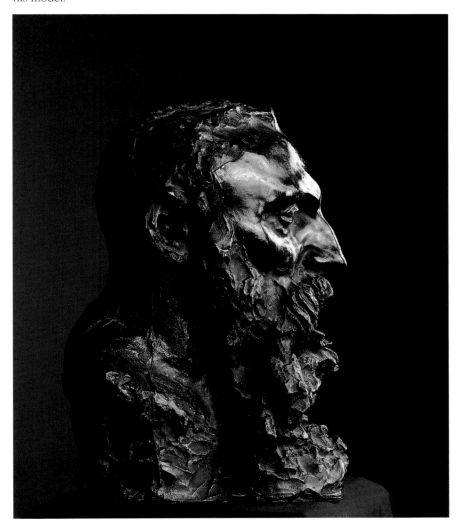

"Neither the wind, nor the rain-swept forests, nor rough country life were able to tame little Camille Claudel, in the village of Villeneuve where she grew up, on the edges of Champagne." So Reine-Marie Paris, great-niece of Camille Claudel, captures the spirit of the wild little girl. The family lived in an old presbytery in the village, opposite the cemetery, beneath a bell-tower that leaned in the wind like the mast of a ship. A boy, born before Camille, died at birth. She was named after him, since the name was suitable for both girl or boy. It is possible that this was the origin of her passionate desire, throughout her life, to prove herself. A younger sister was born and called after their mother, Louise. The family was divided into two groups: the two Louises on the one hand, and Camille and her father on the other. He was a tax-collector, and had to travel a lot; the family eventually left Villeneuve to follow his various displacements. Camille's youngest brother remained closest to her – he was Paul Claudel, later to become one of the great French writers of the twentieth century.

Even as child, Camille would model clay with a primitive instinct, fascinated by the monsters which haunted the neighbouring forest of Geyn. Never taught, she sculpted as naturally as she breathed. The family was now installed at Nogent-sur-Seine, where the father worked, but they spent the summers at Villeneuve, with its legends and stories of witchcraft. He encouraged his children's vocations – writing for Paul, music for Louise, and sculpture for Camille – and arranged for her to have lessons with a sculptor from the same town, Alfred Boucher. He was convinced of the young girl's genius, and persuaded her father to give in to his daughter who wanted to work in Paris. The whole family then moved to the capital, and Boucher entered Camille for the Académie Colarossi, where he taught. She rented a little studio in the rue Notre-Dame-des-Champs. Boucher won a prize at the Salon of a trip to Italy and, in his absence, he called in Rodin who he knew well and had supported during the quarrel about the *surmoulage* of *The Age of Bronze*. Boucher knew that he could entrust Camille's exceptional personality to Rodin, who gave the young artist the sort of

1. *Le Torse d'Adèle* (Preceding pages). *c.* 1882. Terracotta.
10.5×37.3×16.4 cm. Musée Rodin. S.1177.

2. *Bust of Rodin,* C. Claudel. 1888. Bronze.
40.7×27.7×28 cm. Musée Rodin. S.1021.

3. *Portrait of Camille,* L. de Witzlewa. Pastel.
50×40 cm. Private collection.

3
Portrait of Camille,
by Laetitia de Witzlewa.

advice he had received himself: to work on the profiles, never to look at "the surfaces of shapes, always their depth".

The meeting between Rodin and Camille was equally fruitful to both. Camille at last found a fellow and a master in the difficult art of sculpture; somebody who did not see her as a well-brought-up young girl doing it as a pastime. Rodin, for his part, had found the woman for whom he had been searching for a long time, to whom he could teach his secrets. He was dazzled by Camille's culture, swayed by her youth, and fascinated by her talent. He very soon attached her to himself, and asked her to join the team of *praticiens* who were working on *The Gates of Hell* in the rue de l'Université. According to Judith Cladel, Camille Claudel became "a perceptive and wise collaborator. Rodin included her in his work, consulted her about everything, and entrusted her, with the most demanding instructions, with the job of modelling the hands and feet of the figures he was creating." She had to make her mark in the workshop: she was the only female *praticien* – other women were tolerated only if they were models. If at first she aroused envy or scorn, everybody admired her talent. Mathias Morhardt describes her in the studio "silent and diligent, she remains seated on her little chair. She hardly listens to the idle gossip around her. Completely absorbed in her work, she kneads the clay and models the hand or foot of a figurine in front of her". And indeed, as well as *The Gates of Hell,* there were *The Burghers of Calais* to be worked on.

"I now work for myself."

Camille was soon entrusted with man's work: rough-hewing marbles from a plaster model and putting them in a state to be completed by the master. But although Camille shared Rodin's work, she still pursued her own career. In 1883, she presented at the Salon des Artistes Francais a *Portrait of Madame B.,* and a *Bust of Paul Claudel as a child.* At the 1885 Salon, she showed a terracotta: *La Vieille Femme,* or *La Vieille*

"For me, the real Camille Claudel will always be the one who greeted me with a song, laughed as she gave shape to a man's face, gave champagne to her guests without thinking of the next day, who was able to embrace the most elevated spiritual spheres, but who could always express herself with grace and humour."
(Henry Asselin)

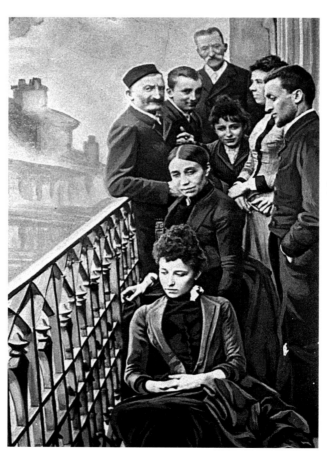

This extract from a letter from Paul Claudel praises his sister's inner genius. Totally devoted to Camille, Paul could not recognise Rodin's genius until 1928. Until then, he felt only blind hatred for him, as he held Rodin responsible for Camille's madness.

The Claudel family moved into the boulevard Port-Royal in 1866. Camille can be seen in this photo, at the back and in the centre. Her mother and sister are in front of her. Her brother, Paul Claudel, is on her right.

Camille, photographed by Carjat, probably at the same time.

72

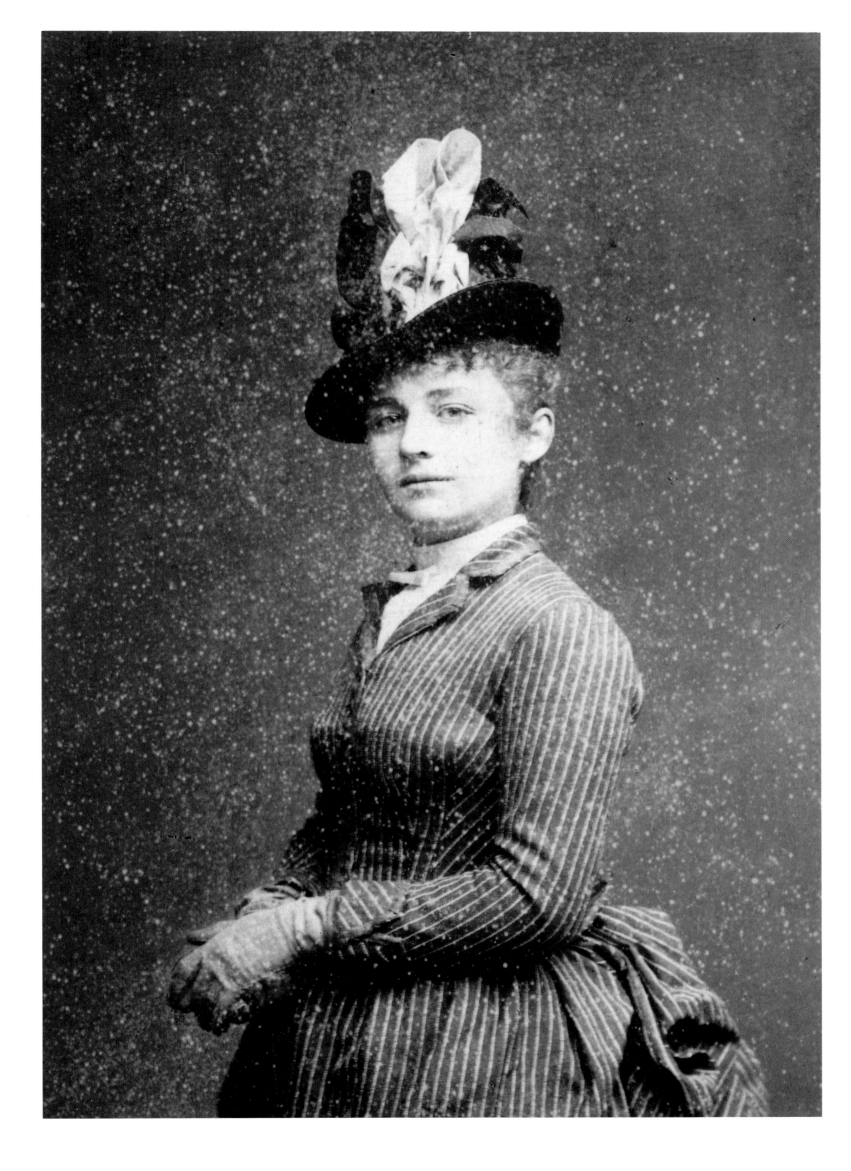

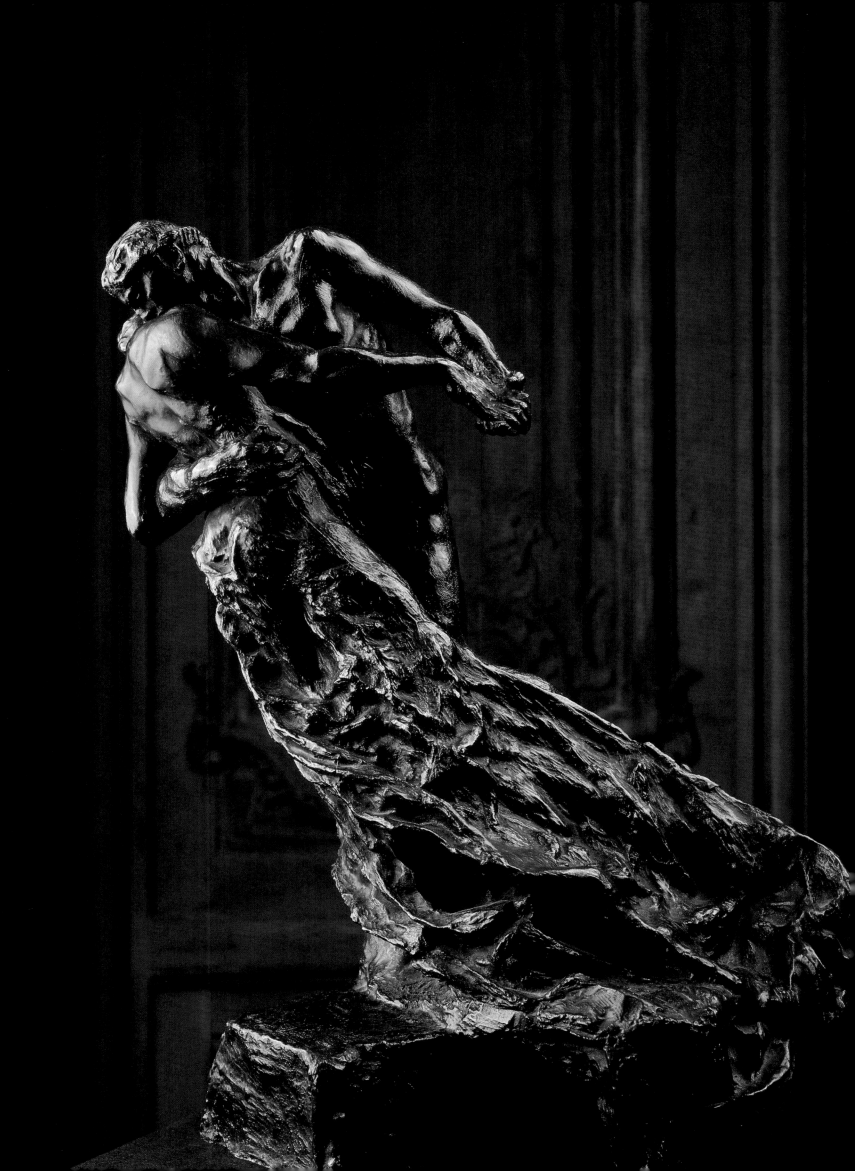

1
The *Sakountala* is probably Camille's most famous work. Inspired by a memory of the Hindu poet Kalidasa, it shows the meeting in Nirvana between Sakountala and her husband. The sculpture, also called *L'Abandon* or *Vertumne et Pomone*, was begun in 1888, but made in marble only in 1905.

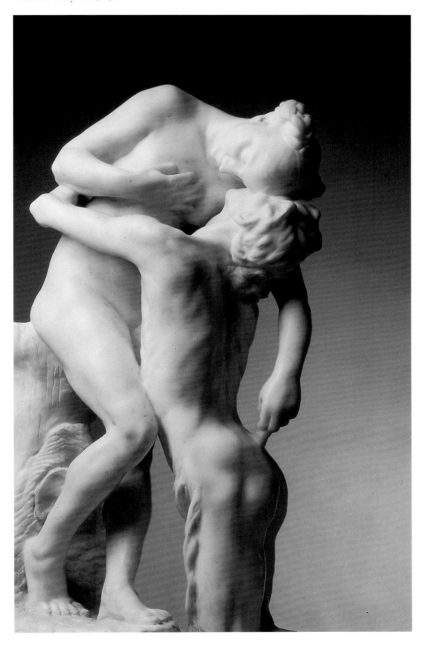

2
Beaux-Arts inspector Dayot granted Camille her wish to make the 1891 *La Valse* in bronze, on condition that the figures were clothed in drapery.

1. *Sakountala*, C. Claudel. 1888. Marble. 91×80.6×41.8 cm. Musée Rodin. S.1293.

2. *La Valse*, C. Claudel. 1891. Bronze. 43.2×23×34.3 cm. Musée Rodin. S.1313.

Hélène, and a nude study. In 1886, she portrayed her brother again, and a brigand's head, *Giganti,* as well as a bust of Rodin. In 1887, she produced an astonishingly sensual woman's torso, echoing Rodin's *Torse d'Adèle.* She could also convey great sadness, mingled with a sense of modesty, in her groups, as in *La Valse* of 1891, or the *Sakountala.* At the rue Notre-Dame-des-Champs, she became friendly with a young English artist, Jessie Lipscomb, with whom she often stayed in England. She became an intermediary between Rodin and Camille. The couple were already obliged to remain hidden, and Rodin had to avoid any scandal other than artistic ones – he was, after all, more than twenty-four years older than Camille. And, of course, there was Rose, who, without actually being married to him, was his common-law wife, whom he kept as a defence behind which he could hide. All his conquests knew that Rose was the main obstacle between Rodin and themselves. Camille knew it too, but thought she would be stronger. She was younger and more intelligent than Rose, and was she not Rodin's collaborator and model as well? Camille's face appears frequently in *The Gates of Hell,* engendering works such as *Paolo and Francesca, Fugit Amor* and *La Danaïde.* It was under her influence that Rodin sculpted what are no doubt his best groups, *Eternal Spring* in 1884, and *The Kiss* in 1886, to which Camille responded with a group in 1888, the *Sakountala.*

The year 1888 was an important one in Camille's life: she showed her group at the Salon des Artistes Francais, where it was warmly received. But more important, Rodin rented a house, the "Clos-Payen", on the boulevard d'Italie, which had already been the setting for the romance between Georges Sand and Alfred de Musset. There, at last, Camille had Rodin to herself. They shared a studio and their work merged, at least for a time. In 1890, the two lovers stayed at the Château de l'Islette in Touraine, but Rodin continued to send affectionate letters to Rose, once again left in charge of his work. We know no more about this stay in Touraine than we do of the next journey, two years later, when he was

researching Balzac. It was during this time that Camille met Claude Debussy, with whom she became close friends, but no more than that, it seems. She was then twenty-four years old.

"I showed her where to find gold, but the gold she found was truly hers."

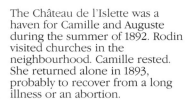

"Camille could not bear to share anything."

The Château de l'Islette was a haven for Camille and Auguste during the summer of 1892. Rodin visited churches in the neighbourhood. Camille rested. She returned alone in 1893, probably to recover from a long illness or an abortion.

In 1888, Rodin rented the Folie-Neubourg in the Clos Payen, previously the home of another famous pair of lovers, George Sand and Alfred de Musset. Camille and Rodin at last had a studio together. The Clos Payen remained Rodin's favourite studio, long after the break with Camille, and he gave it up only towards the end of his life.

After 1892, the relationship between Camille and Rodin entered a new phase. Camille moved into 113 boulevard d'Italie. "She retired into total solitude in her studio on the boulevard d'Italie, and lived there one, two, three years . . . without seeing anybody." There, she took stock of her life. She had finally left Rodin's studio. It was the end of the nineteenth century, and Camille was twenty-eight years old. She was, after all, a woman of her time, and at twenty-eight, you were either married or an old maid. She raised the question of marriage, but Rodin hid behind Rose, because even he, the great man, was a little afraid of Camille. Her talent, her intelligence, her beauty, which would gradually fade, made her an artist who might surpass her master. She then did some drawings of Rodin and Rose that were of a cruelty matched only by her deceived hopes. "Camille", wrote her brother, "could not guarantee to prop up the great man's habits and vanity in the way that his old mistress could. In any case, Camille was exclusive in her demands, and would not allow any sharing." In 1892 she also exhibited a bust of Rodin at the Salon de la Société Nationale which was favourably received. Rodin, for his part, tried to help her, and urged his journalist friends to recognise Camille's talent. For Rodin 1892 was the year he created two highly intense sculptures, *La Convalescente* and *L'Adieu,* premonitions, no doubt, of the final rupture. Camille, on her own, exhibited two very dissimilar works, *Clotho* and *La Valse.* Critics were disconcerted by these two masterpieces, but two journalists, Octave Mirbeau and Léon Daudet, were enthusiastic. Her *Clotho* goes much further than the work of Rodin, who also represented old age in *Celle qui fut la belle beaulmière.*

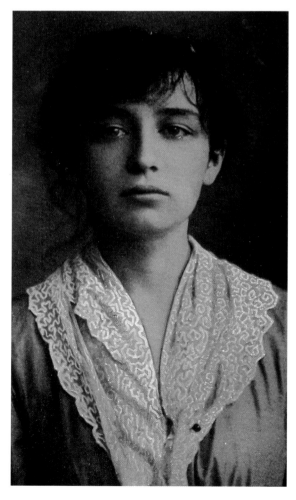

1. *Les Bavardes,* C. Claudel. 1897. Onyx and bronze. 44.9×42.2×39 cm. Musée Rodin. S.1006.

When this photograph of Camille by César appeared in the magazine *L'Art Décoratif* in July 1913, Camille had already been interned for four months, and would remain so. One is reminded of her brother's description in 1951, written for a retrospective of her work: "I can still see her, a superb young woman, triumphant in her beauty and talent, and I remember the influence, often cruel, that she exercised over my early years."

1

In 1893, in a letter to her brother, Camille described *Les Bavardes,* which was repeated several times in different materials. Started in 1895, made into marble in the following year, the group was presented in onyx and bronze in 1897. It was very favourably received by the critics, who praised it for its originality and for the sculptor's great technical mastery.

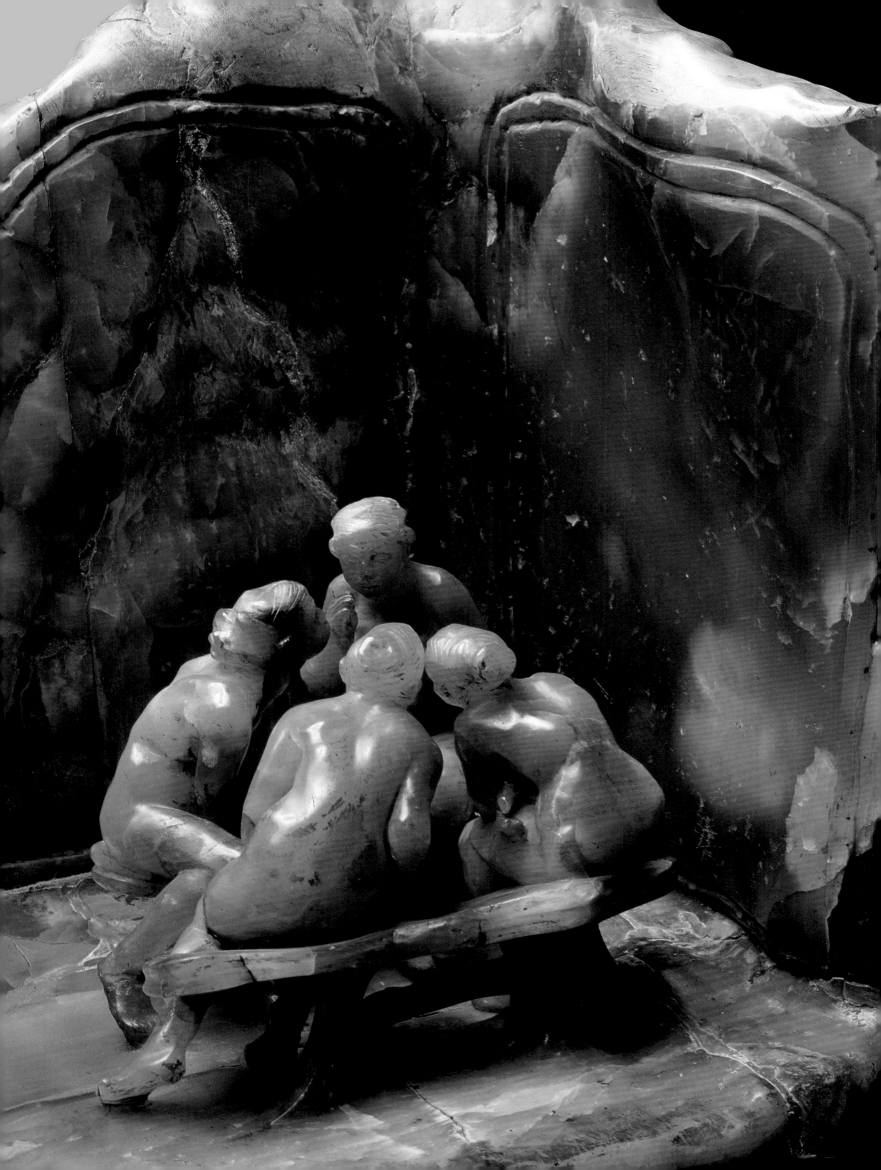

Camille shows us an old woman with flabby sides and withered breasts, thin hair and a bulging stomach; no doubt it is Rose she had in mind. With Rodin old age is dignified and sad, the old woman seems to mourn her vanished youth. With Camille, Clotho, old and ugly as she is, with her hand on her hair, seems to be trying again to shock the onlooker. Rodin represented old age with respect, Camille shows it with hatred. In 1893, Camille returned alone to rest at the Château de l'Islette. From there, she wrote a letter to Rodin, ending with the words: "Above all, don't deceive me any more!" This stay in Touraine corresponded with a deterioration in her health, and it is possible that Rodin may have insisted on an abortion. In a letter to Jacques Cassar, dated 28 December 1976, Mme Romain Rolland repeats a confidence of Paul Claudel's: "So, if you were in doubt about the truth of rumours about that drama, you may be assured that they are not false, and that Paul Claudel mentioned it in his letters ..." Whatever happened, Rodin distanced himself from Camille and installed Rose at Bellevue.

"Do not be unfaithful to me any more."

Henceforth, Camille was alone, trying to get her work recognised. In 1894, she showed the first part of a group later entitled *L'Implorante*. This group, first called *Les Chemins de la Vie* is better known nowadays as *L'Age Mûr*. In an earlier scheme, the group represented the ageing god, dragged away by old age or death, but held back by a young girl begging on her knees. The message is clear: it is Camille on her knees, holding back Rodin, who is already leaving her, dragged away by Rose. This was Camille's most autobiographical work. She retreated, little by little, into madness, seeing enemies everywhere. Paul Claudel made arrangements to have her sent to a lunatic asylum. Camille's father died on 2 March 1913, and on the morning of 10 March, Camille was taken to the hospital at Ville-Evrard. A few days later, the order was given that nobody was to visit Miss Claudel or obtain news of her. In 1914, on 9 September, Camille was transferred to the psychiatric hospital of Montdevergues, at Montfavet in the Vaucluse; she died there in 1943.

1
L'Age mûr, conceived at the time of her separation from Rodin, is Camille's autobiographical statement. In a first version, the young girl still held the man's hand against her breast. Here the rupture is complete: the man leaves the suppliant, dragged away by the old woman.

This *Torse de femme debout* is a fine example of the young sculptor's mastery. The date of this work is uncertain; Paul Claudel put it at 1888. Camille was then 26.

1. *L'Age mûr* no. 2, C. Claudel. 1889. Bronze. 120.8×181.2×70 cm. S.1380.

2. *Torse de femme debout*, C. Claudel. 1888. Bronze. 49×35 cm. Private collection.

3. *Clotho*, C. Claudel. 1893. Plaster. 89.9×49.3×43 cm.

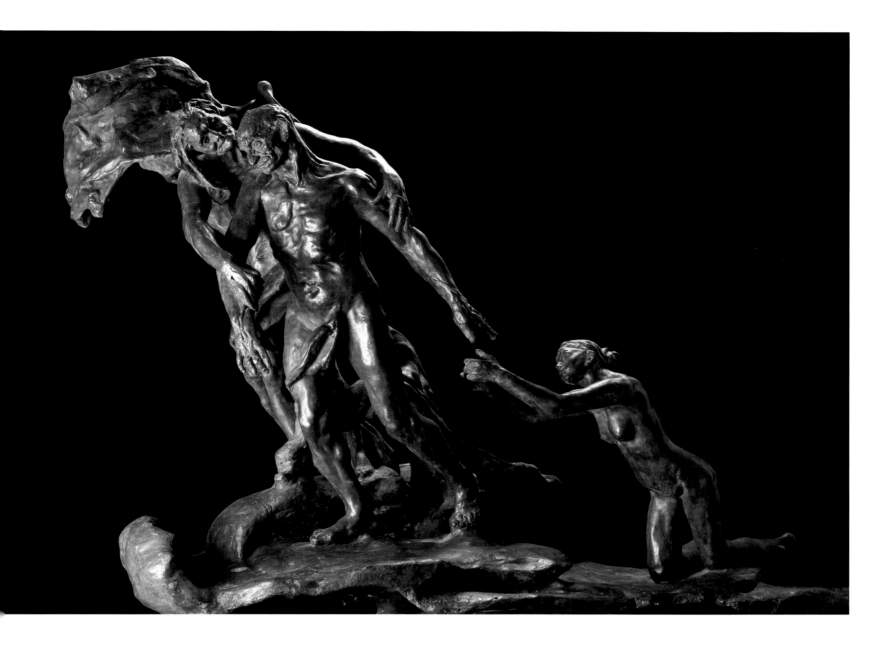

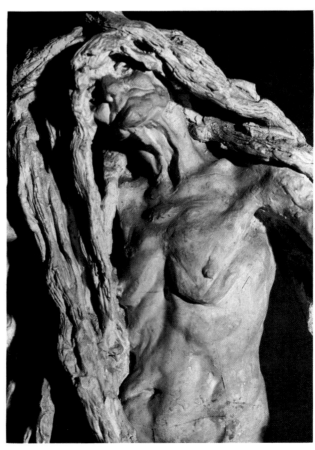

Camille wrote to Rodin when she was alone and waiting for him at the Château de l'Islette. The young woman, who had sacrificed her youth, her social position, and, no doubt, her talent to the Master, swallowed her pride here to write to Rodin begging him not to be unfaithful.

3
Clotho, which saw the light in 1893 is one of Camille's totally original works. Here the youngest of the three Parques is shown, already old and ugly. When Maurice Guillemot reproached her with having plagiarised Rodin's *Celle qui fut la belle heaulmière,* Camille retorted: "My *Clotho* is an entirely original work . . . I only ever get ideas from myself, I have too many rather than too few."

The idyll between Auguste and Camille strengthened his art and stimulated hers, and their union produced numerous sculptures of the human body in all its sensuality. Already, Rodin had sculpted the *Torse d'Adèle;* in 1884, he gave us the *Torse de Centauresse.* This time, Camille posed: the image of the woman in Rodin's art changed. Henceforth, the couples were calmer, the bodies at peace. At the same time, Bartholdi was working on a huge statue which would make his reputation, and become a symbol of liberty for a nation of immigrants. Beside the fierceness and almost masculine solidity of Liberty, who seemed like a mother protecting her young, the *Centauresse* appears gentle, simple and pliable, a woman-child swayed by desire. But it was also the zenith of the Industrial Revolution; plans for the Eiffel Tower were in hand. The gentleness celebrated by Rodin had nothing in common with the work of the engineer Gustave Eiffel, and yet they all belonged to the same decade. At the end of

Whilst Rodin was extolling the body of the child-woman, Bartholdi was constructing *Liberty lighting the world,* a symbol of freedom, but also of motherhood and duty, holding the rights of man firmly against her breast. In 1886, France gave the statue to the United States. In the same year, Gustave Eiffel obtained permission to build the Eiffel Tower, and the works began. "The great grasshopper" became indelibly associated with Paris, just as the Statue of Liberty became the symbol of New York.

1
On this engraving, entitled *Mary Cassatt at the Louvre,* Mary Cassatt, a painter and friend of Degas, is shown in a completely original manner, from behind and leaning on an umbrella. Degas liked to show his subjects in unusual positions, which was something he had in common with Rodin. Mary Cassatt was Degas' loyal collaborator, and she introduced his work to American society.

the century, Rodin mused: "Art is contemplation. It is the pleasure of the spirit penetrating nature, and discovering the spirit with which it is itself animated . . . When I have a beautiful woman's body as model, the drawings I do of it convey images of insects, birds, and fish. It seems unbelievable, and I never would have thought it myself."

1. *Mary Cassatt at the Louvre,* E. Degas. 1879-80. Etching with pastel. 30.5×12.6 cm. Musée du Louvre.

2. *Torse de Centauresse, c.* 1884. Terracotta. 21.5×10.3×7.7 cm. Musée Rodin. S.990.

2
This *Torse de Centauresse* (1884) is an echo of the 1882 *Torse d'Adèle,* another celebration of the female body. It is often shown with the head of *Paolo and Francesca.* The biographers seem to agree that Camille, omnipresent in Rodin's work, was the model here as well.

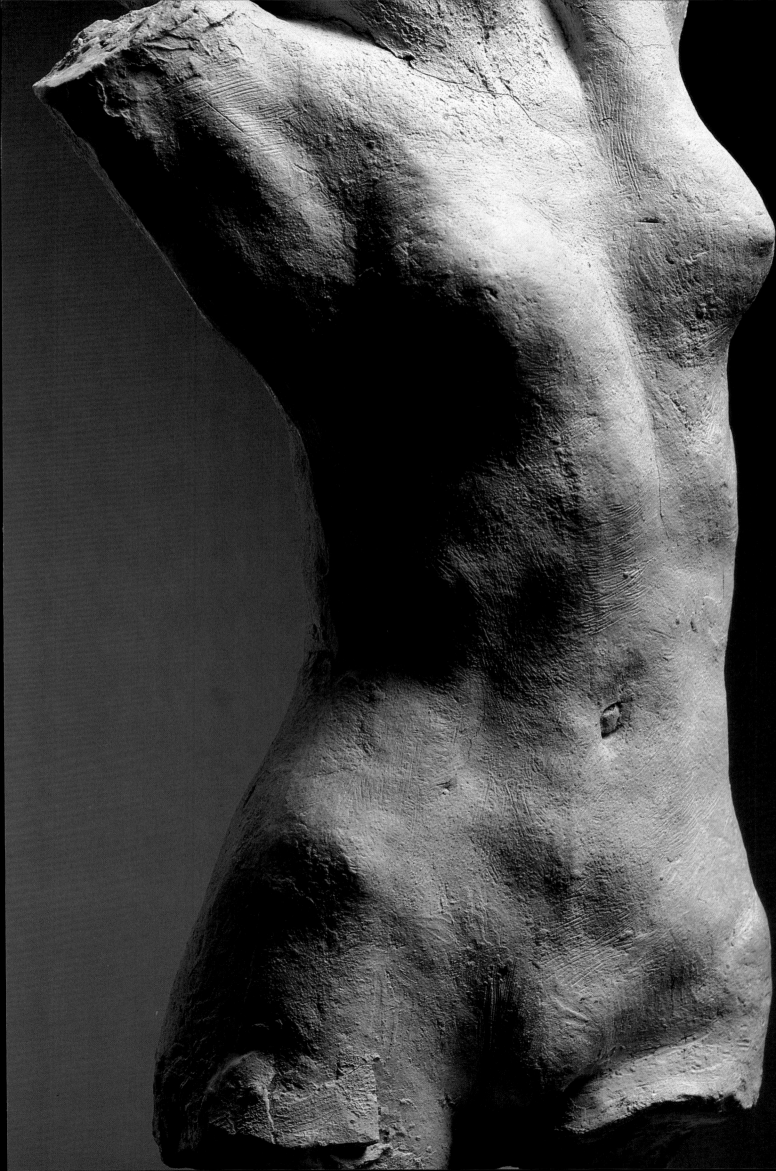

Rodin's ambition was not satisfied by private orders for busts. So, while continuing to work on *The Gates of Hell,* he began to take steps again to obtain commissions from the State. In 1880, Omer Dewavrin, Mayor of Calais, relaunched an old project for a monument to honour the "burghers of Calais".

After a visit to Rodin's studio the Mayor was enthusiastic about his work and urged the committee to hire him. He received a first advance of 15,000 francs, and agreed to present a model a year later. He launched himself into the work, and was satisfied with the first maquette: "It seems to be a completely original idea, from the point of view of both architecture and sculpture. Moreover, the subject itself is a heroic one and imposes a heroic concept; the ensemble of six people sacrificing themselves expresses and conveys emotion. The triumphal pedestal bears, not a quadriga, but human patriotism, abnegation and virtue. Eustache de Saint-Pierre, alone, with his dignified movement, carries along his relations and friends." Each one walks, at his own pace, towards his fate. The group here is not placed in the usual pyramidal arrangement. Rodin expresses by turn pain, anguish and fatalism, and the whole thing is imbued with the sadness of *The Gates of Hell.* The Calais committee was shocked by this vision – they had hoped for a more positive statue, along the lines of Rude's *La Marseillaise:* "This is not how we imagined our glorious co-citizens surrendering to the camp of the King of England. Their air of defeat insults our faith."

The committee demanded several modifications. Rodin defended his project: "You know how one disharmony within a sculpture will lead to others. It is like a play or an opera, one element is removed and everything is dislocated, and a new harmony must be created at the cost of enormous labour ..." Also, his idea for the group did not include a pedestal. He thought it would be more impressive it if was set at ground level, to emphasise "the look of misery and the drama of the sacrifice". Omer Dewavrin, his only supporter, left the Town Hall in 1885. The bank which held the committee's funds closed in 1886, and work was halted.

The Burghers of Calais

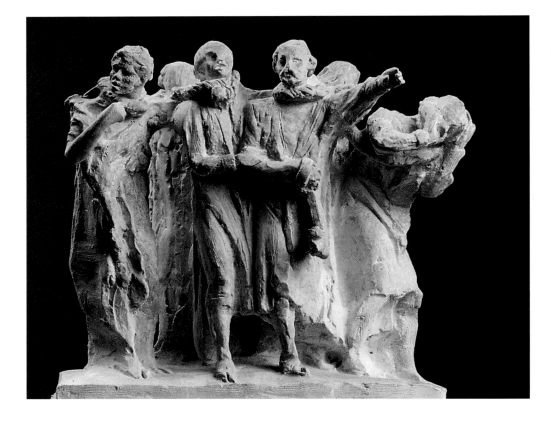

1. *The Burghers of Calais,* 1347. 19th-century engraving.

2. 1st maquette of *The Burghers of Calais,* 1884. Original plaster.
61×38×31.6 cm. Musée Rodin. S.86.

3. Study for a left hand for *The Burghers of Calais.* Bronze. 33×19×12 cm. Musée Rodin. RFR.60.

Following pages:

1. *The Burghers of Calais,* 1884-6. Polished plaster. 231.5×248×200 cm. Musée Rodin. S.153.

2. *Pierre de Wiessant,* 1889. Polished plaster, coated. Musée Rodin. S.153.

3. *Jean d'Aire,* 1889. Polished plaster, coated. Musée Rodin. S.153.

1
During the Hundred Years War, in 1347, the town of Calais was abandoned by Philippe VI, and the Calaisiens were left to the mercy of the English, who had been besieging the town for a year. King Edward III of England agreed to lift the siege on the condition that six of the most important men in the town should come out, bare-headed and barefoot, with a rope around their necks, to hand over the keys of the town before being executed. So Eustache de Saint-Pierre and Jean d'Aire, followed by four other leading citizens, set off for the English camp. The king seeing them, dignified and denuded, "remained silent", and it was the queen, then pregnant, who obtained mercy for them from her royal spouse, and then led them away to satisfy their hunger.

2
In this maquette of the preliminary design, Rodin already included several important elements which would appear in the final group: the original composition of a compact group, and his image of the burghers as beggars, emphasising their tragic situation.

3
Rodin conveyed each figure's emotional content mainly through the modelling of the hands. He was the first to use them as individual sculptures rather than part of a whole. Although Rodin always worked from nature, some of his hands have a sickly look, and the position they are in is beyond the capacity of normal gesture. Yet, oddly enough, it is the very exaggeration of the movement and the atrophied position that make the hand so natural and life-like.

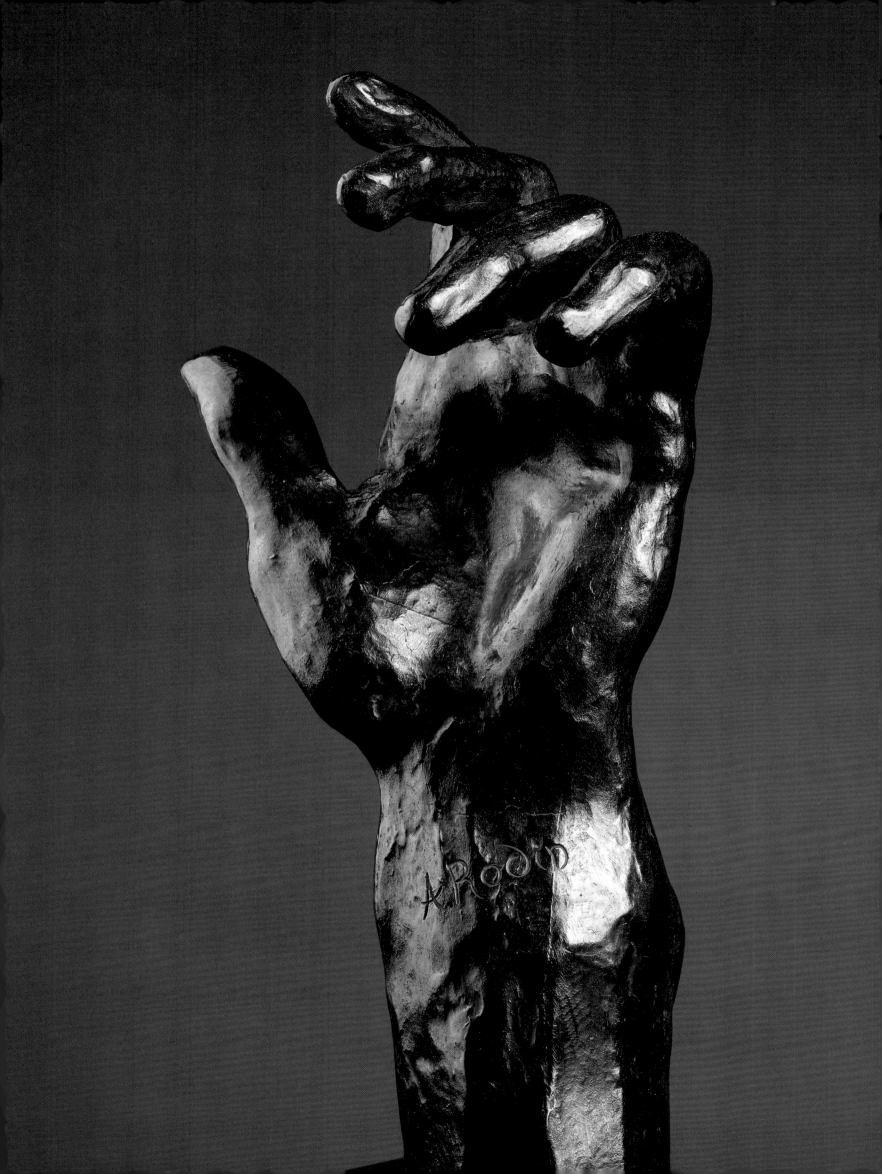

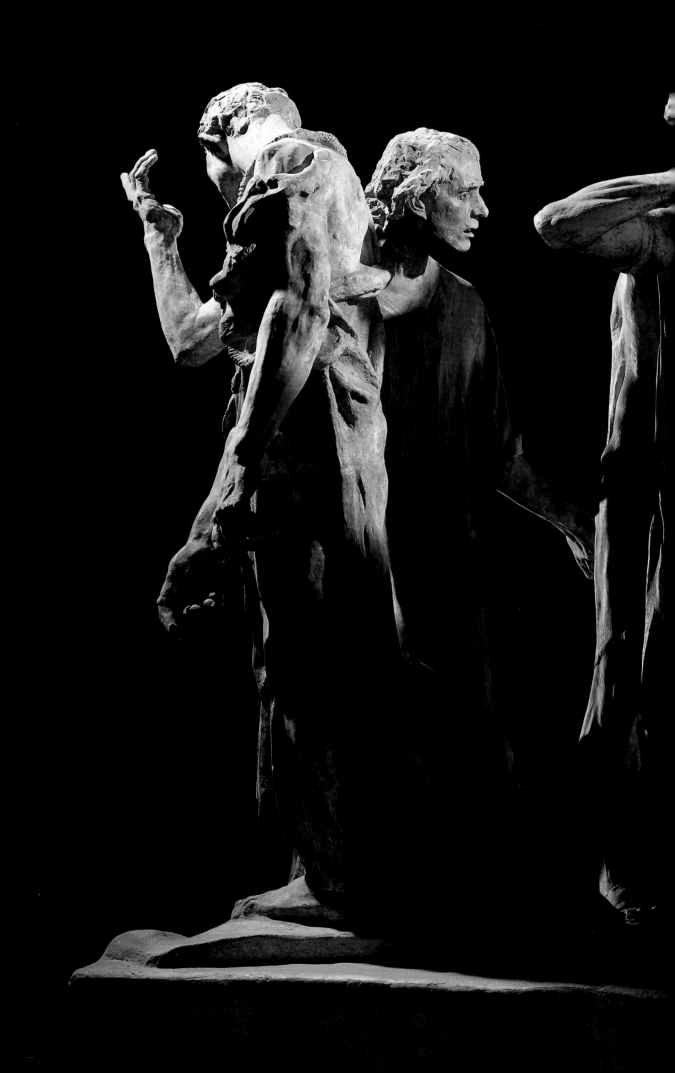

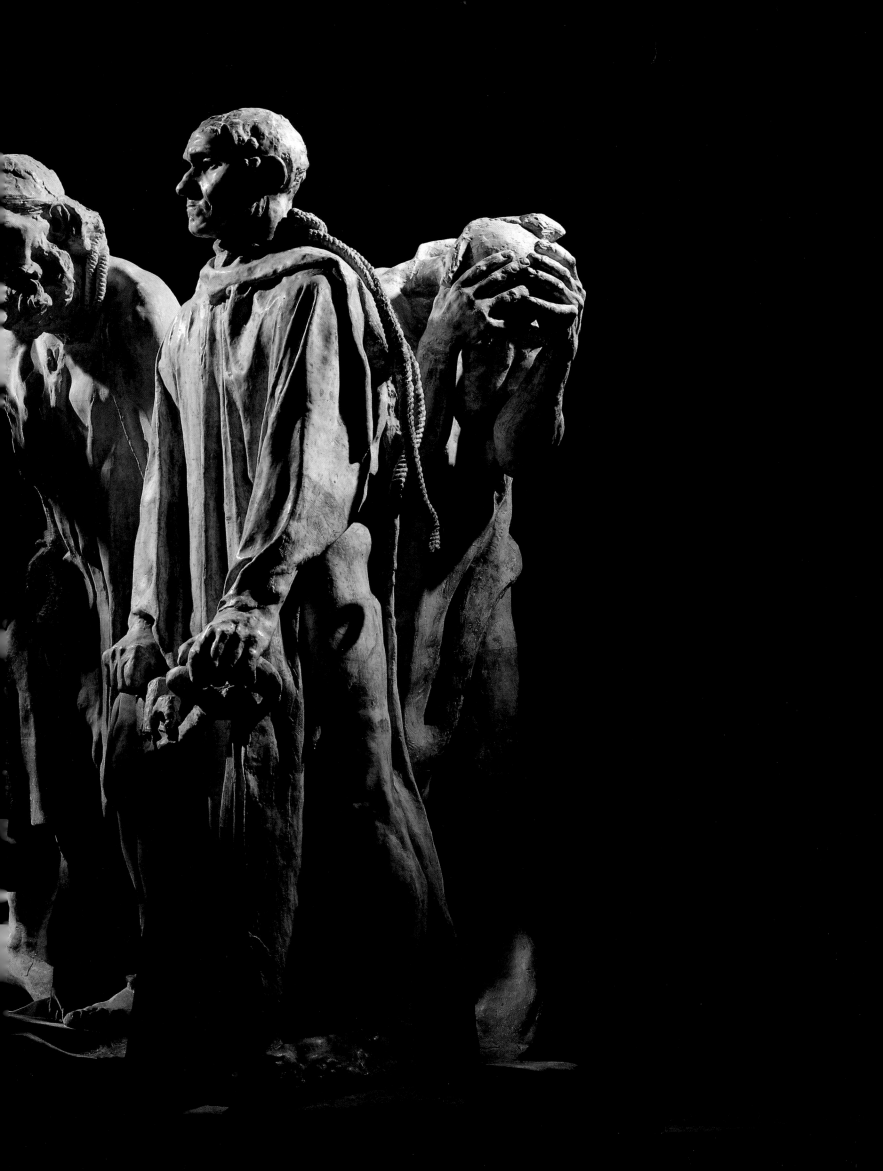

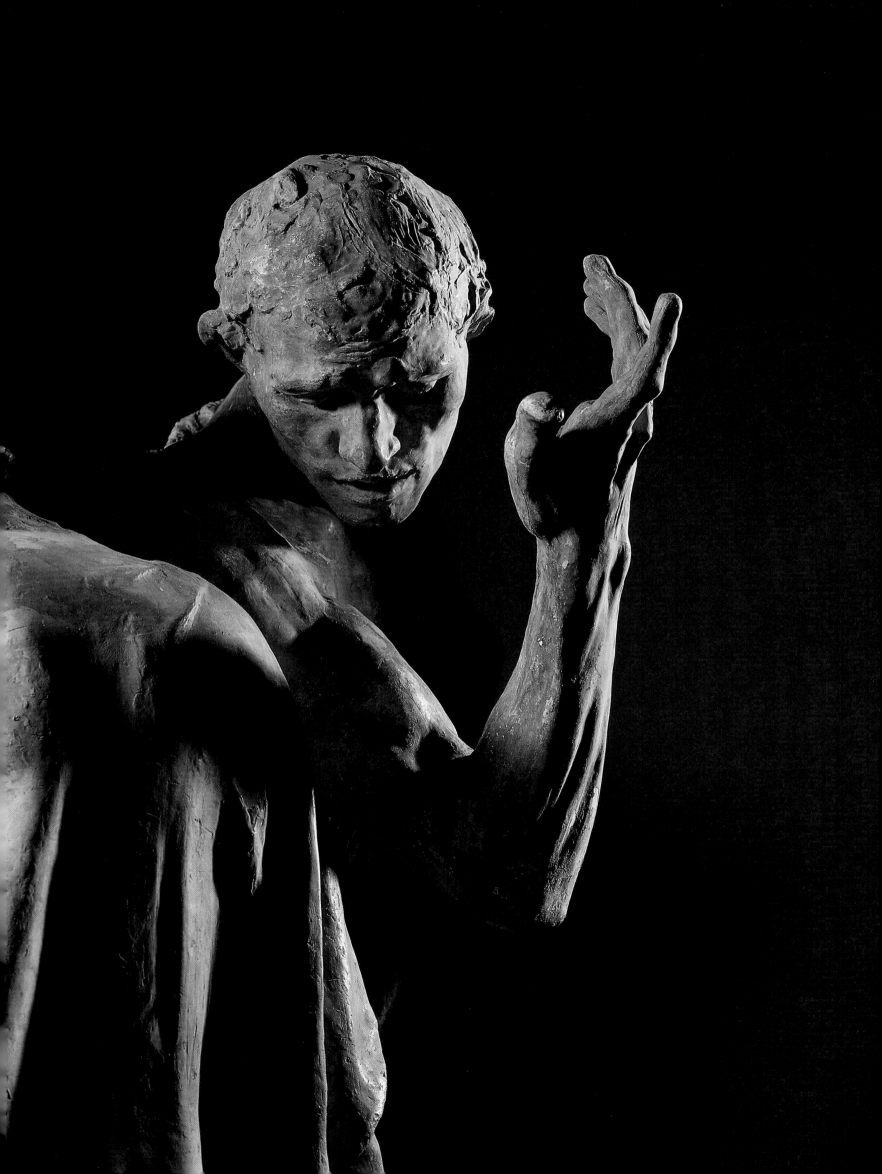

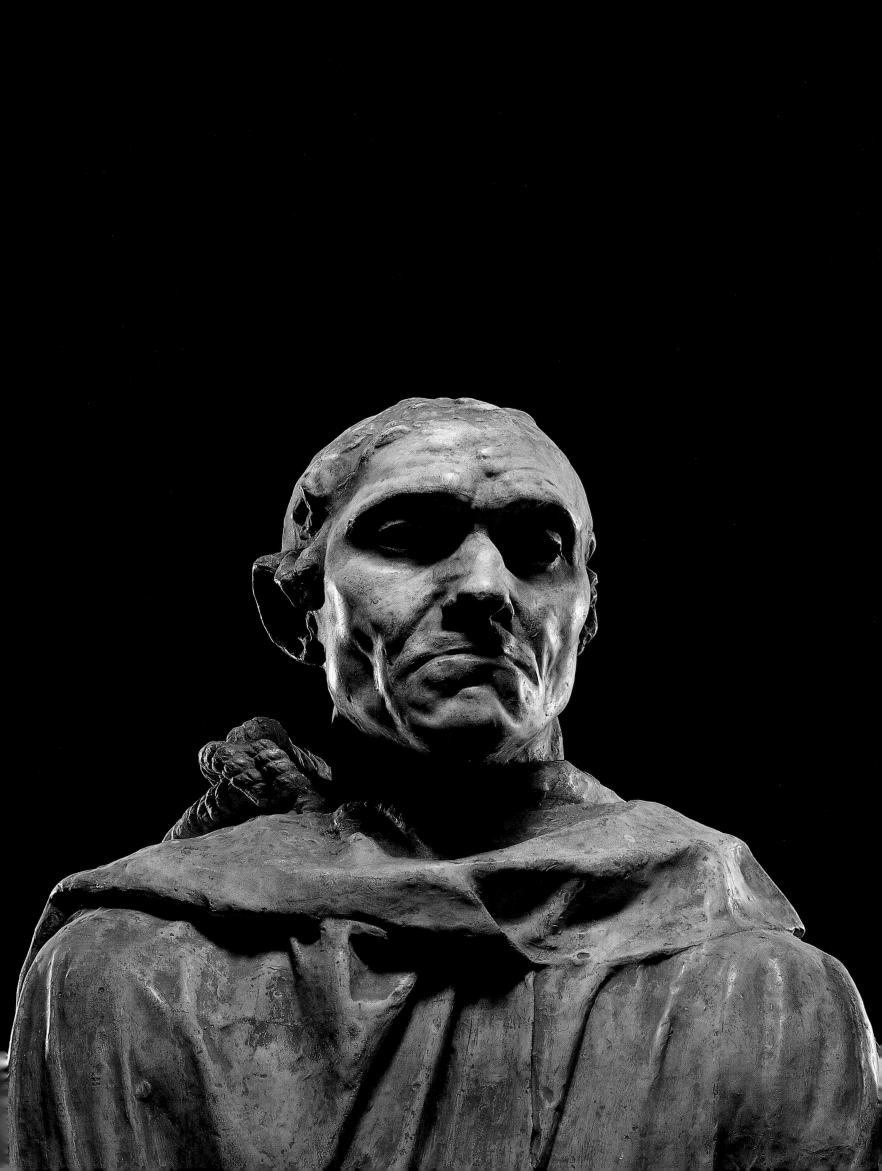

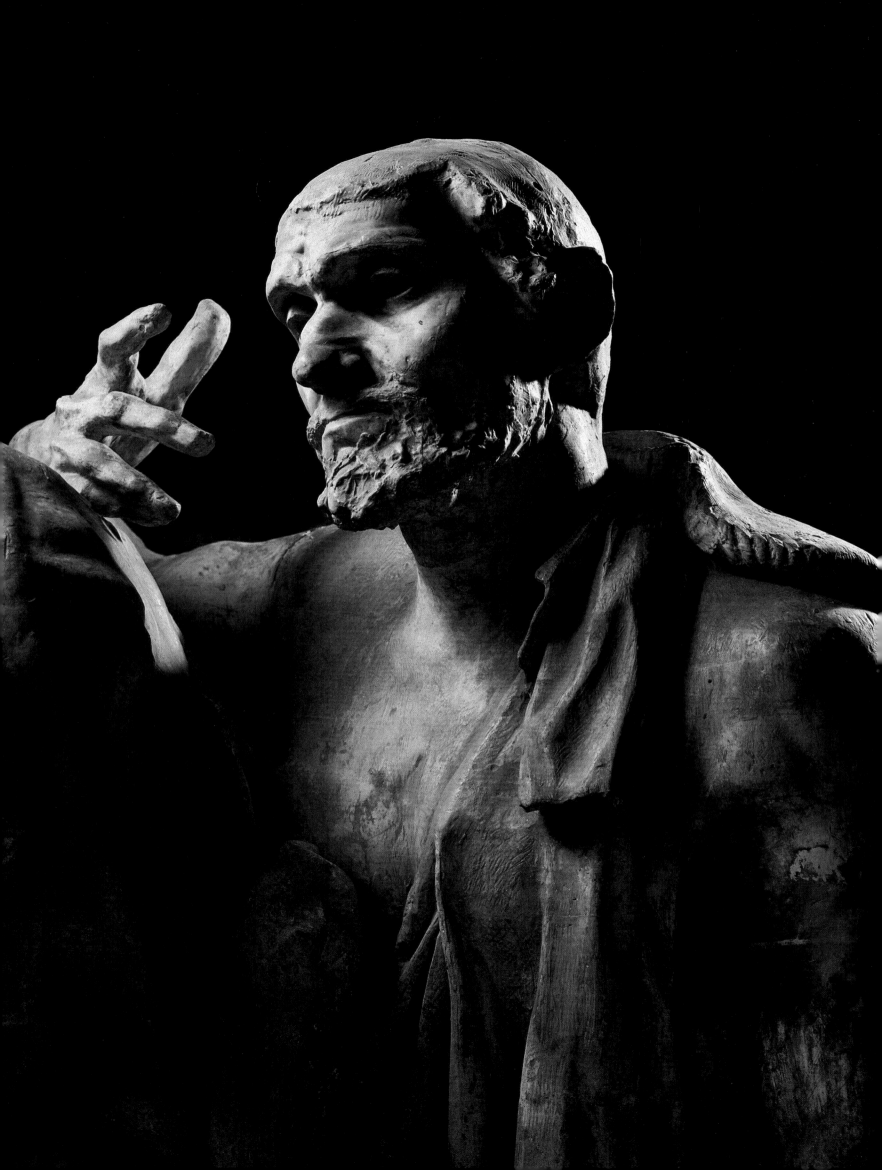

In 1889, the galerie Georges Petit put on a joint exhibition of Rodin and Monet. This show, which aroused a great deal of interest, was followed in the same year by the Great Exhibition. The Calais committee was impressed by the warm reception accorded to *The Burghers of Calais* at these exhibitions. In 1893, a subscription was started as well as a lottery, to raise the money necessary for the completion of the statue. But it was only when the Beaux-Arts contributed 5350 francs that Rodin was able to order the asembly of the six figures into one piece. The inauguration took place on 3 June, 1895. Unfortunately, the committee had not completely capitulated, and the six burghers, whom Rodin had visualised as being at ground level, were placed on a huge pedestal. The monument was erected in front of the Town Hall, lost against the leafy background of the public park. Rodin confided his disappointment to Paul Gsell, who was an admirer of the *Burghers:* "You very perceptively noticed the grading of the burghers, according to their degree of heroism. As you probably know, I wanted to emphasise that effect by fixing my statues, one behind the other, right on the paving stones of the square, in front of the town hall, like a living rosary of suffering and sacrifice. They would have seemed to be setting out from the civic hall towards Edward III's camp, and the Calaisiens of today, almost bumping into them, would have better felt the traditional solidarity linking them to these heroes. I think it would have made a powerful impression. But my plan was rejected, and a disgraceful and superfluous pedestal was imposed. I am sure they were wrong."

The unveiling took place on 8 June 1895. Rodin's happiness was, unfortunately, not complete. The monument, which he had wanted installed on the ground, was placed on a pedestal, itself surrounded by a little garden.

1. *Pierre de Wiessant*, 1889. Polished plaster, coated. Musée Rodin. S.153.

It was only after the Second World War that Rodin's request was heeded. The group was at last installed in front of the ancient medieval Town Hall, and fixed at ground level – after fifty years. In 1903, Rodin oversaw the despatch of another group to Copenhagen. Another was unveiled close to the Houses of Parliament in London on 19 July 1915, and there are also several groups in Belgium.

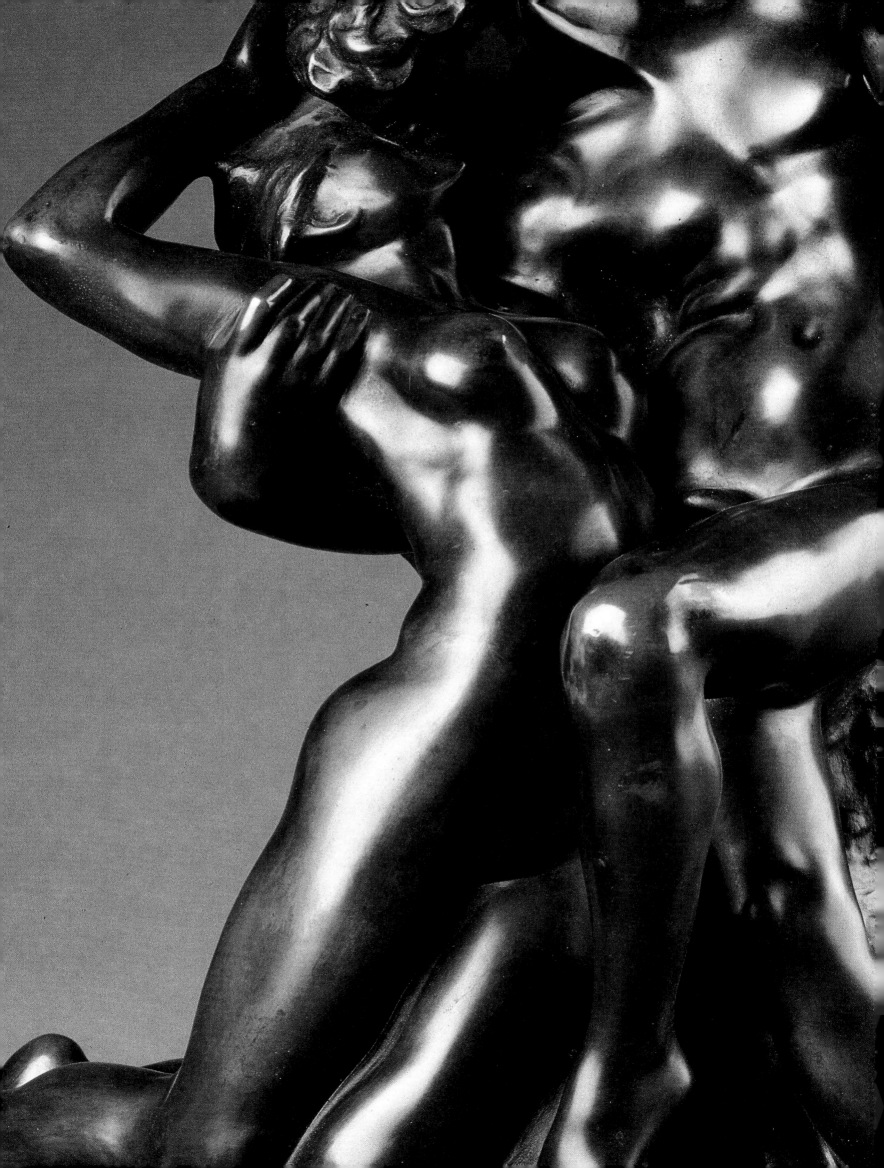

*"The main point is to be moved,
to love, to hope, to tremble, to live.
To be a man first, then an artist!"*

During the decade 1880-90, Rodin produced several groups on the theme of Paolo and Francesca, entwined figures destined for *The Gates of Hell: The Kiss, The Eternal Idol, Eternal Spring.* But he decided not to place them on the gates, and kept them as individual works. Originally called *Zéphire et la Terre, Eternal Spring,* like the others, represents joyful passion rather than tragic torment. Rodin liked to see his models wandering freely in his studio, without holding them to any pose. *Eternal Spring* is a work of imagination, a sort of collage: the man holds in his arms the body of a woman whose torso is that of *Adèle,* which Rodin sculpted when he was working in Nice in 1879. He was still a long way from replacing tenderness with passion, and he wrote to Paul Gsell: "If I judge that a statue can limit itself to representing living flesh, without any actual subject, that does not mean that my work is devoid of thought; if I declare that one need not search for symbols, that does not mean that I am in favour of art being without spiritual significance. The truth is, ideas and symbols are everywhere; the shape and position of a human being will necessarily reveal the state of his soul. The body will always be an expression of the spirit it contains. And for the perceptive, nudity offers the greatest revelation."

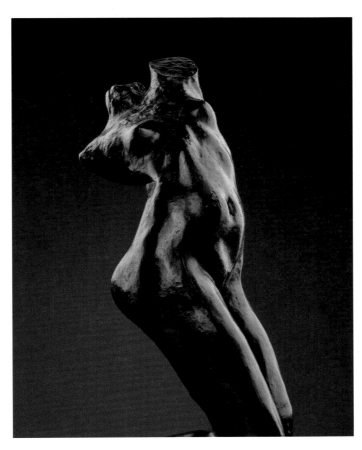

2
This little sculpture, *Désinvolture,* can be compared with *Venus à sa toilette* and the *Faunesse à genoux.* It was, in any case, the same model who posed for these works.

1
This group, *Eternal Spring,* is, with *The Kiss,* one of Rodin's most famous couples. The fact that the man's feet are off the pedestal show that Rodin was planning to place the group on *The Gates.* He had apparently thought of calling it *On n'est pas de bois* (We are not made of wood), after a reading from a text by Léon Cladel, the brother of Judith, Rodin's biographer.

1. *Eternal Spring,* 1884. Detail. Bronze. 40×53×30 cm. Musée Rodin. S.853.

2. *Désinvolture.* Bronze. 58×33×36 cm. Musée Rodin. S.1382.

The woman in *Eternal Spring* was completely transposed in *La Chute d'un Ange.* Rodin, for whom youth was the key of life, always sculpted young and vigorous bodies, full of energy (except *Celle qui fut la belle heaulmière*). The women's bodies are thus stretched outwards, in expectation of experiences to come. *La Faunesse à Genoux* and *Le Torse d'Adèle* are part of the same series. And, as Rodin grew older, the bodies became younger, more vigorous and more daring. The first sculpture of *Paolo and Francesca* is still imbued with masculinity. With Camille at his side, after she came into his life, Rodin began to create, instead of twisted groups, ones where timid, almost modest couples were amorously entwined.

Thanks to his work on State commissions – *The Gates of Hell* and *The Burghers of Calais* – Rodin was now free from financial worries. He began a more intimate type of sculpture, as seen in *La Pensée,* in which Camille is once again a source of inspiration. Her gentle face, which seems to emerge naturally from the raw matter, is capped with a Breton bride's headdress. Behind the marble features and the bonnet, a thoughtful Camille appears to be meditating, or dreaming. The classicism of this smooth and thoughtful carving raises a question about the work of the *praticiens* to whom Rodin entrusted the preparation of the marbles, since, for Rodin as with other artists of the time, all searching for new methods of expression, the tendency was very much against academicism. The face sculpted by Degas, like his women drying themselves after their bath, shows the attempt to avoid "prettiness", as does Van Gogh's *Tête de Paysanne* (1885). But in this year when his romance with Camille was at its height, Rodin's sculptures remained imbued with a sensuality that bore witness to his amorous passion.

"Artists and thinkers are like infinitely delicate and resonant lyres. And the vibrations drawn from them by the events of each epoch are prolonged amongst all other men."

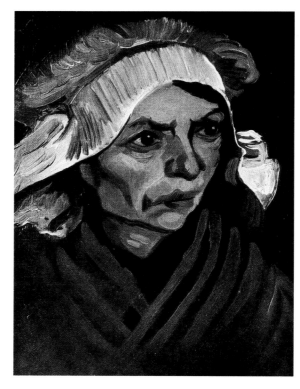

1
In 1886, Rodin made a bust of Camille: *La Pensée.* She was twenty-two, and Rodin chose to show her wearing a Breton bride's coiffe. The gentle face is animated by intransigence rather than beauty, and uncompromising faith. Camille was never to wear a nuptial headdress.

2
Van Gogh, whose *La Paysanne* is shown here, loved Rembrandt as much as Rodin did, and wanted, like him, to paint the soul, to transcribe feeling through art. He said: "I have sought to express terrible human passions with red and green."

1. *La Pensée.* 1886. Marble. 74×55×52 cm. Musée d'Orsay.

2. *Tête de Paysanne,* Van Gogh, 1885. Oil. 41×32 cm. Private collection, Zurich.

3. *Portrait, tête appuyée sur la main,* Degas, 1892. Bronze. H: 11.8 cm.

In 1892, Degas modelled his little bust, which is completely different from the rest of his work. Rodin, in 1864, had been forced by the frost to show his *Homme au nez cassé* without pedestal or stand, and here Degas uses this discovery deliberately.

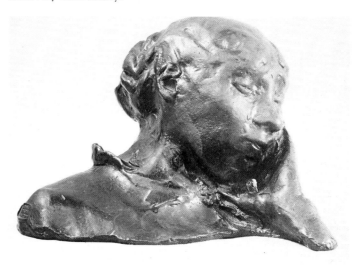

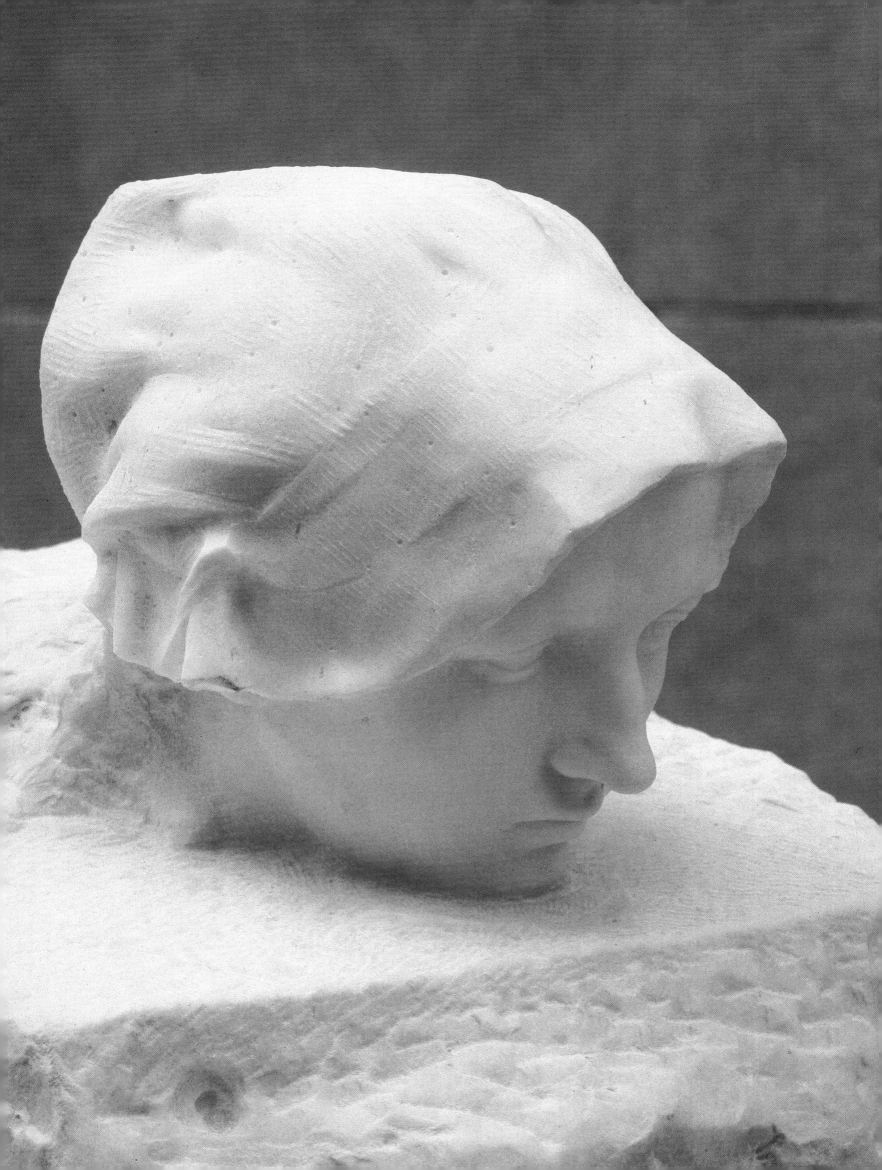

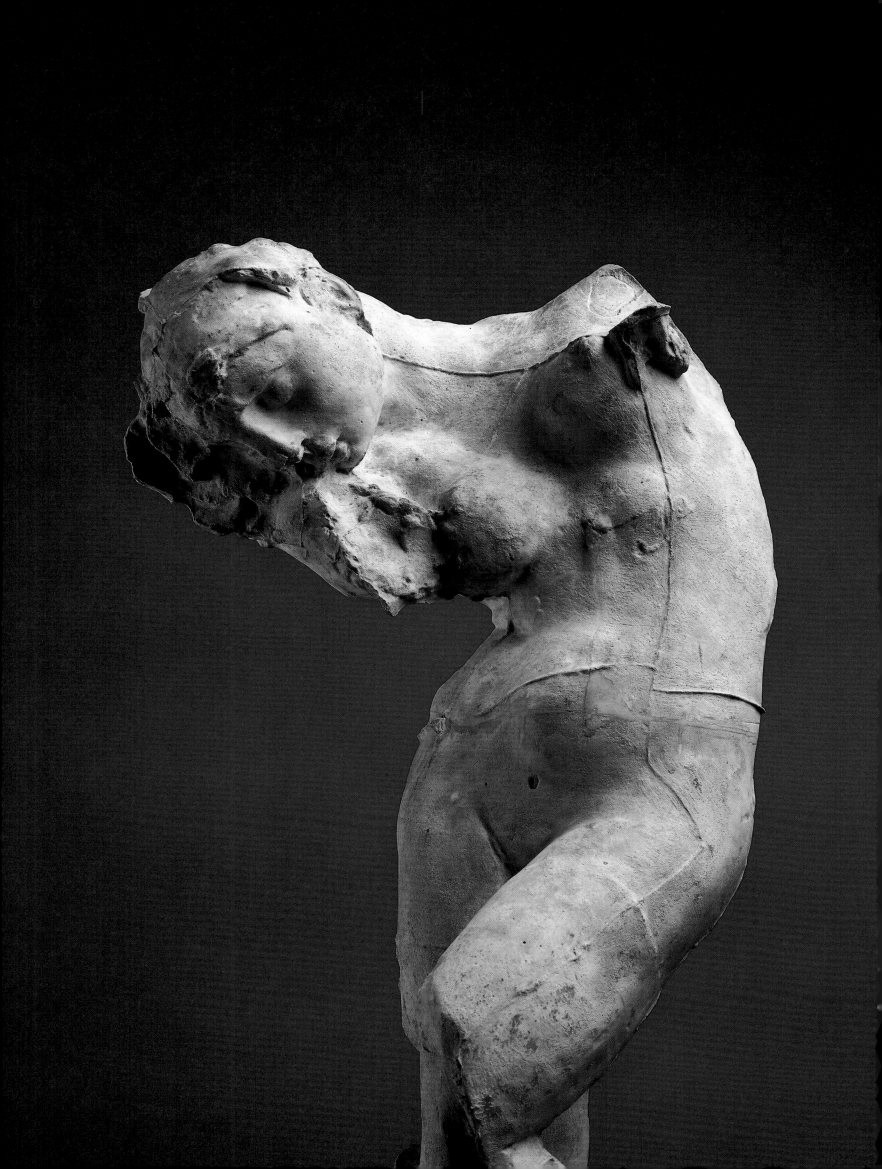

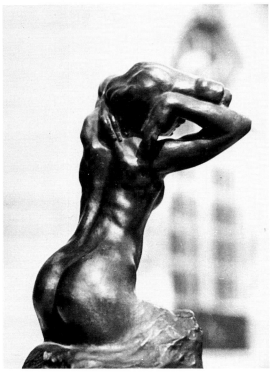

While some of Rodin's works became more sensual, they also contained a pagan sense of pleasure – Rodin was about to illustrate the myth of Pan. From now on, women were not just represented twisted with passion and straining with desire, they were shown in full bloom, discovering their bodies and rejoicing in them. This new facet of his art gave rise to a series of little *Faunesse à genboux* and *Vénus à sa toilette*. From the technical point of view, this was easily explained. Rodin had left the Sèvres factory three years earlier, but he had not forgotten what he learned there. At Sèvres, he had worked with glass paste, a delicate material, unlike stone or marble which had to be attacked with chisel and graver. This material allowed him to tackle gentle subjects, as sensitive and sensual as the paste itself. But the real reason for this development, beyond the technical one, was more intimate and personal, it was Camille herself. It was she, no doubt, who introduced this new mood to his sculpture. And Rodin, who loved women, himself wrote: "In every model lies the whole of nature."

"He watched his models
silently relishing
the play of life and beauty in them;
he would admire the tantalising suppleness
of a young woman
bending down to pick up a chisel."
(Paul Gsell)

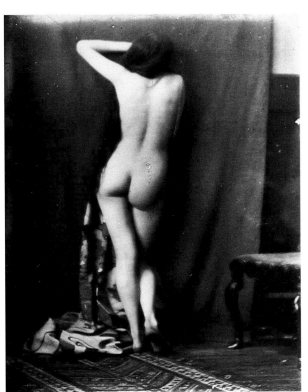

1

This *Vénus à sa toilette* (1885), in its movement and grace, reminds one of Rodin's motif on the Saigon vase from the Sèvres factory. It appears that Mme Abruzzeti posed for this "toilette", and also for the *Faunesse à genoux*.

This photograph shows an unknown model, in a pose the Master was fond of. Rodin loved the female body, as Paul Gsell testifies.

2

This 1885 plaster, *La Méditation sans bras,* was one of a long series that Rodin had made, so as always to have an original in reserve, ready to be reworked. This armless sculpture is one of many variations on the theme of *La Méditation*. Rodin even thought of making this figure into one of Victor Hugo's muses. Rilke described this sculpture: "An entire human body never expressed his deepest thoughts more powerfully . . ."

"How dazzling is the sight
of a woman undressing!"

When he carved the body of a woman, only representing her shape, the sculpture was already a hymn to life and the joy of living; that same year, he sculpted another woman, this time touching on symbol and allegory: the *Eve* of *The Gates of Hell*. Rodin reworked and mutilated it, making it into *La Méditation* or *La Voix Intérieure*. As soon as the theme tackled is the transposition of an idea into an image, the treatment of the material changes: he is trying to show an inner feeling rather than the outward shell. So the body of the *Vénus* is smooth and supple and stretched outwards, towards the world, whereas that of *La Méditation* is rugged and curled in on itself: "I left the statue like that on purpose. It represents my thought. That is why it has neither arms to move with nor legs to walk with. Have you not noticed that when reflection goes too far you find plausible arguments for totally opposed ideas, and inertia is the only answer!"

1. *Vénus à sa toilette, c.* 1885. Bronze. 46×21×21 cm. Musée Rodin. S.37.

2. *La Méditation.* 1883-4. Plaster. 58×18.8×15.9 cm. Musée Rodin. S.1129.

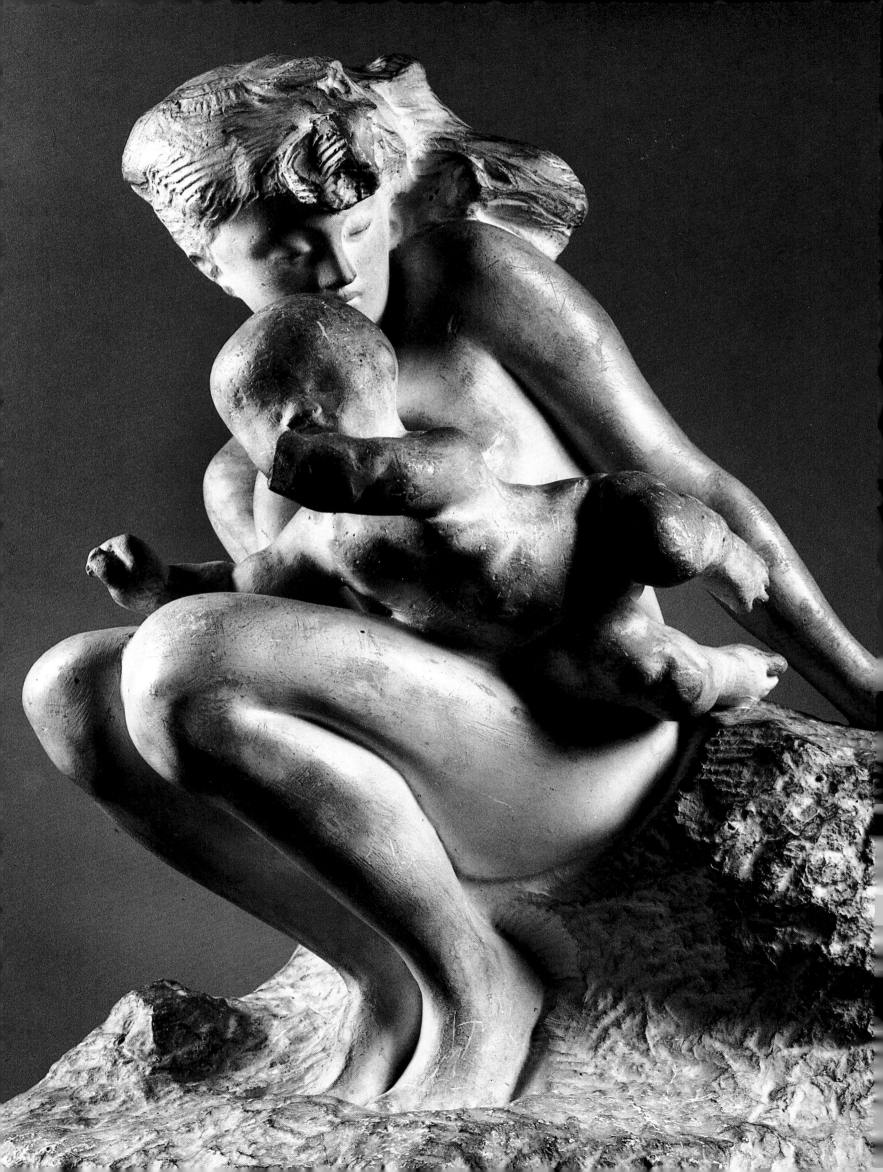

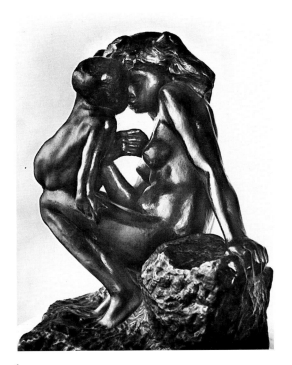

1
This maternity scene can be found on one of the lateral panels of *The Gates of Hell*. This subject was taken up several times by Rodin, and the *Jeune Mère à la grotte* was inspired by this group. Another version, *La Femme et l'amour*, was given by Rodin to a tombola to raise money for the statue of Claude Lorrain.

2
L'amour qui passe (1885) re-introduced the theme of maternity in Rodin's work. It was, no doubt connected with Camille's presence.

Rodin celebrated the beauty and graceful shapes of women; he also celebrated, in them, the whole cycle of life: the child-woman in the *Vénus à sa toilette*, the young woman in the *Torse de Centauresse*, the woman stretched with desire in the *Torse d'Adèle*, the fulfilled woman in *La Danaïde*, and finally the old woman in *Celle qui fut la belle heaulmière*. Motherhood took its natural place in his untiring portrayal of womanhood. Earlier, about 1869, Rodin had portrayed the mother and child. At that time, Rose no doubt posed with her young son, Auguste-Eugène. That sculpture was impregnated with the gracious and charming eighteenth-century style of Clodion, which Rodin was particularly fond of at that time. The young mother's legs are cleverly draped and the hair is very precisely rendered. By 1885, Rodin had long since changed his style; the young mother, shown with her child on her knees, was intended for *The Gates of Hell*. In the earlier style, maternal love does not appear to be the principal element. Here, love is everything: the body completely unveiled, the child curled up on its mother's knees. This period of recurring *Maternity* scenes can no doubt be ascribed to Rodin's love-life – he had just met Camille.

The marble studio at the Dépôt des Marbres, 182 rue de l'Université in Paris, was put at the sculptor's disposal at the time of the state commission for *The Gates of Hell*. He first had studio M, then studio J, and finally studio H, which he kept until the end of his life.

1. *Jeune Mère*, 1885. Bronze 39×36.9×25.5 cm. Musée Rodin. S.977.

2. *L'amour qui passe*, 1885. Plaster. 39.3×37.1×25.1 cm. Musée Rodin. S. 1194.

Was it this meeting which brought out in him a need to return to more sensitive and emotional themes? It may also have been due to the fact that his son was mentally handicapped, and that he felt depressed that he was his only offspring. Judith Cladel relates that Jules Dubois one day heard someone knocking on the studio door at the rue de L'Université, and saw before him "a hideously pathetic and ragged man. The unfortunate fellow asked to see M. Rodin. The sculptor came and spoke quietly to him, and then went out with him. He brought him back to the studio later, having fed him and dressed him in ordinary but neat second-hand clothes. 'Sit there and work!' Rodin told him. He left half an hour later, saying he had an errand to do. 'That's my son,' said Rodin sadly."

The subject of *La Danaïde* is the torment of the daughters of Danaos, condemned to pour water endlessly into a bottomless vase. This nude, which was going to figure in *The Gates of Hell*, was rejected by Rodin at the final assembly. There were no doubt too many intimate memories attached to this work, which coincided with the beginning of Camille and Rodin's romance. This woman, exhausted by her torment, does not resemble the other damned in *The Gates of Hell*. The pose is graceful and sensuous, with highly worked contours. To understand it fully, one must walk around it and see the water spilling out of the jug, echoing the girl's flowing hair. This slender and youthful figure is in contrast with Renoir's opulent *Baigneuse*, which dates from the same period. Rodin explained: "There is nothing in nature with more character than the human body. Sometimes it is like a supple creeper, or a finely arched young tree ... Sometimes a body bent backwards is like a spring, or a beautiful bow on which Eros is fixing his invisible arrows. At other times, it is like an urn: I have often made a model sit with her back to me, with her arms and legs gathered forwards. In that position you see only the silhouette of the back – narrowing at the waist and widening at the hips – it is like a beautifully curved vase, an amphora containing future life within it."

"In short, Beauty is everywhere. It is not that it is lacking for our eyes to see, it is that our eyes fail to see it."

Rodin showed the first marble of *La Danaïde* at the exhibition with Monet at the Georges Petit gallery in 1889, and again at the Salon du Champ-de-Mars in 1890. The state acquired it and Rodin, after a few retouches, handed it over to the Musée du Luxembourg in 1892. He then authorised his *praticiens* to produce other copies, which can now be found in Lisbon, London, Brussels, Philadelphia, Brooklyn and Princeton.

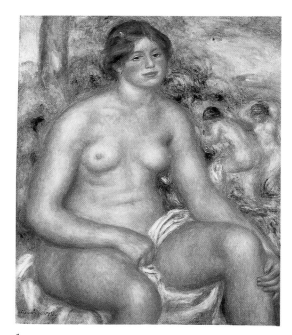

1
This *Baigneuse* by Renoir demonstrates the distance between him and Rodin. The latter liked to show muscled, nervy bodies, whilst Renoir preferred soft generous shapes. This generosity of form, painted here in 1914 at his home at Collettes, was deliberated, emphasised, since the model, Madeleine Bruno, was quite slight. Renoir would say to his friend, Albert André: "Ah! that breast! See how soft and heavy it is!"

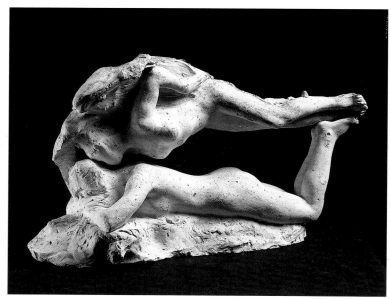

2
Le Baiser d'un ange, also called *Le Rêve* or *Le Sommeil*, a group made prior to 1889, is the juxtaposition of two statues. Here Rodin repeats a technique he was fond of. The angel seems to be inspired by the statue entitled *The Fall of Icarus*; as for the sleeping woman, she is one of the family of small kneeling women that appear in *The Gates of Hell*.

1. *Baigneuse assise*, Renoir. 1914. Oil on canvas. 81×67 cm. Art Institute, Chicago.

2. *Le Rêve*, before 1889. Plaster. 22×37.5×18.3 cm. Musée Rodin. S.1861.

3. *La Danaïde*, 1889. Marble. 36×71×53 cm. Musée Rodin. S.1155.

3
Camille probably posed for this sculpture, *La Danaïde* (1885), which illustrates the legend of the fifty daughters of Danaos. Rodin shows one of them, exhausted from eternally refilling a bottomless pitcher.

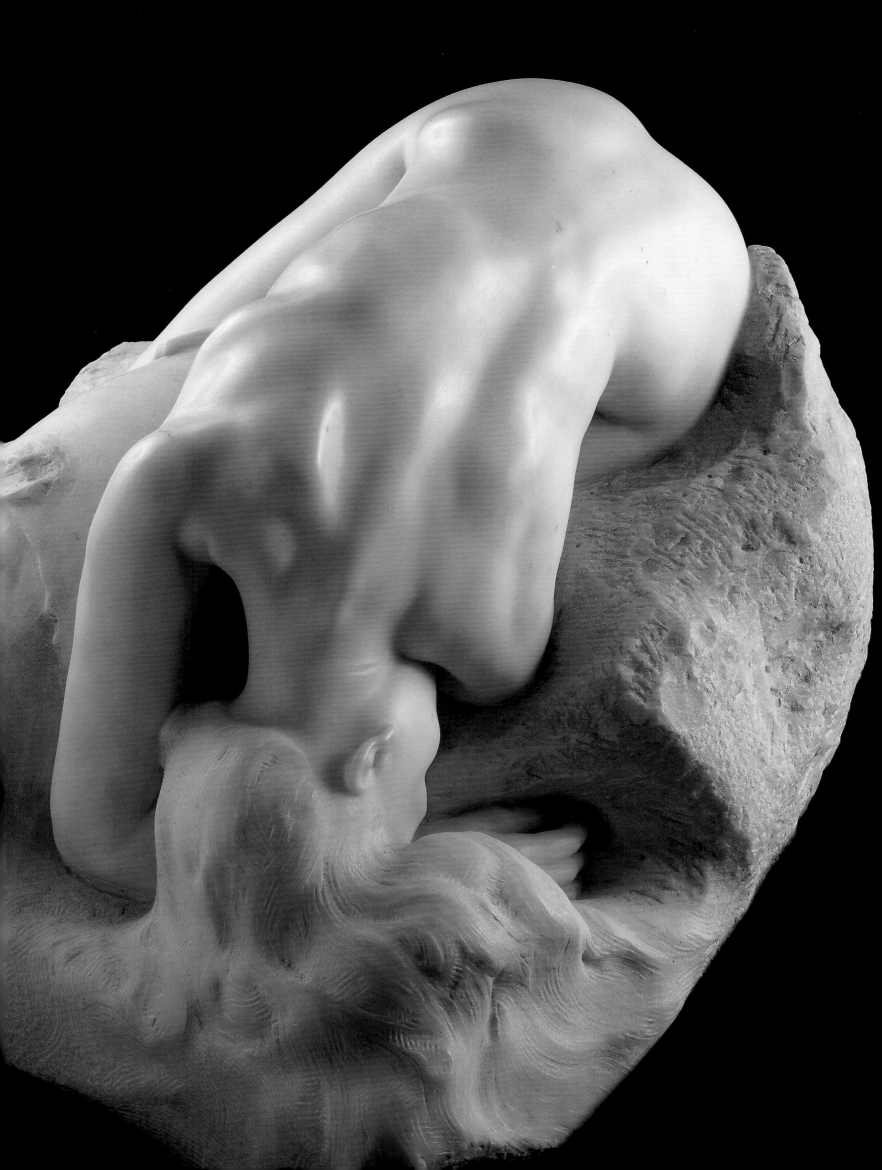

Camille was always Rodin's favourite model, and with her he portrayed both life and death in *The Gates*. In 1889, Rodin and Camille lived at the Folie-Neubourg and in this propitious environment, she became his main model. In 1886, for *La Pensée*, Rodin had put Camille into a bridal head-dress; here, she is twenty-five, and her hair is imprisoned in a Phrygian cap. In this bust, there is no fire or passion, only the calm and serenity which preceded her gradual and tormented loss of reason. The bust of *Camille au bonnet phrygien* was executed in glass paste, the soft and delicate material which Rodin associated with his mistress's fragility. Jessie Lipscomb, Camille's friend and confidante, and her accomplice in her liaison with Rodin, made a rather insipid bust of her, which nonetheless probably gives us a fair picture of what she looked like. The two artists' impressions offer two different interpretations. Jessie Lipscomb tries to emphasise Camille's femininity by giving her realistic curls, Rodin goes straight to essentials, ignoring irrelevant details. He was obsessed, in this bust, as with others, with finding the inner truth: "I have done my best. I have never lied. I have never flattered my contemporaries. My busts have often displeased people, because they were always truthful – truth was certainly their great merit. Let it stand for *beauty!*"

"The human body is above all the mirror of the soul, and hence comes its greatest beauty."

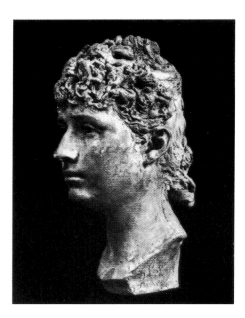

1
Bust of Camille, by Jessie Lipscomb. Jessie Lipscomb was a friend of Camille's, perhaps the only one she ever had, and she acted as an intermediary between Camille and Auguste.

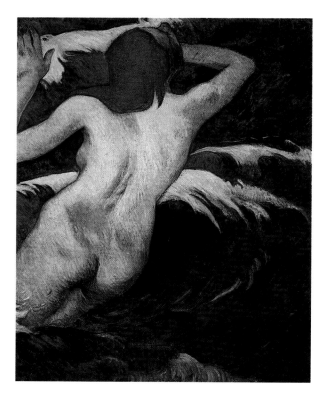

2
Ondine, by Gauguin, dates from 1889. Two years later, Gauguin's impressionist friends organised an auction to pay for him to set off for Tahiti. He returned to France in 1893, and then went back in 1895, after selling up his studio, to die in Atuana in 1903. This painter and seeker was never understood during his lifetime by the public or the critics. He set off unhesitatingly for the distant islands where the exotic subjects suited his personal sensibility. He would write: "Colour, like music, is vibration, and can reach that which is most general and yet also most vague in nature: inner strength."

In that same year of 1889, Gauguin, just as sick of the public, was moving heaven and earth to find the means of going into exile: "I rather agree with Vincent (Van Gogh), the future is in tropical painting, which has not yet been done, for the stupid buyers, the public, want novelty." He was not able to leave till 1891, after an auction, organised by his impressionist friends, which included his *Ondine*.

1. *Bust of Camille*, Jessie Lipscomb, 1886. Painted plaster. Lipscomb collection.

2. *Ondine*, Gauguin, 1889. Oil on canvas. 92×72 cm. Cleveland Museum.

3. *Camille au bonnet phrygien*, c. 1886. Plaster. 25.4×15.3×18.4 cm.

3
Camille au bonnet phrygien, by Rodin. This bust of 1889 is similar in its technique to *La Méditation*, with the outer shell very roughly executed. Rodin shows us a strangely calm Camille. Not a muscle in the completely expressionless face is moving, only the eyes seem alive.

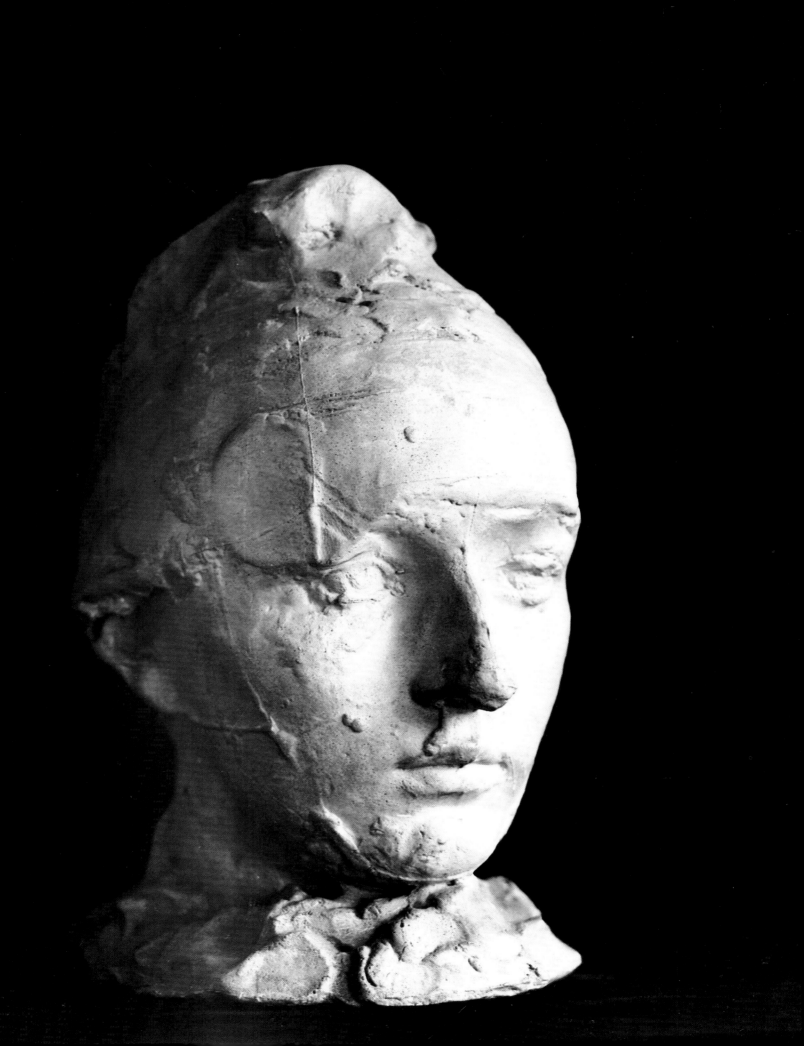

It was probably during the journey to Italy in 1875, when he visited the Vatican museum, that Rodin first saw the *Laocoön and Niobé* groups, the inspiration for the *Tête de la Douleur*. It appeared for the first time on the shoulders of one of the *Sons of Ugolino*, like a dying child of Niobé. The head can equally be found in several groups on *The Gates of Hell*. Whether it is *The Prodigal Son*, or *Paolo and Francesca*, this juvenile, androgynous head was to become, like *Torse de Centauresse* and *Torse d'Adèle*, an individual work. Carved in marble, it became a *Medusa* or *Joan of Arc* or *Orpheus*. This head contained all the styles with which Rodin's work was imbued, and which had only one aim – to convey feeling: "And even in those of my works where movement is less emphasised, I have tried to give some indication of gesture – I have very rarely shown complete repose. I have always tried to convey inner feeling through the movements of the muscles . . . Art cannot exist without life."

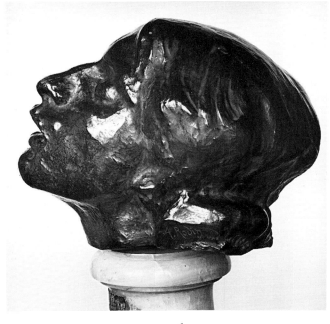

"The artist can fix the enthusiastic gaze of a man who has guessed the decrees of fate upon his own anguish, and upon his cruellest wounds."

Edvard Munch, who was to paint Rodin's *The Thinker* in 1907, was already writing in 1889: "One can no longer paint interiors, people reading and women knitting – now one must show living beings who breath and feel, who suffer and love." This subjective idea that Munch had of art later led him to explain his philosophy thus: "I do not believe in any art which is not impelled by man's need to open up his heart." For Munch, to paint was to expose and reveal everything about himself, and re-express it with his palette. *The Scream,* painted in 1893, is an expression of fear and anguish. The subject shown is closely linked to the painter's feelings, and the painting is nothing more than an expression of those feelings. Before the end of the century, Rodin too modelled his own *Scream,* pure feeling, based firmly on lived experience.

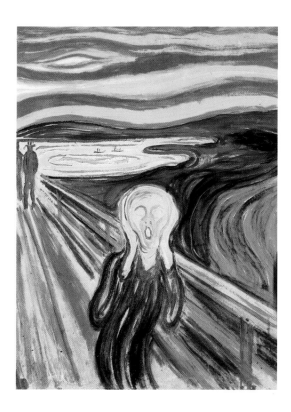

1
This *Tête de la douleur,* begun in 1882, can be seen on several figures in *The Gates of Hell.* It is symbolic of the whole work. Rodin made it into a separate sculpture, as the features of this head were so powerful and expressive.

2
Probably done before 1899, this *Scream* is a new interpretation of another bust, *La Tempête.* Here the face is the same, only the hair is different.
3
In this painting by Edvard Munch of 1893, *The Scream,* the painter crystallises the deepest human emotions. He was also an innovator who created a new space by breaking away from the central perspective in use since the Renaissance. This new framework gives more powerful expression to the person in the foreground, and the painting provokes a feeling of unease in the onlooker.

1. *Tête de la douleur,* 1882. Bronze.
22×22.4×26.8 cm. Musée Rodin. S.1127.

2. *The Scream,* undated. Bronze.
25.2×28.7×18.9 cm. Musée Rodin. S.1126.

3. *The Scream,* Edvard Munch, 1893. Distemper on board.
83.5×66 cm. Oslo Museum.

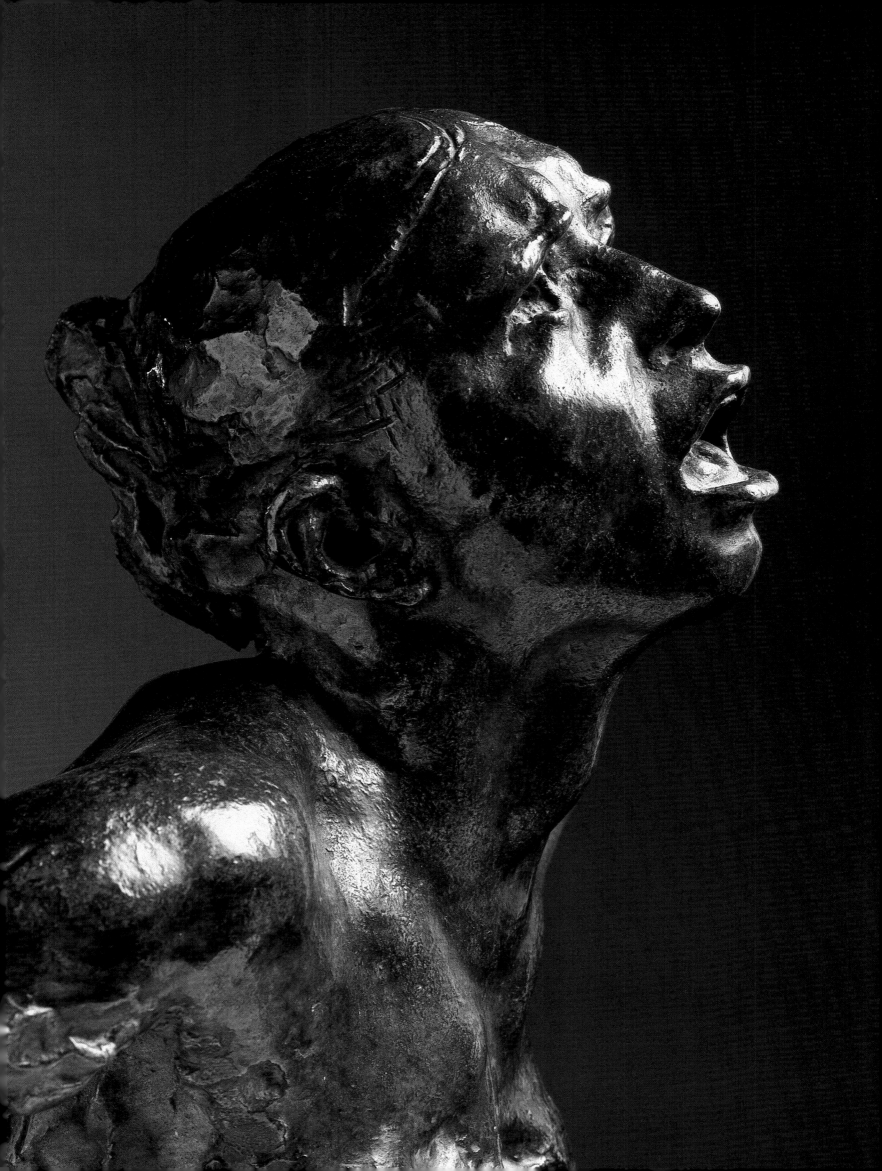

The Kiss of 1886 is no doubt Rodin's most famous work, and the one least representative of his art. The group, which was intended for *The Gates of Hell,* is a representation, faithful to the text of the *Divine Comedy,* of Paolo and Francesca. It illustrates the following passage: "One day, for our delight, we read of Lancelot, how love constrained him . . . When we read how that fond smile was kissed by such a lover, he kissed my mouth all trembling. We read no more that day." *The Kiss* was enthusiastically received by the public when it was first exhibited, particularly at the 1898 exhibition, where the marble was first shown. Some of them, who did not know the story of Paolo, thought that Rodin was depicting his contemporaries, and were shocked by the nudity. *The Kiss* established Rodin's reputation as an erotic sculptor.

"The eyes are under the illusion of seeing the movement taking place."

Rodin withdrew the group from the *Gates,* wishing, according to Rilke, "to remove anything that stood out too strongly to submit itself to the gigantic ensemble", and he confessed: "no doubt the entwinement in *The Kiss* is pretty enough, but the group meant nothing to me. The theme is treated in the academic tradition; a subject complete in itself, but cut off from the world that produced it." Commenting on the pose of the seated lovers, Paul Claudel said, "He is sitting down as if to dine off her and make the most of his opportunity. He has seized her with both hands and she is doing her best to 'deliver the goods', as the Americans say." What is one to make of this description from a writer who is not objective? In fact, Paolo is not holding Francesca's body with both hands. He even seems to be resisting, and it is the young girl who is taking the initiative. After the consummation of their love, Paolo and Francesca find themselves in Hell, chained together for eternity. In the bronze *Fugit Amor,* Francesca is shown beneath Paolo, whilst in the *Gates,* Paolo comes towards the onlooker, trying to bring back Francesca who this time is above him.

"*Painting and sculpture can make people move . . . And sometimes they can equal the theatre by showing in a picture, or even a sculptural group, several scenes succeeding one another.*"

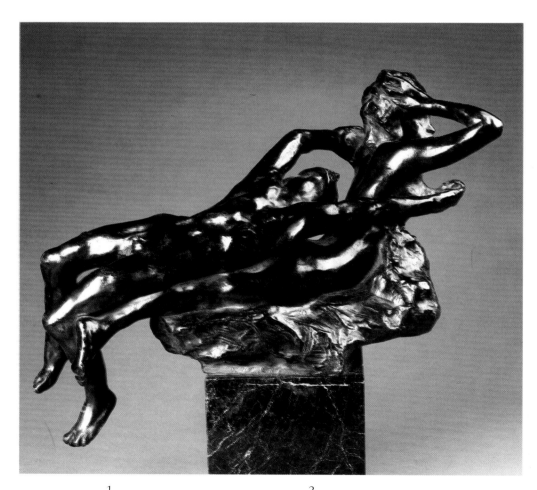

1
Fugit amor. Rodin confided to Dujardin-Beaumetz: "When figures are perfectly modelled, they approach one another, and regroup by themselves . . . I have copied two people separately; I assembled them and that was enough; the union of the two bodies produced *Paolo and Francesca.*"

2
This group, *The Kiss,* was supposed to be part of *The Gates of Hell.* It appears to have been begun in 1880-1, but the first version was shown only in 1886. The French government financed the marble which was shown at the 1898 Salon, a few yards from the *Balzac* which was to cause such scandal.

1. *Fugit amor,* 1887. Bronze. 38×48×20 cm. Musée Rodin. S.598.

2. *The Kiss,* 1886. Marble, 183.6×110.5×118.3 cm. Musée Rodin. S.1002.

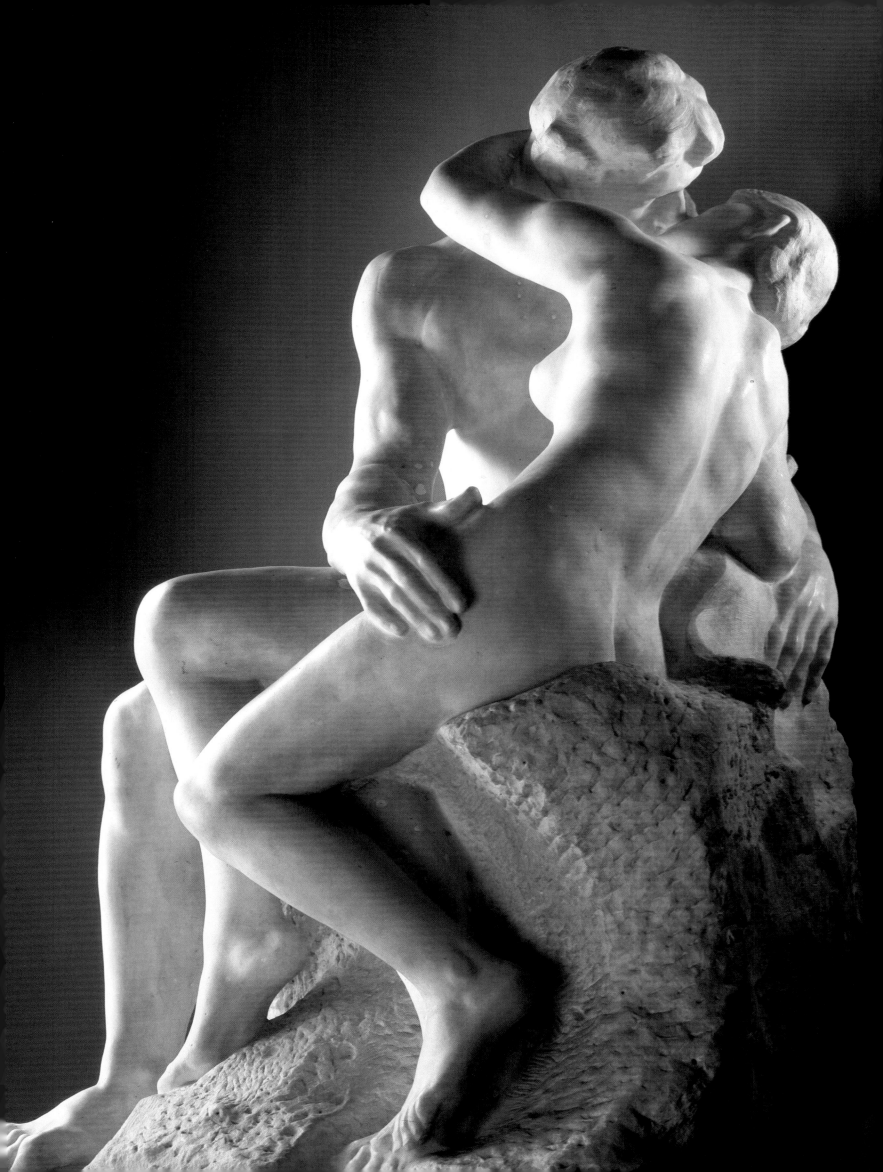

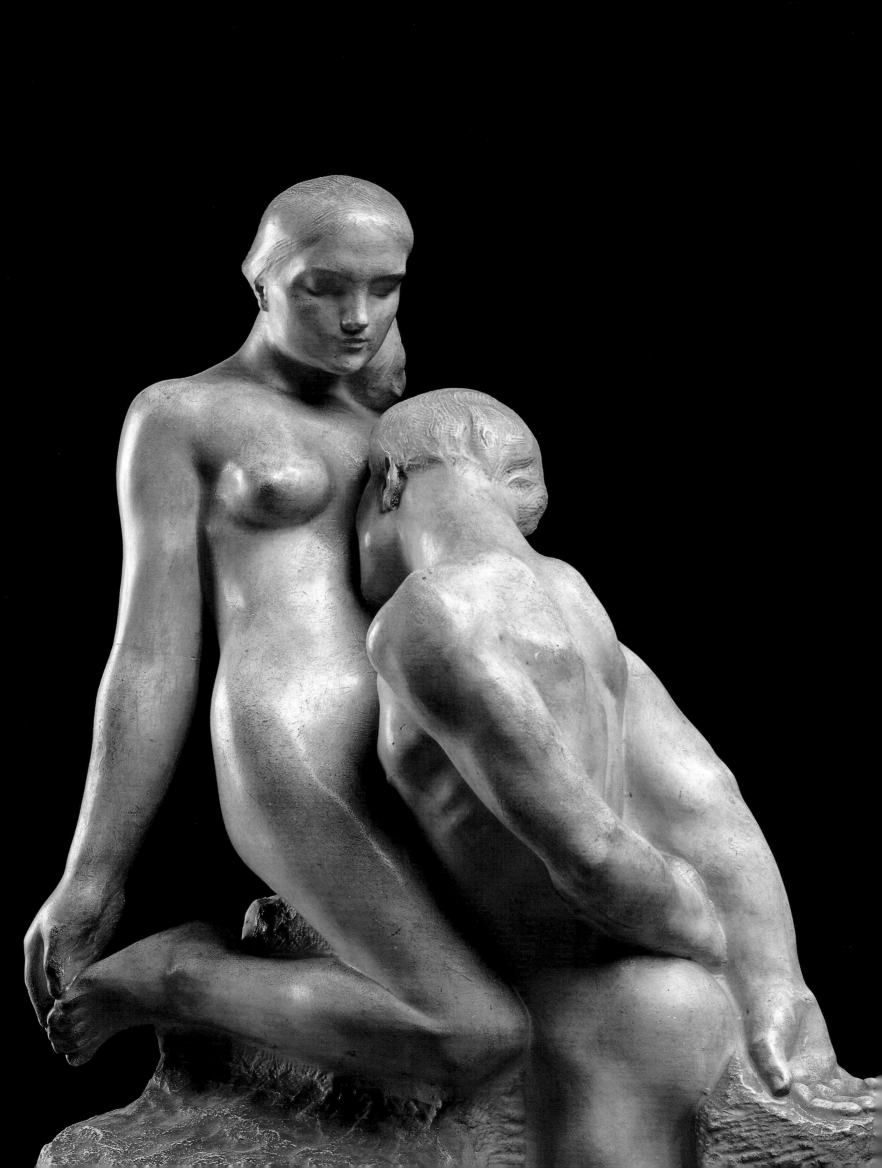

1
Rodin was probably inspired by Géricault's *Kiss* for his series of groups on Paolo and Francesca da Rimini. But this is closer, in its action, to *La Jeunesse Triomphante* of 1894.

2
This 1889 marble, *The Eternal Idol*, can be seen as a response to Camille Claudel's *Sakountala*. It was also destined for *The Gates of Hell*, but it was removed from the final assembly, perhaps because Rodin thought it too gentle and sensitive.

3
This *Baigneuse accroupie* (1888), which differs from *The Eternal Idol* both in technique and inspiration, is one of Rodin's many studies of movement and the female body.

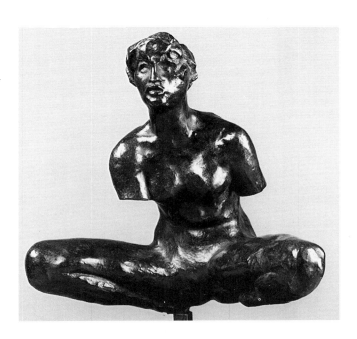

1. *The Kiss*, by Géricault. Thyssen-Bornemisza Foundation.

2. *The Eternal Idol*, 1889. Plaster. 73.2×59.2×41.1 cm. Musée Rodin. S.1044.

3. *Baigneuse accroupie*. Bronze. 22.5×23.4×14.1 cm. Musée Rodin. S.644.

In 1888, Camille sculpted a gentle and sensitive group, the *Sakountala*, also called *Vertumne et Pomone*, or *L'Abandon*. Her brother Paul describes it like this: "In my sister's group, the spirit is everything; the man is on his knees, he is pure desire. With his face raised, he breathes and embraces, before daring to touch, this marvellous being, this holy flesh which has descended to him from a higher sphere. She surrenders, blind, dumb, weighed down by this Love . . . One cannot imagine anything that could be more passionate and yet more chaste." This description was making the contrast with *The Kiss* of 1886, but *The Eternal Idol* would very much resemble *L'Abandon*. Rodin, here, would be Camille's pupil. It was a year since Rodin had rented the Folie-Neubourg, a year during which Camille sculpted the *Sakountala*, which Rodin echoed with *The Eternal Idol*. This group, along with *The Kiss* and *Eternal Spring*, was intended for *The Gates of Hell*. Like the others, it represented Francesca and Paolo, the damned lovers. Deeply moved by this sculpture, Rilke wrote: "There is the same magical strength in the rise and the fall. A young girl is on her knees. Her beautiful body is folded back . . . One cannot give it one meaning. It has thousands."

"For the artist, life is infinite pleasure, perpetual delight, wild intoxication, because he walks always in the light of spiritual truth."

Thus, Rodin re-expressed tenderness and fragility, but at the same time, he could show a woman's body with the boldest of lines. The *Baigneuse Accroupie* is the very image of womanhood, powerful and vigorous, with perfect forms and a masculine face. Her daring position is attenuated by the mutilated arms. This statue opened the way to other sculptures, in which Rodin twisted and dislocated bodies in order to create movement; it also opened the way to the erotic drawings, and the ones of dancers. The gentle and sensitive and even chaste *Eternal Idol* was to give way to Sapphic couples, both in his watercolours and his sculptures.

Rodin, over the years, built up a collection of antiquities, which would be part of his gift to the State. But the main importance of these *chefs-d'oeuvre* of sculpture from the past was their role in stimulating his own development. Already, at the age of fifteen, he used to visit the Louvre and admire the masterpieces there: "I often went up there ... to admire the Titians and the Rembrandts. But alas! I did not have enough money to buy canvas and tubes of paint. But to copy the antiquities, I needed only paper and pencil. So I was forced to work solely in the basement rooms, and I soon conceived such a passion for sculpture that I could think of nothing else." When he assembled figures into different groups, his passion for his antique sculpture often led him to include his predecessors' works with his own.

1
This photograph shows the sort of *assemblage* that Rodin was fond of: his own work joined with that of the ancients.

"I won't quite say that a woman is like a landscape that changes with the movement of the sun; but the comparison is almost right."

2
Degas often showed women in daring situations, often in position more grotesque than gracious. This ferocity was most often aimed at women drying themselves after a bath.

Thus he fixed a little plaster figure inside an antique bowl, making it, for his purposes, into a basin, with a bit of plaster overflowing from it, like a drapery. Later, he had this object turned into marble by his *praticien,* Mathet, who produced a rather tamer version. This *Petite Fée des eaux* stands up well to the pastels of Degas, a misogynist painter, who liked audacious settings and unusual positions. He turned his pitiless gaze on women washing themselves, catching them at the moment when a graceful position turns to the grotesque. What was, for Degas, "a coarse fat frog", was, for Rodin, an object of passion; he liked to pose the female body, without ever putting it in a vulgar position. This *Petite Fée* was described by a journalist: "In his studio at the Dépôt des Marbres, Rodin has just completed a charming allegory of springs . . . In her white marble basin, *The Spring,* a young girl, almost a child, is crouched. With a highly supple movement, she leans towards the spectator, serene and curious at the same time . . ."

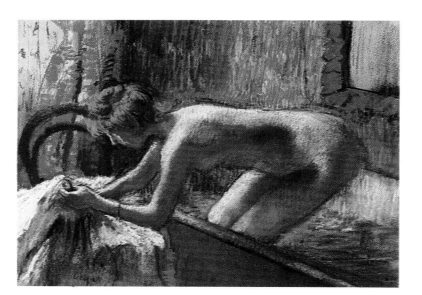

1. Assembly. Plaster and antique. 15×12.6×20.9 cm. Musée Rodin. S.343.

2. *Femme sortant de bain,* Degas, 1886-8. Pastel. 28×38 cm. Gibson Collection.

3. *La Petite Fée des eaux,* 1903. Marble. 42.2×61.6×66.3 cm. Carbon photograph by Bulloz. Musée Rodin. PH.1303.

3
This *Petite Fée des eaux* was the result of assembling a plaster woman and an antique bowl. Georges Grappe, who did the Meudon inventory, suggested 1890 as the date, but it seems that the marble was made in 1903.

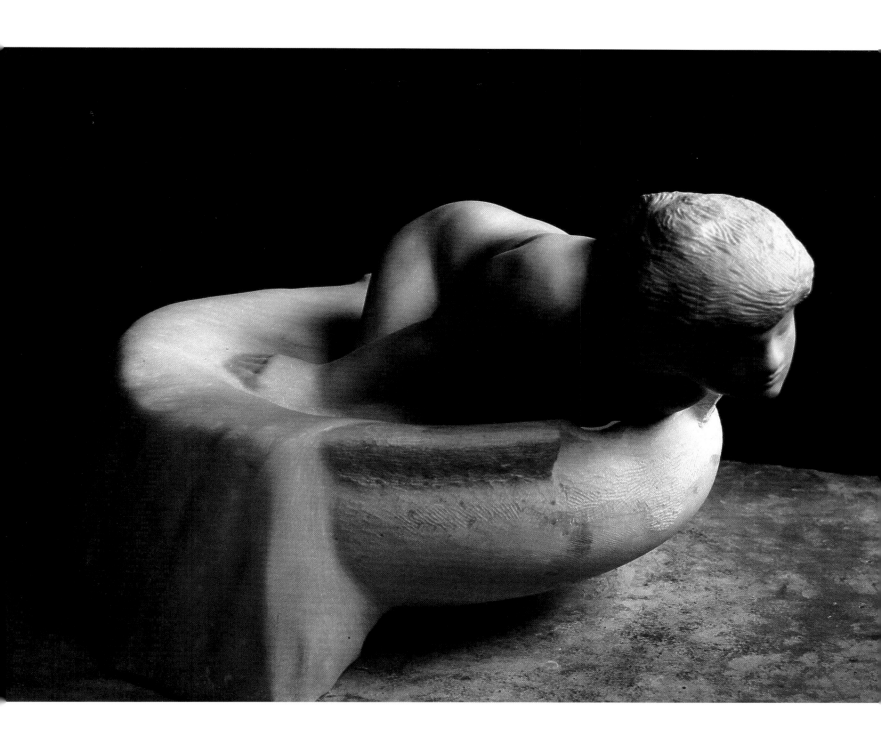

On 5 October 1889, there was a rush of Parisians towards the butte Montmartre: the Moulin-Rouge had just opened. People went there to dance, but also, which was new, to watch the show. The *tout-Paris* flocked there to see the "Gambilleuses". The artists appearing at the Moulin-Rouge had exotic stage names: Grille d'égout (gutter cricket), Nini-pattes-en-l'air, la Môme Fromage, Jane Avril, Valentin le Désossé and the famous Goulue, all of whom captured the imagination of a young painter, Toulouse-Lautrec. One finds in Rodin, too, the same theme of wild joyful dancing. Neither artist wished to show the complicated and sophisticated steps of classical dancing – they were more interested in the *joie de vivre* of the popular dances. Toulouse-Lautrec, a cripple, was celebrating the exuberant movement denied to him by his infirmity. Rodin saw it as an extension of nature, and produced *Iris, messagère des dieux*. This muse was part of a group of female figures surrounding Victor Hugo in the original plan for the monument. It was a repetition of the position of the 1890 figure, *Despair,* in *The Gates of Hell*.

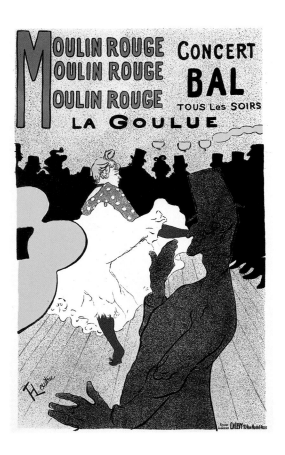

1
In October 1889, an establishment opened in Montmartre which was to become famous throughout the world: the Moulin Rouge. People came to see the "Gambilleuses" with their exotic names: Nini-pattes-en-l'air, Grille d'égout, and the merry Goulue, whom Lautrec painted several times. The Moulin Rouge poster was made in 1892.

2
Rodin gave *Iris, messagère des dieux* the more provocative title of *Eternal Tunnel.* It was also proposed to make the sculpture without its head or its left leg.

3
The movement of this curious 1890 *Figure volante* seems to flow quite naturally from that of *Iris, messagère des dieux.*

"I only want to represent what is shown to me spontaneously by nature."

The figure is seated, curled up, holding her foot in her right hand. Rodin must have liked this position because he repeated it several times: here all idea of despair has gone. On the contrary, Iris is open wide, with her leg thrown forward, revealing her sex. Rodin was aware of her provocative nature, and liked to give her other more evocative names, such as the "Eternal Tunnel". Always ready to develop a theme in several versions, Rodin, in the same year, produced a *Flying Figure,* very similar to *Iris.* The two sculptures seem to be trying to become lighter and leave the ground, which is why Rodin puts them on one leg, ready to fly away. This work on the flexed body, followed immediately by extension, prefigures the dancers, although their appearance only materialised with Rodin's discovery of Loïe Fuller, Isadora Duncan and, most important of all, Nijinsky.

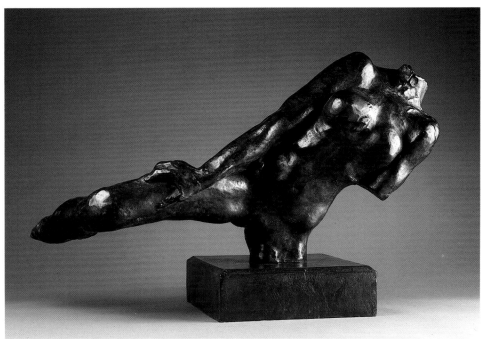

1. *La Goulue at the Moulin Rouge,* Toulouse-Lautrec, 1891. Lithograph. 192×122 cm.

2. *Iris, messagère des dieux,* 1890. Bronze. 48.4×38.6×21.1 cm. Musée Rodin. S.970.

3. *Figure volante,* 1889-90. Bronze. 52×76×31.6 cm. Musée Rodin. S.786.

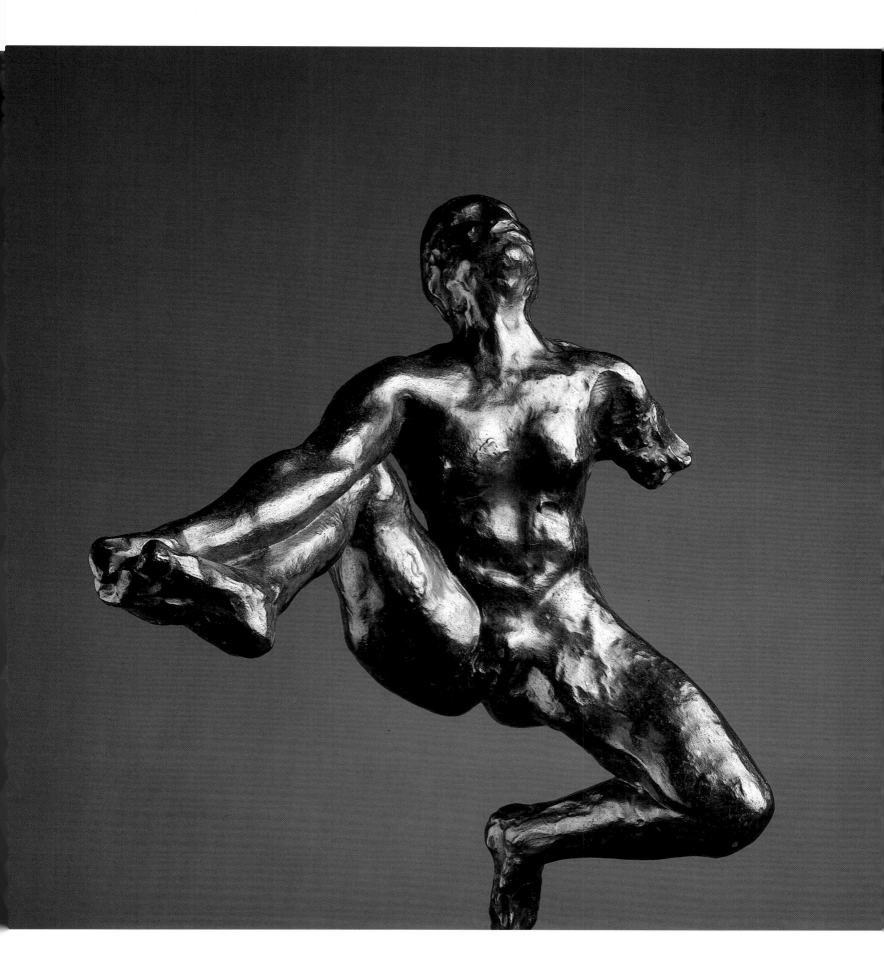

In 1886, Rodin was commissioned to make a statue of Victor Hugo, who had died the previous year. He was chosen in preference to the sculptor Dalou for two reasons: his talent was already recognised, and he had already made a bust of Victotr Hugo in 1883. The poet, although often asked, had always refused to sit, and Rodin was forced to base his work on numerous rapid sketches. In 1886, he had already decided what he would do: he would have Victor Hugo sitting on a rock, surrounded by muses. He went to Guernsey to absorb the atmosphere, just as later he would go to Touraine, in search of his *Balzac*. The commission wanted to see Rodin's work, and suggested that he might paint on canvas a life-size picture of the monument, so that they could judge what it would look like in the Pantheon. Rodin agreed, and it was a disaster.

However, the project was not completely abandoned. In 1891, Rodin obtained permission for his Victor Hugo to be placed in the Luxembourg Gardens. The group was to be composed of muses of a sensuality hitherto unknown in Rodin's work, something which certainly would not have displeased the author of the *Contemplations;* the most suggestive of these was *Iris, messagère des dieux*. In 1893, Rodin had to work on a group more suited to the wishes of the committee. This time, Victor Hugo was shown standing, with naked sirens worshipping at his feet, and a muse stroking his forehead. When the group was shown, in 1897, a critic voiced the opinion of the committee: "the *Victor Hugo* was no more than a broken-up, incoherent maquette, about which it was too early to give any judgement". In 1903, his enemies had not given up, and reproached him, not only for the Victor Hugo, but also for the large income he obtained from State commissions which they said he never delivered – which was false. At any rate, the *Seated Victor Hugo,* "silencing the public outcry" was unveiled on 30 September 1909, not in the Luxembourg Gardens, but in those of the Palais-Royal.

"The first time I saw Victor Hugo I was deeply impressed; his eye was magnificent; he had a terrifying expression . . ."

The unveiling of the *Seated Victor Hugo* took place on 30 September 1909 in the gardens of the Palais-Royal, not the Luxembourg as had been planned. Here, in the final version, Victor Hugo is shown alone, without the Muses whose sensuality had so shocked the members of the commission.

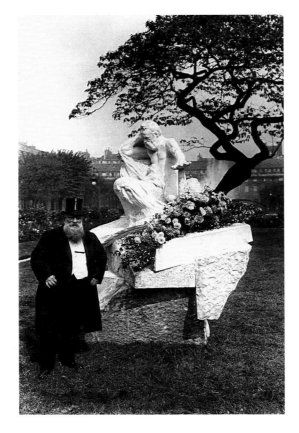

1
This monument to the author of the *Châtiments,* was produced in Serravizza marble for the statue, and Carrara marble for the pedestal. This work, which deteriorated with time, came to the Musée Rodin in 1935.

Rodin was photographed here in Guernsey, where Victor Hugo went into exile in 1855. Walking in the poet's footsteps on the island, as he did later in Balzac's in Touraine, enabled Rodin to absorb the atmosphere necessary for his creation.

1. *Bust of Victor Hugo,* 1897. Bronze. 70.6×61.5×56.8 cm. Musée Rodin. S.1070.

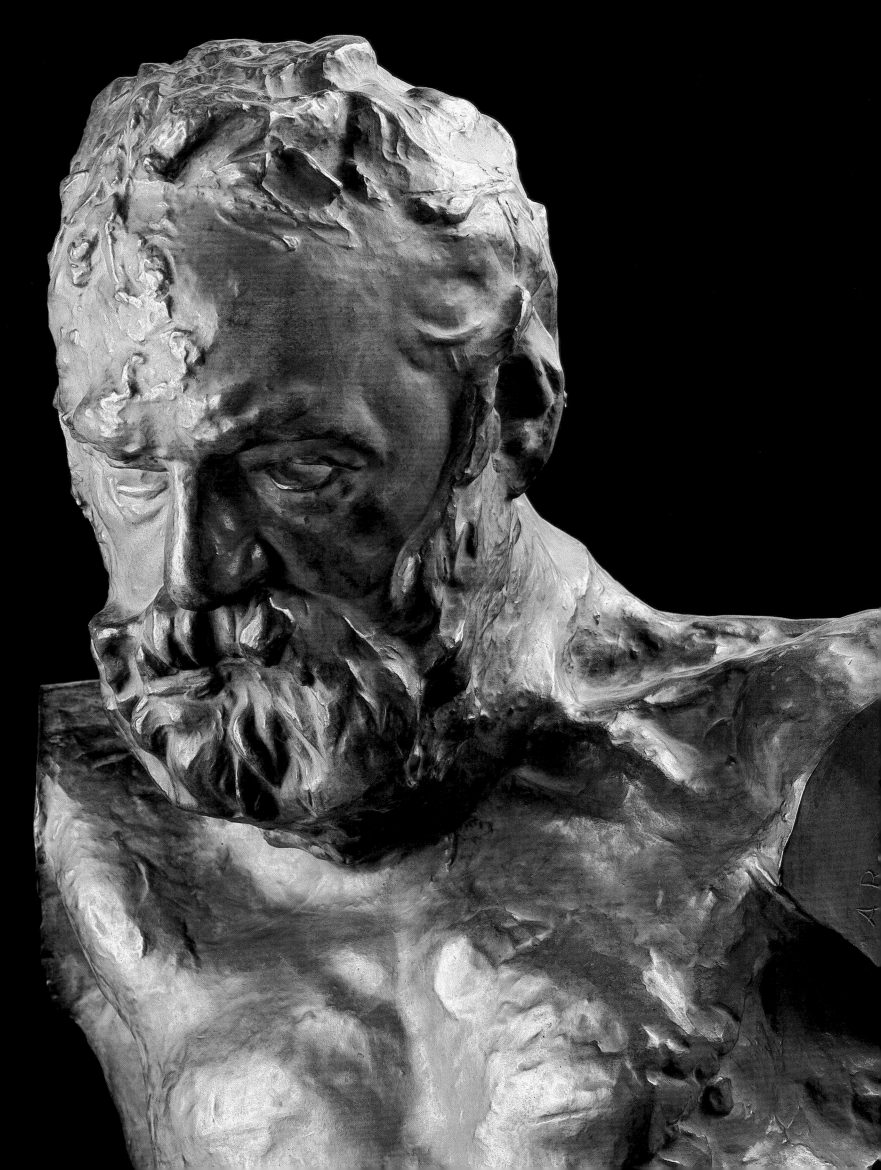

Rodin had just been asked by the Society of Literature to make a statue of Balzac; this was thanks to the influence of its President, Emile Zola. He threw himself enthusiastically into the project from 1881 to 1893. But when, in 1893, the committee wanted to look at Rodin's work, it was not ready. The displeased subscribers called in the lawyer, Alfred Duquet. When they had visited Rodin's studio, in June 1893, their immediate reaction was that the statue was shocking and indecent. Zola supported Rodin and obtained a reprieve until 1895. The subscribers demanded a second visit, and this time the *Balzac* was judged to be "a shapeless mass without name, a colossal foetus . . ." Duquet obtained an injunction that the *Balzac* should be delivered within twenty-four hours. Aicard, Zola's successor as President of the Society, managed to get this delayed to a fortnight. Rodin explained, by letter, that he fully intended to complete the work and that he would deposit the 10,000 francs that had been advanced to him at the Caisse des Dépôts et Consignations. The committee could then have its money back if it was not satisfied. Aicard, depressed by all the wrangling, resigned, followed by seven other members of the committee. This all took place during the height of the Dreyfus affair; most of Rodin's friends were Dreyfusards, and he felt uneasy, not wishing to take any part in it himself. In 1898, Rodin showed *Balzac* and *The Kiss* at the Salon in the Galerie des Machines, at the Champ-de-Mars. Balzac was greeted with sneers and catcalls, and called a "mental aberration". However, the young sculptor Bourdelle, who was among the crowd, was heard to exclaim: "There, he is showing us all the way!"

"It is the culmination of my life's work."

The exhibition at the Palais did however bear fruit, and produced buyers amongst both collectors and admirers. The great names of the time started a subscription, and soon collected 3000 francs. But Rodin did not want to be "saved" by anyone, and withdrew the *Balzac* from the Salon, shutting it away in the garden at Meudon.

1
Rodin worked in close collaboration with photographers. This pen drawing is probably done from the photograph of the statue. Rodin often used this method which allowed him to redraw the subject and send the drawing to the press.

2
This famous photograph of the statue was taken by the young photographer Edward Steichen. He had seen a picture of the *Balzac* in a Milwaukee newspaper, and, fascinated, decided to go there and then to Paris, "where artists of Rodin's stature live and work". An exceptional series of photographs resulted from the collaboration between the sculptor and the photographer.

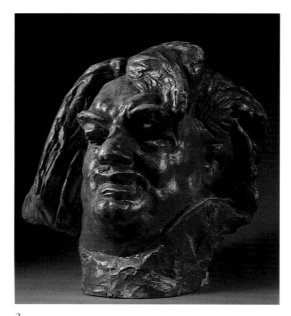

3
Years after leaving the Sèvres factory, Rodin still remembered the techniques he had learnt there. He called in great ceramic makers, Chaplet in 1891, Lachenal in 1895, Jeanneny in 1903, to carry out his work. This head is in painted and varnished sandstone. Made alongside a *Bust of Jean d'Aire*, one of the Calais burghers, it was sent to the Saint Louis Exhibition in the United States, in 1904.

1. *Study, Balzac. c.* 1898. Pen drawing. 27.7×16.7 cm. Musée Rodin. D.5329.

2. *Balzac in the garden at Meudon.* 300×120×120 cm. Photograph by Steichen, 1897. Musée Rodin. PH.226.

3. *Balzac,* head, 1904. Varnished sandstone. 42.2×44.6×38.2 cm. Musée Rodin.

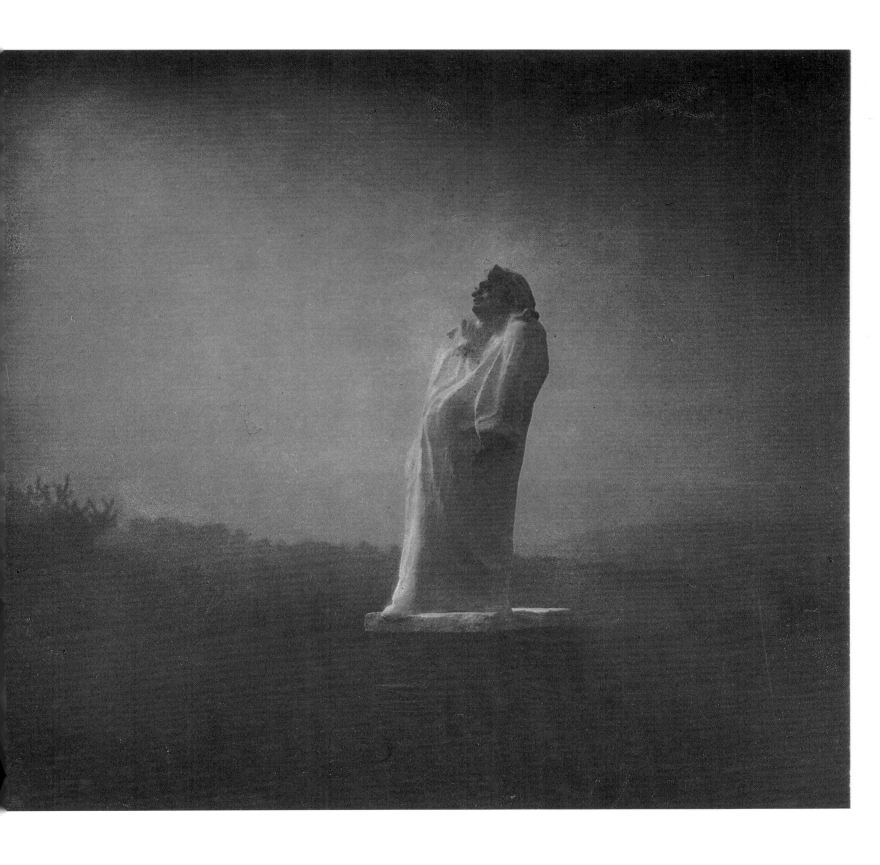

The twentieth century came to an end. Rose was always there, vigilant in the background. She still looked after Rodin's work, as she had done when he was in Belgium. He relied upon her to moisten the clay, and to look after the studio. In 1886, he wrote to her from England, where he was with Camille: "I am thinking of you, and I feel comfortable, knowing that my work is in your hands, do not wet it too much and feel it with your finger." Elsewhere, he reproaches her: "I do not understand how you could have let the model do the damping, when I told you to do it. I do not want the model coming every day to look at the clay." Rose was his privileged listener, especially as she herself remained dumb, contenting herself with preserving the letters of the man whom she referred to all her life as "Rodin" or "the Master". As Rodin became more and more famous, his letters to his mistress increasingly took the form of notes. All through these years, Rose, with unshakeable loyalty, suffered all the humiliations that Rodin inflicted on her: his sexual conquests, his passion for Camille, his constant absences. Camille, for her part, wanted to dominate Rodin's life and his art, unconsciously forcing him to re-examine himself, which he could not bear to do.

Rose is occupied with some small sewing task, Auguste chooses drawings. A glimpse of an apparently calm and happy life. But Rodin wrote: "This photograph is deceptive". How many torments had passed through Rose's life, how many women through Rodin's.

1
In 1890, Rodin sculptured Rose for the last time. She was forty-six, he was fifty.

2
This photograph shows the collaboration between Rodin and his *praticiens*. In the background one can see Rodin's plaster moulding, and in the foreground, the marble executed by Bourdelle.

"My dear Rose, I am coming back to you this evening."

By 1893, Rodin had separated from Camille. He settled with Rose at Bellevue, and then permanently at Meudon, in the Villa des Brillants, a suburban villa with a view over the Seine and Saint-Cloud. Meudon soon became Rose's territory, and there are many photographs showing the couple dining or out in the garden. Rodin looks the picture of a happy and serene *bon viveur*, whereas Rose seems sour and bitter, prematurely aged. Rodin made a last bust of Rose in 1890, when she was forty-six, and, much later, had it finished by his *praticien*, Bourdelle, who completed the marble. Rodin gave it to Rose in 1898. In 1916, at the time that Rodin's work was given to the State, Rose also donated the bust. Rodin had returned to his old campanion, about whom Octave Mirbeau had said: "Oh! Just a little laundry girl, quite unable to communicate with him."

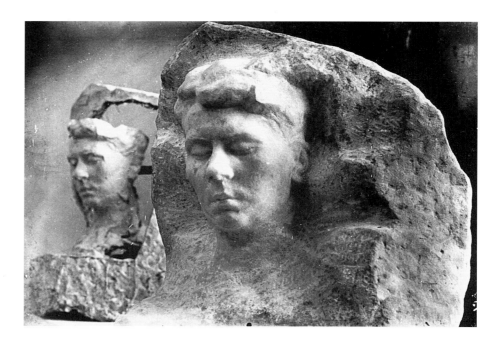

1. *Bust of Rose,* 1890. Plaster. Musée Rodin. Ph.2047.

2. *Bust of Rose,* 1890. Marble. 47×40×50 cm. Photographed in 1890. Musée Rodin.

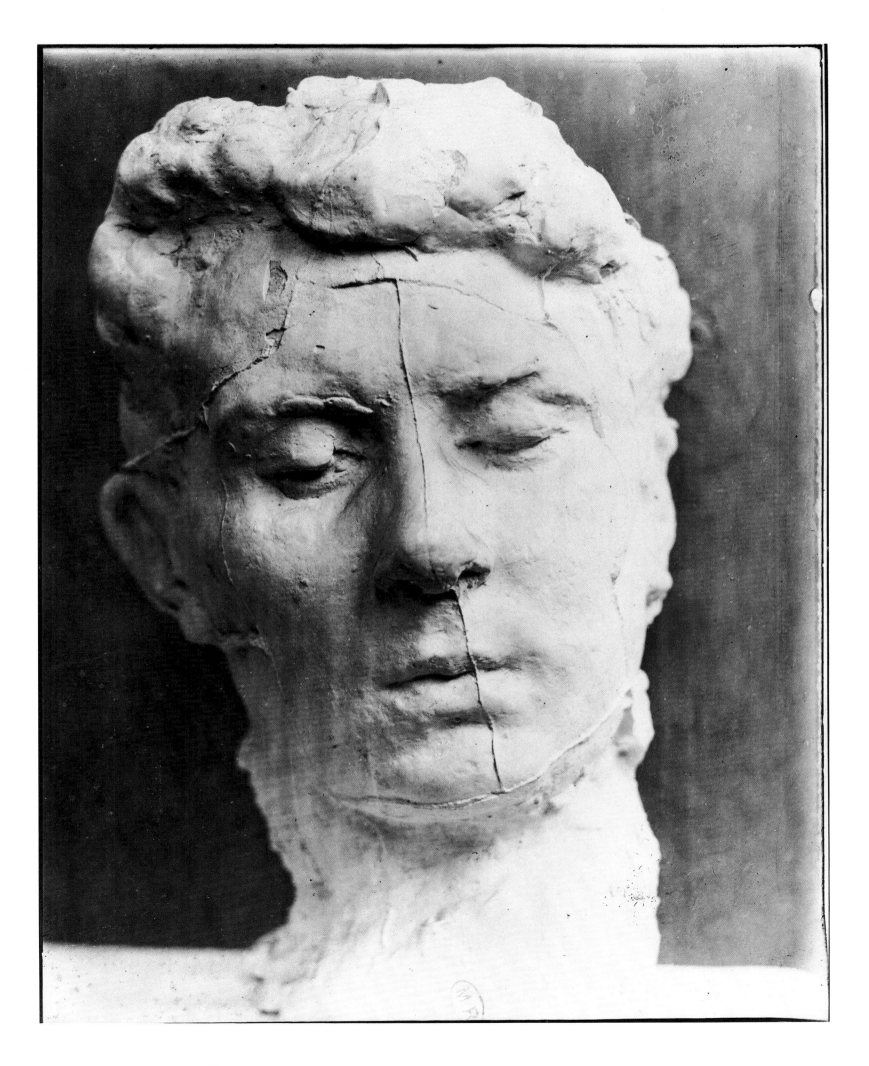

Rose, at last

The break between Rodin and Camille Claudel came in 1892. Rodin had sculpted *L'Adieu,* a sort of assembly of Camille's face and two hands, on a block of wood, the whole thing held together by a scarf. Was Rodin missing the passion and the creative force that Camille inspired in him and, like Orpheus with Eurydice, would his search for her lose her altogether? Camille no longer wanted an unfaithful Rodin; she wished to be recognised as his wife and as an artist. Rodin certainly tried to help her, but each attempt placed Camille in an unbearable position of dependency. Rodin confessed once: "I no longer have any authority over her." Camille, whose psychosis was beginning to be apparent, called on Mathias Morhardt: "If you could . . . delicately and tactfully persuade M. Rodin not to come and see me any more, you would give me the greatest possible pleasure."

Perhaps Camille did want to succeed on her own, without owing anything to Rodin, but what made her hide in the bushes at Meudon, trying to catch a glimpse of him? He wrote to her again, using Lebosse, his *praticien,* as an intermediary, asking her opinion about *Balzac.* It seems that their liaison began again, and it is even possible that Rodin, rather late in the day, in 1904, asked her to marry him. It was probably at this time (the dates are not certain) that Rodin undertook *La Convalescente,* a work inspired by *L'Adieu.* In 1932, Eugène Blot, a patron and dealer, wrote to Camille, telling her of a visit Rodin had made to him, and his shock at the sight of her statue *L'Implorante:* "I saw him . . . gently stroking the metal . . . and crying . . . Yes, crying like a child."

1
Orpheus enchanted all human beings with his music and his poems. He loved Eurydice and, when she died, he went down to the underworld to implore the guardian Hades to give him back his loved one. He agreed to do so on condition that Orpheus did not turn around on the return journey to look at Eurydice. But Orpheus, despite his protestations, could not resist the temptation to turn and look at the object of his love. Eurydice then disappeared for ever. Rodin sculpted this group around 1893, and it is now in the Metropolitan Museum, New York.

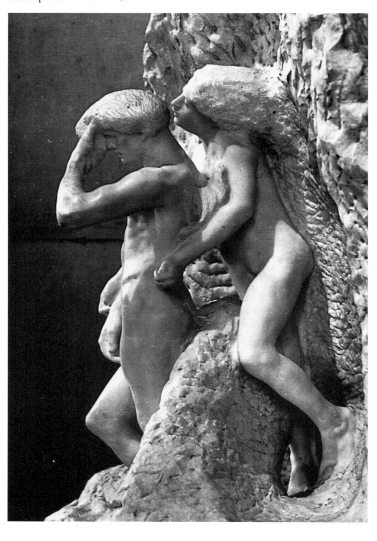

"Everybody seems to think that Mlle Claudel is my protégée, when in fact she is an unappreciated artist."

"Truly, reality, he only ever loved you, Camille, I can say it now. All the rest, those wretched adventures, that ridiculous society life, for somebody who was basically a man of the people, it was all just an outlet for his excessive energy . . . Time will put everything in its proper place."

1. *Orpheus and Eurydice,* c. 1893. Marble. 127×76 cm. Metropolitan Museum, New York.

2. *La Convalescente,* 1892 or 1906. Marble. 49×74.1×55.4 cm. Musée Rodin. S.1016.

1
La Convalescente is directly inspired by *L'Adieu* (1892). It seems from an inventory card that it was struck in marble by the *praticien* Matruchot in 1906.

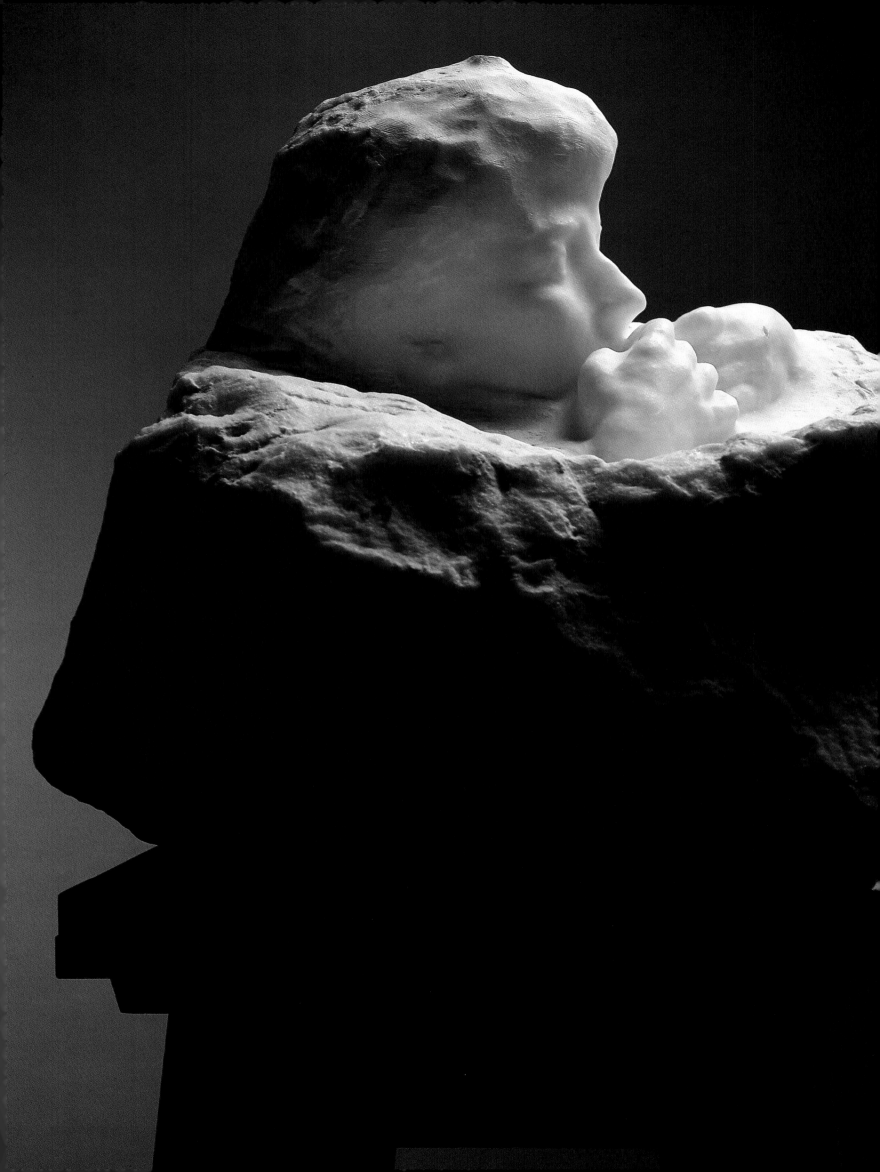

2
The Villa des Brillants in Meudon, where Rodin lived from 1897 onwards. On the left the Pavillon de l'Alma, rebuilt on the property after the 1900 exhibition.

2
Anonymous photograph of Rodin at work, around 1900.

3
Festivities on the Seine during the Great Exhibition.

4
In 1899, Captain Dreyfus was condemned to ten years, imprisonment, and loss of rank. During his trial in Rennes, the soldiers formed a "hedge of shame", turning their backs on him. Dreyfus was rehabilitated in 1906.

5
The Pavillon de l'Alma, which, in 1900, held Rodin's one-man exhibition.

1900

6
Blériot crossed the Channel by plane in 1909.

7
Beneath the Eiffel Tower, "the great grasshopper", during the 1900 exhibition.

8
1900 calendar by Czech painter Alfons Mucha, one of the originators of art nouveau.

9
The iron cladding of the métro station "Place Saint-Michel", before the tunnelling.

10
On 29 December 1901, Henry Fournier broke the speed record in a Renault, at 112 km/h.

11
A métro station designed by Hector Guimard.

In 1900, a young Austrian poet arrived from Russia, and settled at Worpswede, an isolated artists' colony in Lower Saxony. There he married in 1901 a dark-haired German girl, Clara Westhoff, who knew Paris and had met Cézanne. The young couple needed money, and, in 1902, Rainer Maria Rilke arrived in Paris to write a commissioned book on Rodin, whose fame was spreading through Europe. In September of that year, he presented himself at the door of the studio in the rue de l'Université. He wrote immediately to Clara: "Yesterday, Monday, at three o'clock in the afternoon, I went for the first time to Rodin's house . . . He was kind and gentle. I felt as though I had always known him. His forehead and nose look as though they are carved from stone. His mouth speaks with a good, young, approachable sound . . . I like him very much, I felt it straight away." Rodin, highly flattered at being the subject of a book, invited Rilke to Meudon. He described Rose thus: "Tired, irritable, nervy, her appearance neglected." About dinner with the Master, to which he was invited: "We had hardly sat down at the table when Rodin began complaining of the lateness of the meal; he was already dressed to go into town." Embarrassed that Rodin should reprimand Rose in the presence of a complete stranger, Rilke wrote: "This scene was not painful, just sad." After he finished his work, Rilke did not see Rodin until 1905, when he visited him at Meudon, and was hired as the sculptor's secretary. That year, Wanda Landowska played the harpsichord for Rodin in the garden at Meudon – he was dazzled by so much attention.

Rilke arrived in Paris in 1902 to meet Rodin and write a book about him, and became his secretary in 1905; despite their quarrel in the following year, he always remained a faithful friend to Rodin. In 1908, he introduced him to the Hôtel Biron.

Wanda Landowska, the famous harpsichordist, played for Rodin in the garden at Meudon in 1905.

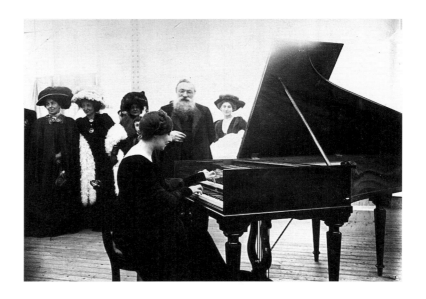

Rilke did his job well, particularly as he held Rodin in great respect. And yet in May 1906, Rodin sacked him for no very clear reason. It may have been the duchesse de Choiseul's interference, for as soon as she became part of Rodin's life, she began to alienate his friends. Rilke continued, however, to give lectures throughout Europe on the Master's art, and Rodin, touched by this, resumed his correspondence with him. Rilke, a perceptive writer, had clearly understood Rodin's work and his genius: "Rodin was a solitary man before he became famous. And fame has made him even more solitary. Because fame, after all, is no more than the sum of misapprehensions which gather around a new name."

"I am confident in the fine work that you are good enough to devote to me."
(Rodin to Rilke)

1. *Entwined Sapphic couple,* c. 1900. Graphite, woodcut, watercolour and gouache, on paper. 23×24 cm. Musée Rodin. D.4052.

Rodin
M.R
405

For the Great Exhibition of 1900, Rodin decided to show his work separately, and built the Pavillon de l'Alma for this purpose. As well as his sculptures, Rodin hung drawings and watercolours which brought blushes to the cheeks of the right-thinking *bourgeoises*. They were of tenderly entwined lesbian couples, and nudes in daring positions. The bourgeoisie of the time, snubbed by the nobility it was trying to ape, had set itself severe moral standards, and virtue and morality were strenuously enforced. Divorce was then considered a disgrace, and children were brought up to respect institutions, particularly that of marriage. But if the ideal young girl had to be without a stain, her suitor was expected to be "experienced". He would have frequented such creatures as these, and "seen life". One can imagine what the reactions must have been when confronted by Rodin's completely uninhibited nudes. This *Woman Undressing*, like several sculptures before 1900, is reminiscent of Degas. The sculpture, commissioned by an enlightened patron, the industrialist Maurice Fenaille, was intended, along with three others, to decorate the swimming pool of his Paris house. It does not yet have the provocative character of the drawings.

"I really worship the nude."

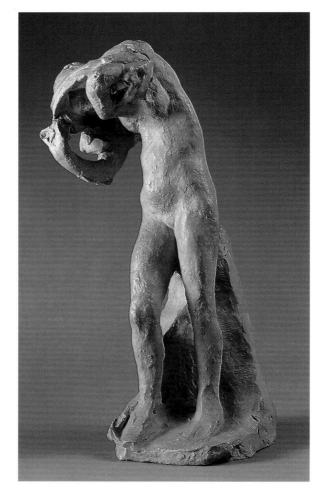

1
This woman undressing, along with three others, was destined for the swimming pool at the Paris house of industrialist Maurice Fenaille. This enlightened patron also ordered a bust of his wife in 1898, and several other works. In 1897 he also published a series of drawings by Rodin.

2
These watercolours, rapidly executed on paper, introduce a theme hitherto unknown in Rodin's work – the erotic nude. These women are certainly lascivious, far more so than the little bathers that Rodin made for his friends the Fenailles' swimming pool.

T hese began to proliferate only after 1899. They really "gushed out" after his definitive break with Camille. He had numerous sexual encounters, no doubt in order to forget Camille and free himself from her. The drawings must also be seen as a kind of artistic liberation. He was now convinced that he was an innovator, and he took on this role, unceasingly transmitting his vision of the world to the younger generation. Carving marble required great strength, modelling needed time. Drawing and painting in watercolour, on the other hand, enabled him to transfer his fantasies quickly onto paper. He worked fast, and the erotic drawings run into hundreds. They were always the drawings of a sculptor, however, as he recalled: "My sketches are the essence of my sculpture, which is drawing from all sides."

One imagines that a drawing can be beautiful in itself. But it is only beautiful through the truths and sentiments that it conveys."

1. *Woman undressing,* 1899. Terracotta. 40×13×16 cm. Musée Rodin. S.525.

2. *Woman putting on a garment, c.* 1900. Graphite and wood-cut. Musée Rodin. D.849.

Following pages:

1. *Woman lying on her side, c.* 1900. Graphite and watercolour. 32.6×25.5 cm. Musée Rodin. D.4851.

2. *Nude with hair, c.* 1900. Graphite, wood-cut and watercolour. 32.6×25 cm. Musée Rodin. D.4019.

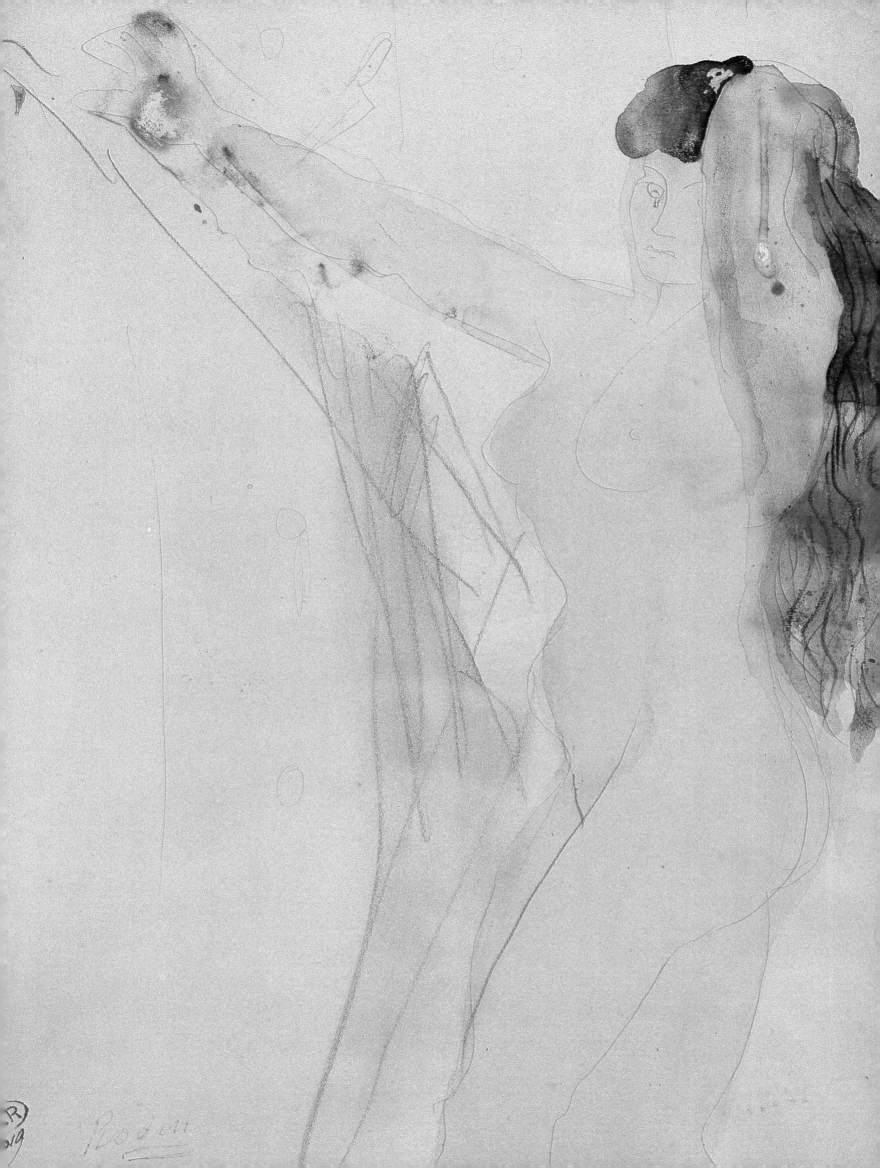

Also known as *La Création,* this group appeared in 1902. *La Main de Dieu* is shown extracting a still entwined Adam and Eve from matter. This group, of which several copies were made, was shown in Vienna, Munich and Berlin. Encouraged by his success, Rodin made *La Main du Diable* holding the woman. The technique is the same, but this time it is a left hand holding the figure. According to ancient symbolism, the left hand is the spirit of evil, the one that commits the crime. And for the symbolists of the beginning of the century, woman herself was the source of all evil. Rodin shows her as a siren, a creature who charms men.

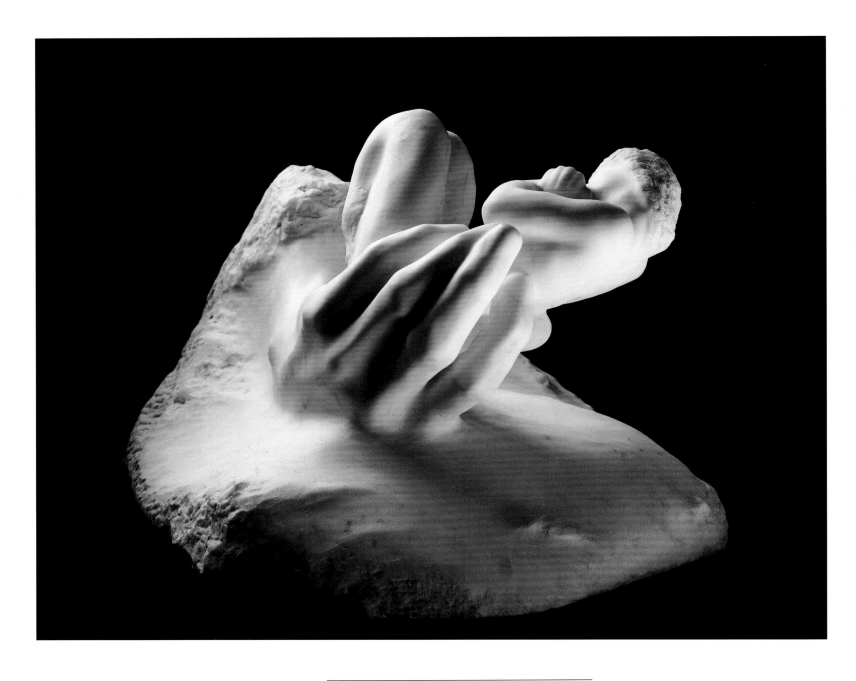

1. *La Main du Diable,* 1902. Marble. 38×64.3×53 cm. Musée Rodin. D.1107.

2. *La Main de Dieu,* 1902. Marble. 94×82.5×54.9 cm. Musée Rodin. S.988.

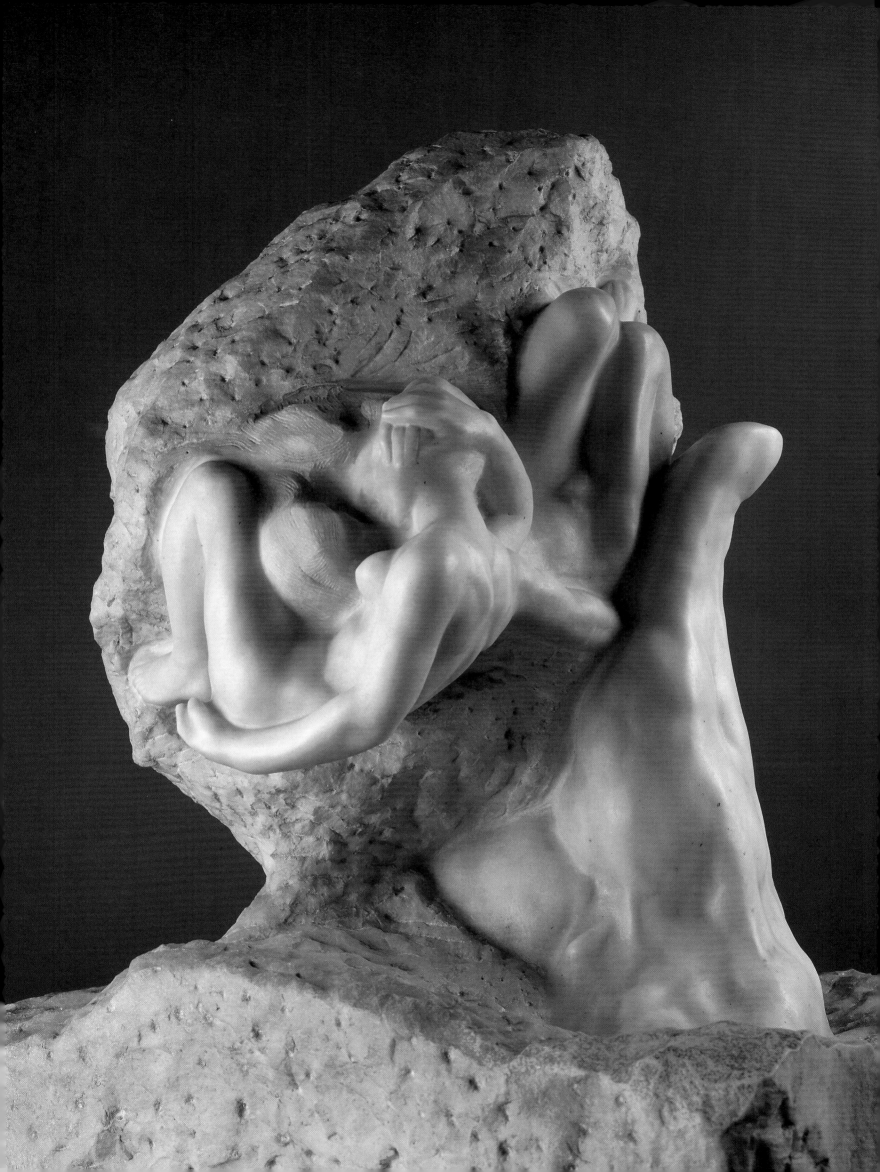

The busts ordered by high society brought Rodin the money and the contacts that he needed. The bust of *Eve Fairfax* is certainly one of the most beautiful and melancholic. Lord Grimthorpe introduced his fiancée to the artist in February 1901. Rodin wrote to her in 1904: "You still shine like the good goddesses. Even when you do not speak, your gestures, your sober expression, your desirable movements, are so expressive that they touch the soul of the artist. You know that I would be happy to see you in Paris if you are able to come, and that I am always with you, thanks to the bust which is not yet finished." For Eve Fairfax, Rodin was "a remarkable man, full of charm; a gentle man, devoted to art. We used to talk during the modelling sessions, I in broken French . . . Rodin liked me very much. He found me refreshing because at the time he was very popular and many French women were running after him. I think I appealed to him because, unlike most other women at the time, I was not prepared to jump into bed with him at every occasion". Nevertheless, the order for the bust was cancelled; Rodin did not abandon the project, however – he completed the bust and entitled it *L'Amazone*. This old photograph adds to the melancholy of the bust. Rodin said: "The statue is transformed by the effect of light, like anything else which has volume; the atmosphere imposes successive changes."

"How flat-chested they are – oh those planes and the bony structure of these Englishwomen."

"For the work, it is important to get as close as possible to the truth; the colours adjust and spread themselves on their own, they play on the actual shapes, therefore on the exact contours. Light separates, breaks up, decomposes and destroys false shapes, but when it falls on a faithful piece of modelling, it gives it a life-like character and appearance."

Rodin said of Eve Fairfax:
"A Diana and a satyr in one."

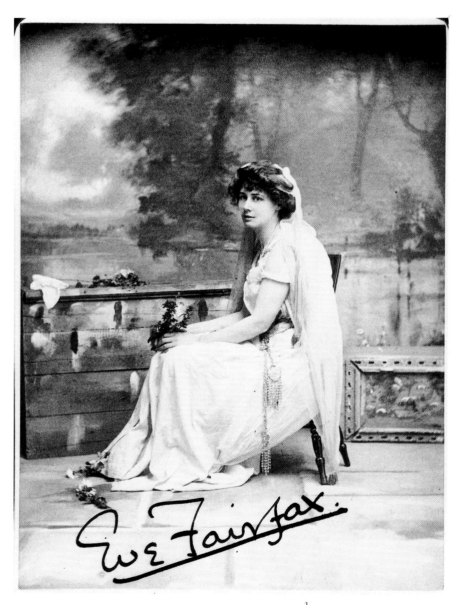

1
Eve Fairfax. This photograph by Bulloz contributed to Rodin's success as a portrait-sculptor. He was never content with merely modelling surfaces; what he sought to do was to "portray the soul".

1. *Eve Fairfax,* 1905? Marble. Photographed by Bulloz.

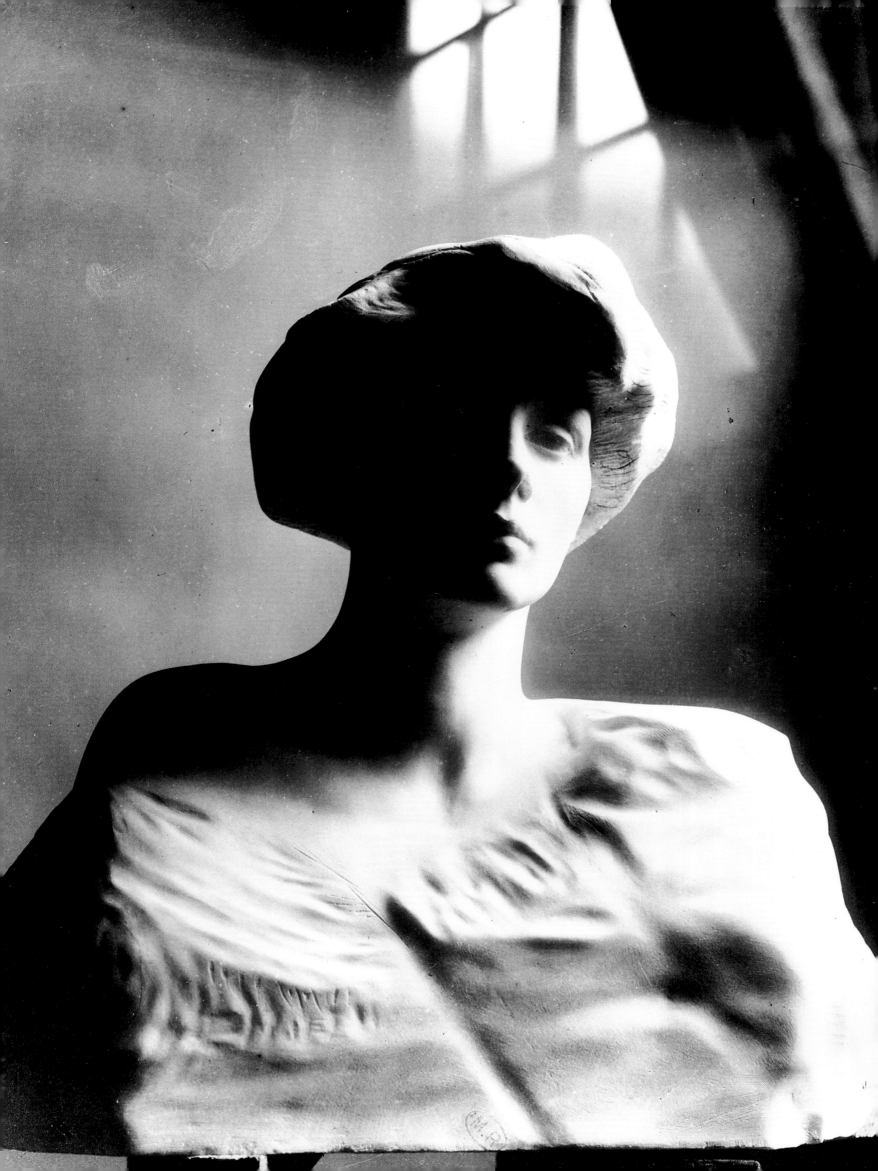

odin had been installed at Meudon since 1897. The property had a charming view over the Seine and the valley of Saint-Cloud, although the house itself was described by Rilke thus: "It is not a beautiful villa; there are three windows on the front, walls of red brick with yellow piers, a steep grey roof, high chimneys." Yet Rodin liked to wander around his property like a sultan: "Every morning I go out and admire a new country, the railways puffing out smoke, the little mists. And one can feel infinity. And to think that one can paint all that, that one can do anything by nurturing one's talent." Rodin, installed like a living god in his temple at Meudon, would show people round his studio. But he did not neglect promotion tours of Europe. He travelled and took part in conferences and in 1902 attended an exhibition of his work in Prague; in the same year he met Isadora Duncan whose ballets fascinated him. He saw natural movement in her dances, a celebration of nature. Elsewhere, he said of her: "Ah! If only I had had models like that when I was young!" And it is true that in those days he knew only classical dancing. In 1903, Isadora Duncan danced in Rodin's honour in the woods of Vélizy. She was also on the point of surrendering to the sculptor's charms: "How often have I regretted this

The duchesse de Choiseul, an American who had married the duc de Choiseul, came into Rodin's life in 1904. With her great *joie de vivre,* she flattered Rodin's vanity, subjugated him and alienated his most faithful friends and *praticiens.*

Rodin, seen here in a carriage, went to Prague for the exhibition of his work, from 10 May to 10 August 1902, in the Manes Pavilion in the Kinsky gardens. There were eighty-eight sculptures and seventy drawings in the exhibition.

Isadora Duncan, a friend and neighbour of Rodin's, danced for the master in the Vélizy woods. The young American woman and Loïe Fuller were the inspiration for the last major theme of Rodin's life – dance.

childish incomprehension which lost me the divine chance of giving my virginity to the Great God Pan himself, to the mighty Rodin." Another woman, who would have no such hesitation, was the duchesse de Choiseul who came into Rodin's life in 1904.

1. Female figure inverted on another. Plaster. 35.2×21.7×20.6 cm. Musée Rodin. S.2122.

1
This *assemblage* is the fusion of two sculptures that had already been seen in Rodin's work. The inverted figure is one of the three sirens on the left-hand panel of *The Gates of Hell.* The figure underneath is a single sculpture entitled *Polyphème.*

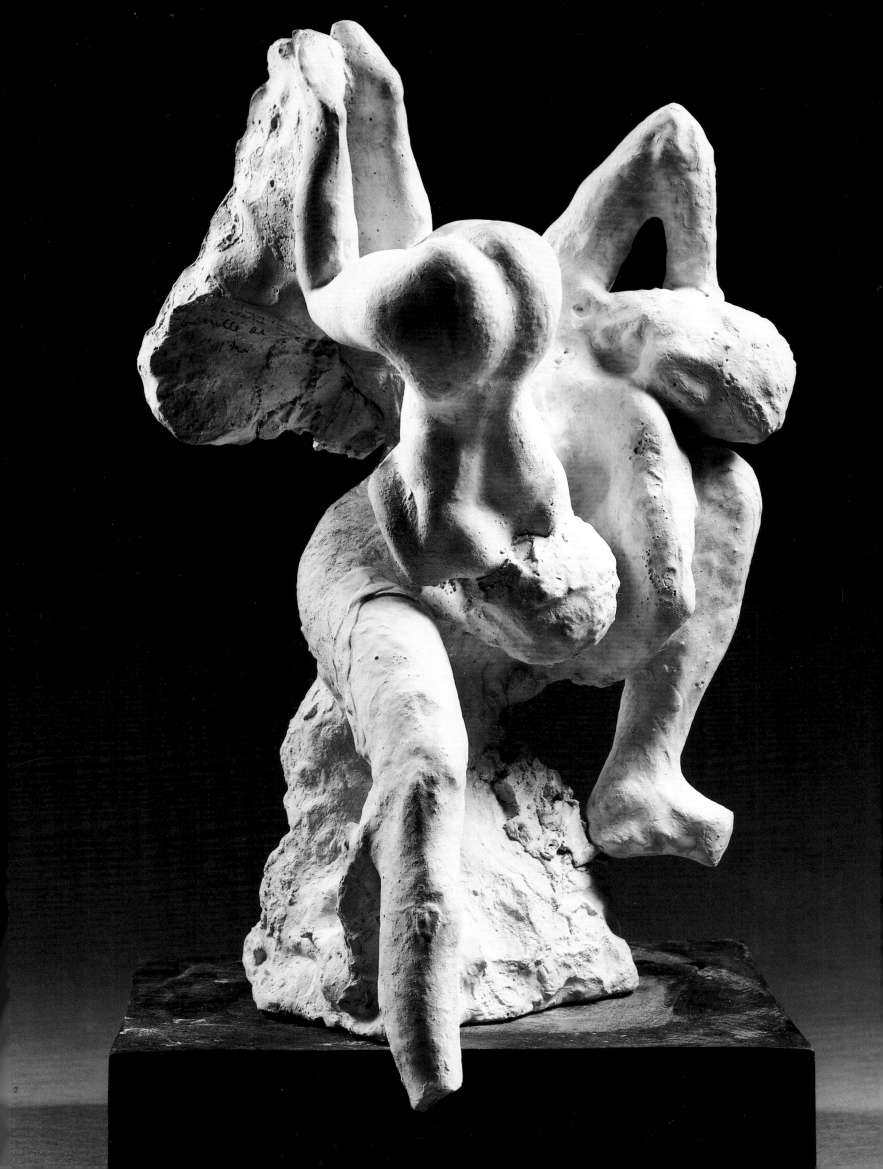

In 1906, Rodin experienced a revelation when he discovered the Cambodian dancers. They were accompanying the king of Cambodia on an official visit to the Colonial Exhibition at Marseilles. Rodin saw them performing at the Pré-Catelan in Paris and was dazzled. He had never seen such small dancers, with supple bodies able to bend to every demand of the ballet. This new form of expression inspired him to some beautiful watercolours. Charmed, he followed the ballet to Marseilles, getting the little dancers to pose for him. He wrote to a friend: "I have come from Marseilles, where I have been drawing the Cambodians. I have found things completely new to me, and seen that nature is larger and more varied in shape and ideas than one could ever have thought, and that the soul can adapt to different forms of worship." Later, he explained to a journalist why he had been so bowled over by these dancers: "These Cambodian girls have shown us all that antiquity can hold, their own antiquity, which is as good as ours. In the last three days we have had a glimpse of three thousand years ago. I have never seen human nature brought to such perfection."

The Cambodian dancers pose for this photograph. Directed by the eldest daughter of King Sisowah, Princess Soumphady, the ballets deeply impressed Rodin, and he produced a great many sketches and studies of the little dancers.

Rodin followed the ballets to Marseilles, in order to be able to continue drawing them. He was unable to attend the departure of the delegation, as he was obliged to take to his bed: "I was going to work on the boat and attend the departure of these incomparable, admirable artistes . . ."

"I drew with infinite pleasure the little Cambodian dancers who came to Paris not long ago with their king. The tiny movements of their agile limbs were strangely and marvellously seductive."

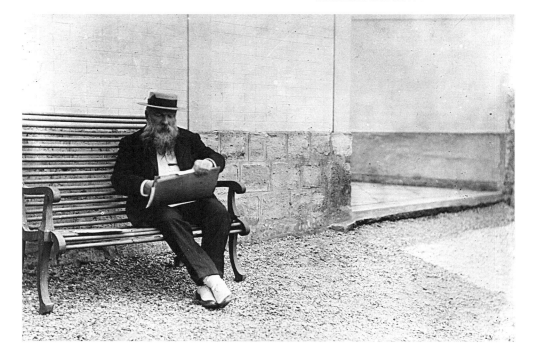

Rodin painted movement. In his drawings, the colour sometimes overflows the line, giving a three-dimensional effect. Searching for the effect of movement, he developed a technique of sticking paper in layers to convey it; in this as in other things he was anticipating the work of Matisse and Picasso.

1. *Study of Dancers,* 1906. Graphite, pen, watercolour, gouache on paper. 23.7×35.5 cm. Musée Rodin. D.4517.

Following pages:

1. *Cambodian dancer,* 1906. Graphite and greasepaint. 30×20 cm. Musée Rodin. D.4429.

2. *Seated Cambodian dancer,* 1906. Graphite and gouache. 31.3×19.8 cm. Musée Rodin. D.4428.

*"I gazed at them in ecstasy . . .
What a gap they have left! . . .
I followed them to Marseilles;
I would have followed them to
Cairo!"*

Rodin made a quantity of studies
of the Cambodian dancers. Their
suppleness and grace continued
to inspire his work on the theme
of dance, right up to his death.

M.R
4428

Rodin had sacked his secretary, Rainer Maria Rilke, and he wrote to his friend Hélène de Nostitz: "I will not come because I have quarrelled, through my impatience, with Rilke. He is a faithful friend." The faithful secretary continued nonetheless with his lectures on Rodin and his work. In 1907, the correspondence between them began again: "But what I have missed most painfully," wrote Rilke, "was not to be able to visit you at Meudon to gather strength from your work, and hear your own words ... You have, more than you may think, entered into the mystery of the Cambodian dances." In the following year, Rilke discovered in the rue de Varenne a magical place of the sort Rodin liked, a private house to rent in the centre of Paris, surrounded by greenery, built between 1728 and 1831. Rilke's wife had installed herself in the old cloister of the house, which was let as a studio. The two men renewed their old friendship thanks to the Hôtel Biron: Rodin became the tenant of the State, and Rilke became Rodin's sub-tenant.

"Truly,
these master-builders
were proud men!"

Others came to occupy the building: a young painter, Henri Matisse, Isadora Duncan, Jean Cocteau. Meudon and its "factory of *praticiens*" were left in Rose's care, while Isadora Duncan's pupils danced wildly in the gardens of the Hôtel Biron. Rodin was in heaven: bodies in movement all around him, which he could study. The female models still came and went, and Rodin, happy at so much attention, often succumbed to their charms. Hardly surprisingly, his reputation as a satyr increased. For the first thirty years of his life, Rodin had been short of everything: understanding, love, money, confidence. The thirty following years had been a permanent struggle to make himself recognised and understood. His money attracted women and false friends, and the son of the little police inspector often mistook the interest he aroused for signs of love and admiration.

Two years after the Cambodians, the little dancers taught by Isadora Duncan and Loïe Fuller became another subject that appealed to Rodin.

Isadora Duncan, Cocteau and Matisse all became tenants of the Hôtel Biron, as did Loïe Fuller who danced for Rodin in the gardens of the house.

1. *La Cathédrale,* 1908. Bronze. 65×30×30 cm. Musée Rodin. S.478.

1
Rodin was passionate about Gothic architecture, and it seems it was because he thought that he had discovered the source of the ogival arch in these hands joined in prayer that he called his work *La Cathédrale.*

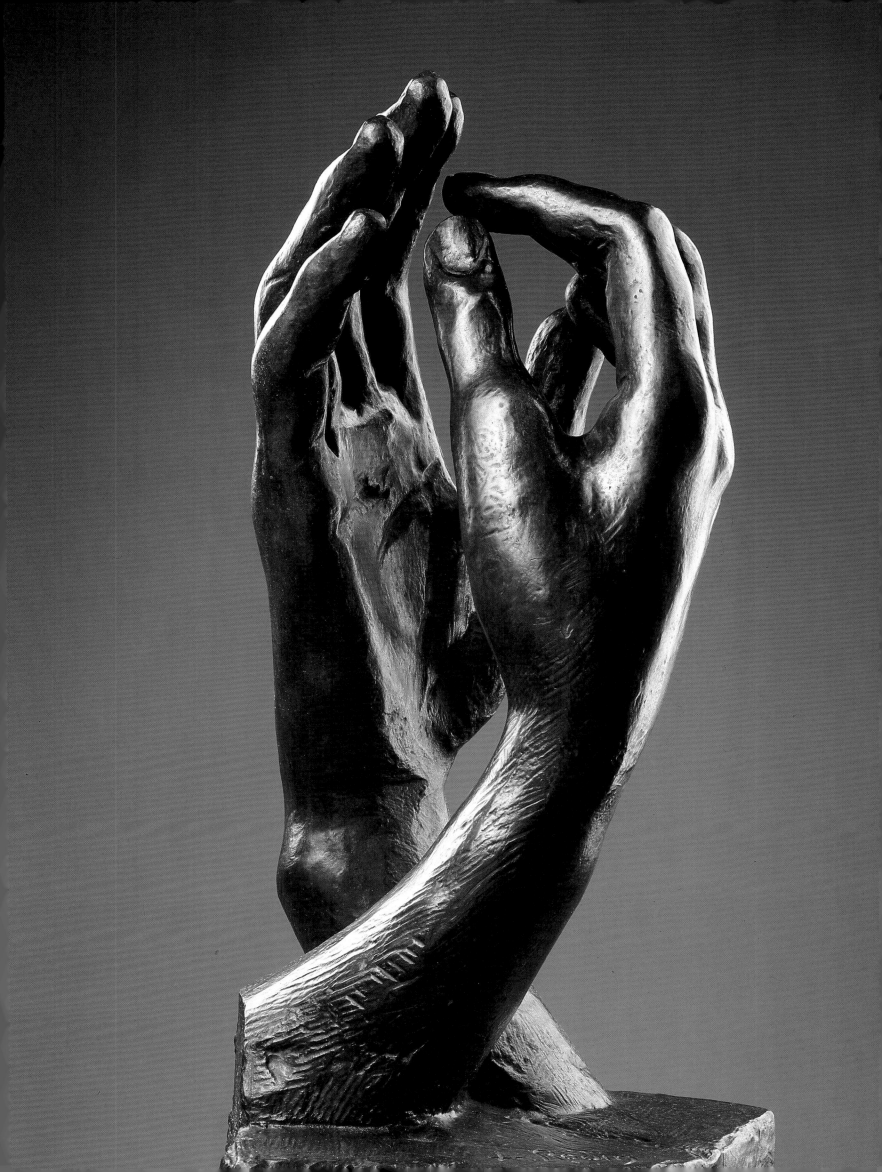

The duchesse de Choiseul was an American of French origin, married to the noble but impoverished duc de Choiseul. She came into Rodin's life in 1904, sweeping all before her, and creating a void around him. Rodin did not include her in the category of models turned "pupils" for the duration of a liaison. He called the duchesse "Madame", and she became his muse. She was no longer very young, but she had energy to spare. She was a ray of sunshine in the autumn of Auguste's life. He handed over his affairs to her. She became his secretary, and little by little isolated him from his old friends. To those who wished to see the Master, she would reply: "There is no point in disturbing him, because I am here. I am looking after everything. Rodin is me!" At the beginning of the twentieth century America was discovering Rodin, and the duchesse, a businesswoman with a flair for money, was the ideal agent for Rodin; and it is true that she was very efficient.

"Madame is a right little reveller."

The duchesse de Choiseul was certainly a good impresario for Rodin just as his work was beginning to appeal to the American market. All the same, he dismissed her in 1912.

1
La duchesse de Choiseul is a work produced jointly by the sculptor and his *praticiens*. No doubt one of them found it too difficult to carve the sophisticated hairstyle that Rodin had modelled in clay, and the bust was left as it was, the hair uncarved. The mark of the tenons remains visible, and gives the sculpture a provocative character.

She occupied the Hôtel Biron from 1908 to 1912, leaving Meudon to poor Rose. Rilke, who had once again become Rodin's secretary, observed sadly: "Each day his old age becomes more grotesque and laughable". Only Rodin noticed nothing. She had persuaded him that she was the reincarnation of his sister Maria, and that people were trying to murder him. The *praticiens* left, one by one, having, until then, sacrificed their talent to Rodin's genius. They did not want to take orders from her, and moreover, were convinced that the Choiseuls were poisoning Rodin with arsenic. This was certainly an exaggeration, although it is possible that the duchesse encouraged Rodin in his alcoholic excesses. She did, however inspire some remarkable little marble busts, in which the treatment of the hair was innovative. The duchesse's reign came to an end in 1912, when Limet, Rodin's polisher and one of the most faithful of the *praticiens,* announced that he would not work for him any longer if she remained at the Hôtel Biron. Rodin gave in to his old friend's arguments, and charged him with sending her away. An attack of hemiplegia finally brought him back to reality, and back to Rose in Meudon.

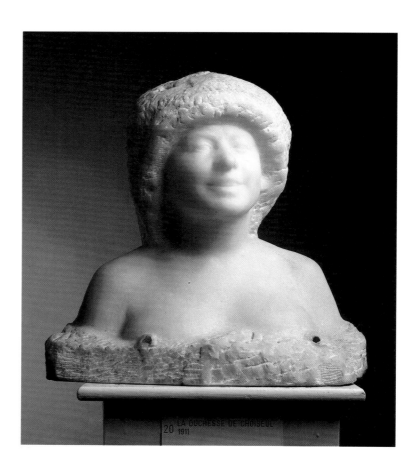

1. *La duchesse de Choiseul*, 1911. Marble. 49×50.3×31.9 cm. Musée Rodin. S.1040.

2. *Nude in profile*, around 1900. Graphite, watercolour on *papier collé. 27.2×19.1 cm. Musée Rodin. D.5234.*

2
Rodin painted erotic watercolours and used *papier collé.* The duchesse joined in this game and used to unveil her charms to the sound of a gramophone.

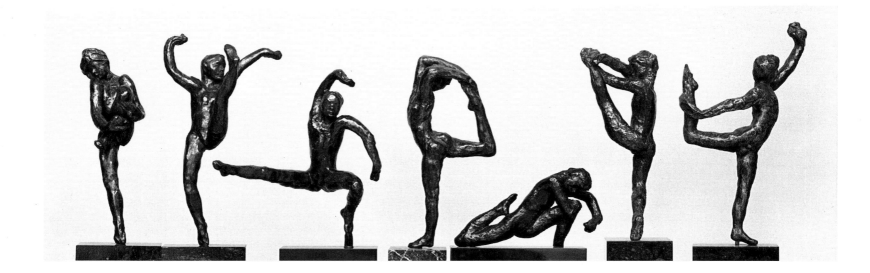

All Paris was acclaiming a young dancer in Diaghilev's Ballets Russes: Nijinsky, who had just made his Paris debut in 1909. He returned the following year to triumph once again in *The Spectre of the Rose;* at the beginning of 1912, he danced *L'Après-midi d'un Faune,* with music by Claude Debussy, which scandalised the public. Gaston Calmette wrote in *Le Figaro:* "We have seen an indecent faun, with ugly movements of a bestial eroticism, and heavily obscene gestures. There were, quite rightly, wolf-whistles at this all too expressive mime of an ill-constructed animal's body, hideous in face and even worse in profile." Rodin, on the other hand, was enthusiastic. Roger Marx published an article in defence of Nijinsky, which Rodin signed: "In dancing, as in painting and sculpture, progress has been impeded by routine rather than prejudice, by laziness and inability to renew. We only admire Loïe Fuller, Isadora Duncan and Nijinsky so much because they have rediscovered the freedom of the instincts, and a tradition based on respect for nature." But Gaston Calmette counter-attacked and declared that it was not for Rodin to judge, as someone who, "in the ancient chapel of the Sacré-Cœur, and in the empty rooms of the proscribed nuns of the Hôtel Biron, exhibited a series of libidinous drawings and brazen sketches". This struck home: Rodin, afraid of losing the lease on the Hôtel Biron, and in the clutches of the duchesse de Choiseul, disowned his signature. Roger Marx, who had lost face, tried in vain to see Rodin to obtain an explanation but was blocked by the inflexible duchess. He died the following year never having recovered from this betrayal. Rodin's sculpture of Nijinsky was, nevertheless, one of his finest creations, all movement and bulging muscles.

"This must be stopped, by court order or any other method, I have been horribly hurt; come at once and do what you can. This journalist must be satisfied with an indemnity. Your Rodin."
(Letter to Judith Cladel)

1
These dance exercises appear to date from 1910. Rodin uses here, for each figure, the principle of *Saint John the Baptist:* the transition from one movement towards another. This is what gives these figures such a lively character.

Rodin received Nijinsky and made him pose in his studio. The painter Emile Blanche recalls in his memoirs how Diaghilev found Nijinsky, prostrated by heat and drink, naked at Rodin's feet, both fast asleep.

1. *Dance movement,* 1910. Musée Rodin.

2. *Nijinsky,* 1912. Plaster. 17.3×9.9×6.4 cm. Musée Rodin. S.1185.

3. *Small head of Nijinsky,* 1912? Bronze. 6.4×3×3.5 cm. Musée Rodin. S.659.

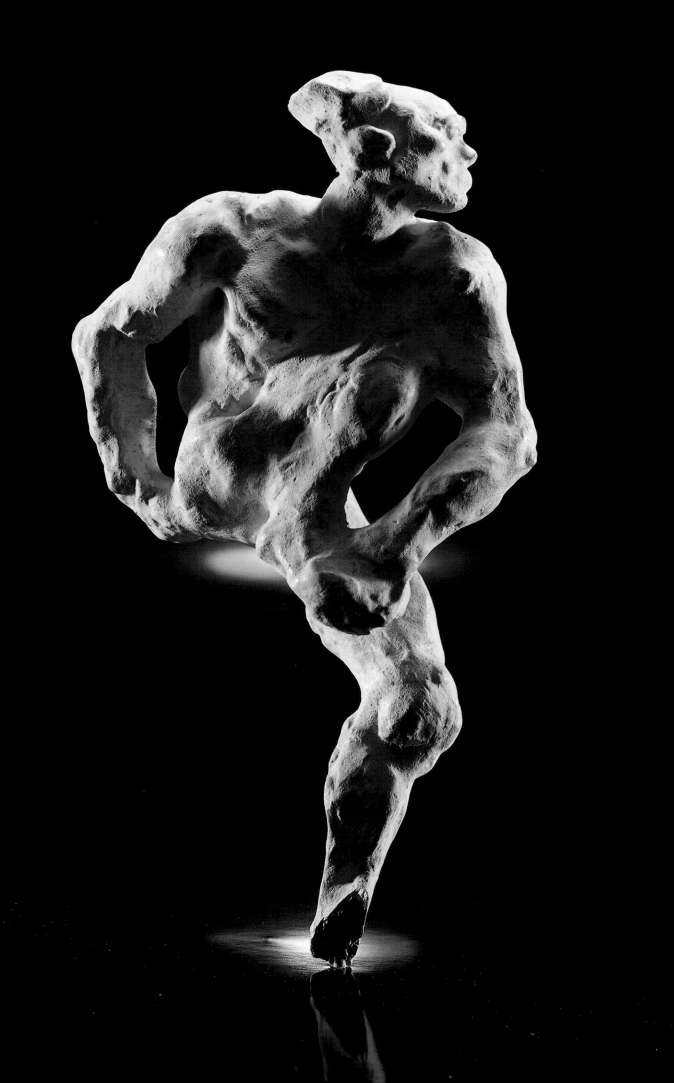

"Be truthful, young people. But that does not mean be flatly precise. There is a base kind of precision, that of photography and moulding. Art only begins when there is an inner truth. Let all your forms and colours show feeling. You, painters, observe truth in depth. Look, for example, at a portrait painted by Raphael. When he shows a person facing you, he makes the chest recede obliquely, giving the illusion of a third dimension. All painters are probing space. Their strength lies in the notion of depth. Remember this: there are no lines, only volumes. When you are drawing, do not think of the contours, only of the reliefs. It is the reliefs that determine the contours." This painting lesson of Rodin's might have been heard by Picasso. *The Demoiselles d'Avignon* (1905-7) was the result of the dual influence of sculpture and Cézanne. The women seem to be in movement, springing from the canvas. At the same time, Klimt was drawing inspiration from Japanese prints, with the asymmetrical positioning of his subjects. Rodin, too, was for a time interested in Japanese art, particularly the work of the engraver Hokusai and his "perfect masterpieces of grace, simplicity and strength". Klimt is clearly in-

1
Les Demoiselles d'Avignon (in fact the inhabitants of a brothel) expresses Picasso's protest at their condition rather than worship of the female body. This painting of 1907, in which can be found the influence of both Cézanne and Iberian sculpture, represents the beginning of Cubism.

2
Klimt, with his asymmetrical setting of *The Three Ages of Woman,* reminiscent of Japanese prints, was a great innovator, shaking the dust off Austrian art. His importance was such that he was the leader of the Secession movement.

spired by this Eastern art in his painting *The Three Ages of Woman*. Little by little, the younger artists would make use of the avenues opened up by Rodin to engage in their own experiments.

During the night of 27-28 June 1905, the sailors on board the battleship *Potemkin* mutinied in protest at the bad food, and joined the striking workers in Odessa. After trying to rally the crew of the *St George* to their cause, they gave themselves up to the Romanian authorities. This action, which shook the Tsar's regime, was immortalised in 1925 in Eisenstein's film, *The Battleship Potemkin.* Workers were demonstrating all over Europe. Here, the protesters are reading a tract. Rodin, despite the approaching storm, continued to draw and celebrate women with his Sapphic couples. Here he is on a motoring trip with Rose and a couple of friends.

The artistic revolution of the beginning of the twentieth century was the prelude to another world upheaval. Workers' demands became more vociferous, in the East the mutiny on the *Potemkin* took place, and the Great War was approaching.

1. *Les Demoiselles d'Avignon,* Picasso. 1907. Musdeum of Modern Art, New York.

2. *The Three Ages of Woman,* Klimt, 1905. National Gallery of Modern Art, Rome.

3. *Sapphic couple in profile, c.* 1900. Graphite, print, watercolour. 31.3×15.6 cm. Musée Rodin. D.5254.

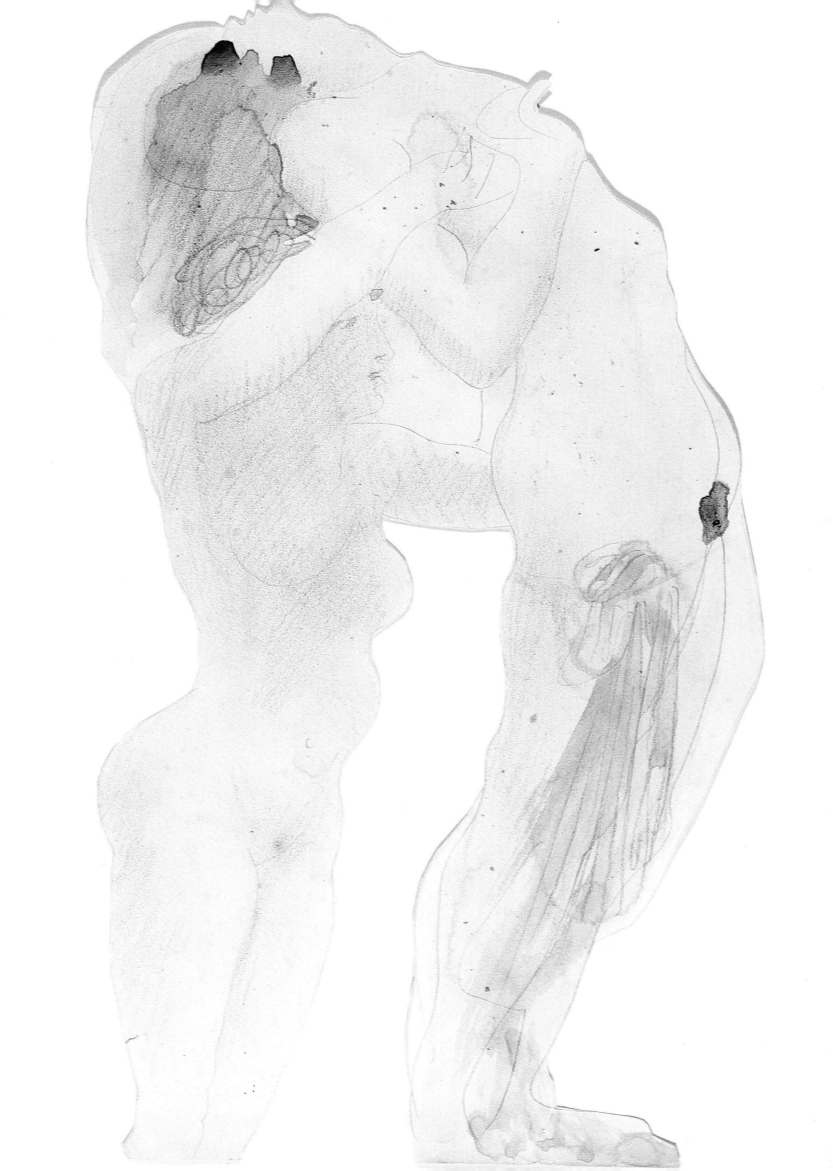

War. The French, singing *La Marseillaise* and the *Chant du Départ,* embarked on trains to the front, amongst flags and flowers. While the war machine was remorselessly grinding 1,400,000 soldiers to death, Rodin complained; Paris was threatened, but the only thing that counted for him was the museum planned in the Hôtel Biron. He fled to London in the company of Judith Cladel, but he needed medical attention and returned to Paris, where self-seeking women awaited him. Although the duchesse de Choiseul had gone, the marriage hunt continued. This time, it was the inheritance that was at stake: the women wanted to prise it from the hands of businessmen and civil servants. Rodin fled the war once again, and travelled to the South of France with Rose. Back at the Hôtel Biron, his friends had the greatest trouble protecting the Master's work. Rodin set off again for England, and then, accompanied by Rose and Loïe Fuller, he went to Italy. Albert Bernard, who directed the Villa Medici, described him at that time: "I think that deep inside him he thought that the world was too much preoccupied with the war, and not enough with him." He returned to Meudon, however, where disorder reigned, as it did at the Hôtel Biron.

1917. The French join their regiments. On the train, an anonymous hand had written "To Berlin". These soldiers never reached the German capital.

First used for reconnaissance, aviation, still in its infancy, was soon to play an active part in the war. The first decisive battle took place on 5 October 1914. The first French air squadron was formed in 1915.

"When I recall all the loving kindness I've received I feel my life has been replete, and my art, too, mingled with the living inspiration that fertilised it."

Women came and went, and he said happily of them: "My final years are crowned with roses; I am surrounded by generous women, and nothing could be more agreeable." On 1 April 1916, Clementel, the Minister of Commerce, made him sign a provisional deed of gift to the State. But there was a new attack of hemiplegia on 10 April, and fearing that the deed would not be validated in time, Rodin was made to sign a new will, leaving everything to Rose. Marcelle Tirelle, his secretary, removed his pen and ink, to prevent any "beautiful lady" from extorting a new will from him. At the urging of Loïe Fuller, Rodin married Rose Beuret on 29 January 1917. About a fortnight later, she died of broncho-pneumonia. The State was now the only heir, and the old man died, amid general indifference, on 17 November 1917. He was buried at Meudon, next to Rose, who had had to wait for death to keep him beside her.

On 29 January 1917, Rodin married Rose. The marriage took place, with exemption from the town hall, at the Villa des Brillants, in the strictest privacy. Rose died sixteen days later, and Rodin ten months afterwards.

"And that is what sums up the whole of life, this little cluster of memories; the rest, that did not stay in the mind, is like dead leaves."

1. *Rainbow.* Graphite and watercolour. 32.5×2.5 cm. Musée Rodin. D.4062.

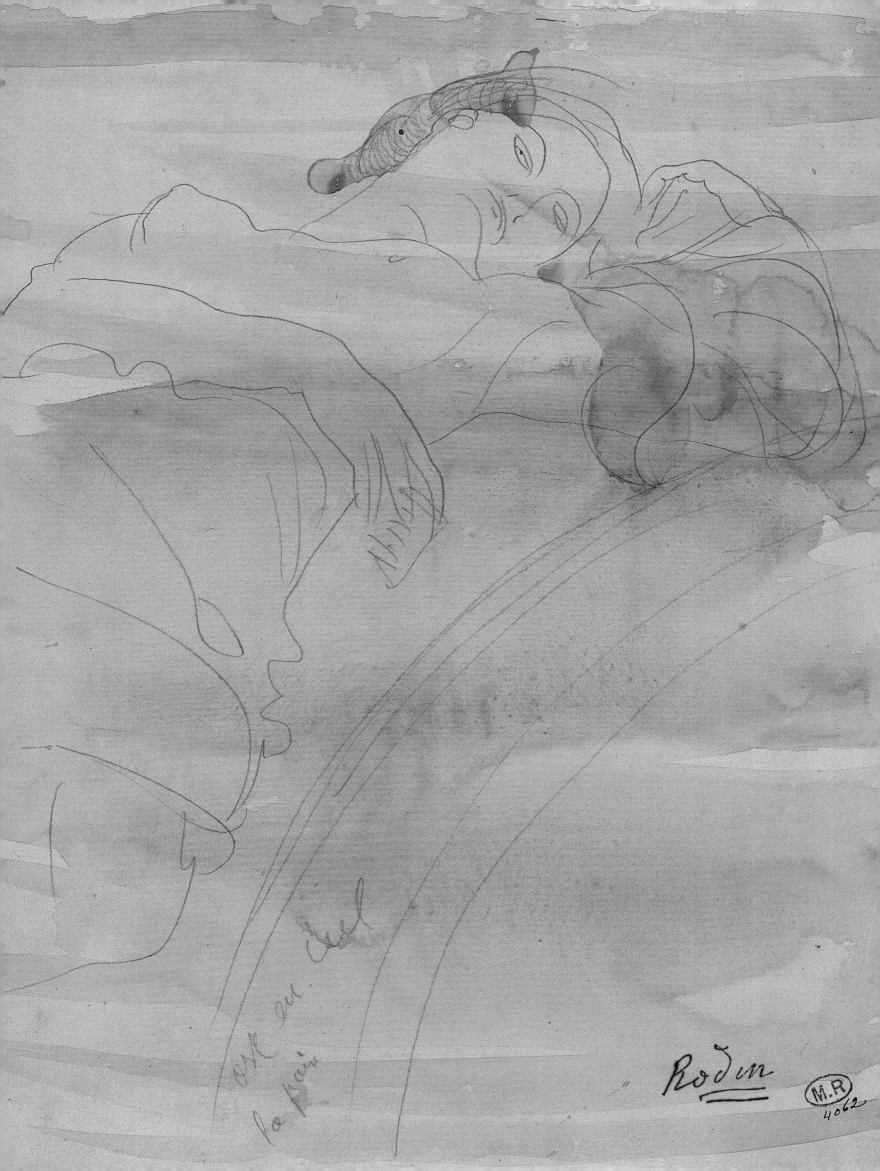

Rodin

M.R
4062

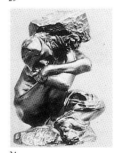

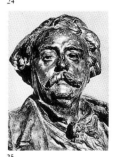

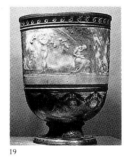

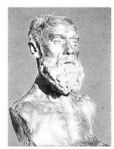

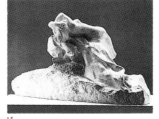

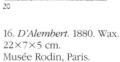

1. *Bust of Father Eymard.* 1863. Bronze. 59×29×29 cm. Musée Rodin.

2. *Jean-Baptiste Rodin.* c. 1864. Bronze. 41×28×24 cm. Musée Rodin, Paris.

3. *Bacchante.* c. 1865. Plaster. Musée Rodin, Meudon.

4. *Mme Cruchet.* 1865-70. Terracotta. 27×10×12 cm. Musée Rodin, Paris.

5. *Young girl with flowers in her hair.* c. 1868. Plaster. 52×36×26 cm. Musée Rodin, Paris.

6. *M et Mme Garnier.* 1869-70. Terracotta. 45×46×27 cm. Musée Rodin, Paris.

7. *Young Woman and Child.* c. 1869. Bronze. 57×24×36 cm. Musée Rodin, Paris.

8. *Titans' Basin.* Terracotta. Musée Rodin.

9. *Le docteur Thiriard.* 1872. Plaster. 57×47×28 cm. Musée Rodin, Paris.

10. *Bust of Beethoven.* Medallion. Signed by Van Rasbourg. Conservatoire de musique, Brussels.

11. *L'Idylle d'Ixelles.* 1876. Bronze. 56×40×40 cm. Musée Rodin.

12. *Bellone.* 1878. Terracotta. 80×47×45 cm. Musée Rodin, Paris.

13. *Call to Arms.* 1878. Study. Plaster. 235×105×80cm. Musée Rodin, Paris.

14. *La Petite Mousquetaire.* 1879. Marble. 66.5×38.4×27.2 cm. Unsigned, undated. Musée Rodin.

15. *The Temptation of Saint Anthony.* 1880-90. Plaster. 61.9×97.8×75 cm. Spreckel collection.

16. *D'Alembert.* 1880. Wax. 22×7×5 cm. Musée Rodin, Paris.

17. *Adam.* 1880. Plaster. 192×75×75 cm. Musée Rodin, Meudon.

18. *Mask of woman with turned-up nose.* 1880? Bronze. 11.5×11.5×7.9 cm. Signed A. Rodin. Spreckel collection.

19. *Night.* 1880-1. Pompeian vase. Porcelain. 32×22 cm. Musée Rodin, Paris.

20. *Jean-Paul Laurens.* 1881. Bronze. 56×33×31 cm. Musée Rodin, Paris.

21. *Alphonse Legros.* 1881. Bronze. 29×18×23 cm. Musée Rodin, Paris.

22. *Bas-relief for a detail from The Gates of Hell.* Plaster. 30×112×20 cm. Musée Rodin, Meudon.

23. *Bas-relief for The Gates of Hell.* Plaster. 30×112×20 cm. Musée Rodin, Meudon.

24. *Fallen caryatid carrying her stone.* Before 1881. Gilded Bronze. 44×32×32 cm. Musée Rodin, Paris.

25. *Carrier-Belleuse.* 1882. Bronze. 59×39×26 cm. Musée Rodin, Paris.

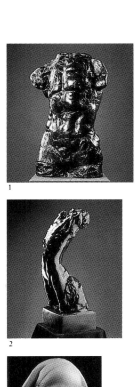
1

6

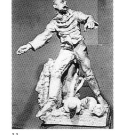
11

16

21

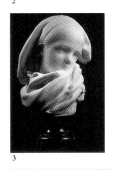
2

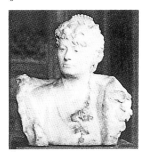
7

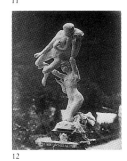
12

17

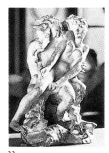
22

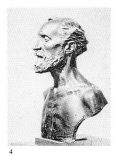
3

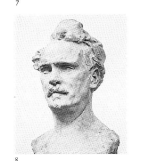
8

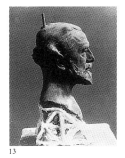
13

18

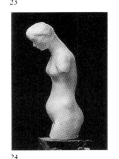
23

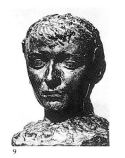
4

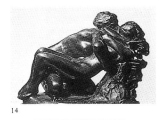
9

14

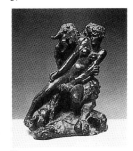
19

24

5

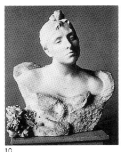
10

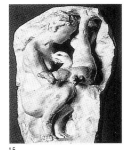
15

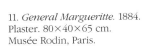
20

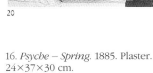
25

1. *Torso of L'Homme qui Marche.* 1882. Bronze. 108×68×42.5 cm. Musée Rodin, Paris.

2. *Narcissus.* After 1882. Bronze. 76.8×31.1×34 cm. Musée Rodin.

3. *Alsatian orphan.* 1883. Marble. 30.2×22.4×17.5 cm. Signed A. Rodin, no date. Musée Rodin.

4. *Jules Dalou.* 1883. Bronze. 57×26×17 cm. Musée Rodin, Paris.

5. *Earth.* 1884. Bronze. 46×105×38 cm. Musée Rodin.

6. *Damned Woman Struck by Lightning.* Around 1884. Bronze. 22×37×16 cm. Musée Rodin, Paris.

7. *Mme Alfred Roll.* 1884. Marble. 56×48×33 cm. Musée Rodin, Paris.

8. *Henri de Rochefort.* 1884. Plaster. 57×26×17 cm. Musée Rodin, Meudon.

9. *Camille Claudel.* 1884. Bronze. 27×21×21 cm. Musée Rodin, Paris.

10. *Mme Luisa Lynch de Morla Vicuna.* 1884. Marble. 57×49×35 cm. Musée Rodin, Paris.

11. *General Margueritte.* 1884. Plaster. 80×40×65 cm. Musée Rodin, Paris.

12. *Orpheus and the Furies.* 1884. Plaster. 23.5×17.5 cm.

13. *Antonin Proust.* 1884. Earthenware or bronze. 34.6×25.4 cm. Atelier Rodin.

14. *Ovid's Metamorphoses. c.* 1885. Bronze. 33×40×26 cm. Musée Rodin, Paris.

15. *Young mother in grotto.* 1885. Plaster. 37×27×20 cm. Musée Rodin.

16. *Psyche – Spring.* 1885. Plaster. 24×37×30 cm. Musée Rodin, Paris.

17. *Daphnis and Lycenion. c.* 1885. Bronze. 29×59×29 cm. Musée Rodin, Paris.

18. *The Idyll,* said to be of Anthony Roux. *c.* 1885. Bronze. 48×28×28 cm. Musée Rodin, Paris.

19. *Crying Girl. c.* 1885. Bronze. 30×18×13 cm. Musée Rodin.

20. *Avarice and Lewdness. c.* 1885. Plaster. 25×56×50 cm. Musée Rodin, Meudon.

21. *Small head of damned woman.* 1885. Bronze. 9×8×8 cm. Musée Rodin, Paris.

22. *The Minotaur. c.* 1886. Plaster. 34×25×25 cm. Musée Rodin, Paris.

23. *Contorted hand.* 1884-6. Plaster. 46×29×19 cm. Musée Rodin, Meudon.

24. *Female torso.* 1886. Plaster. 20.4×7×10.2 cm. Unsigned, undated. Spreckel collection.

25. *Faun and Nymph.* 1886. Bronze. 32.7×21.6×29.7 cm. Signed A. Rodin. Spreckel collection.

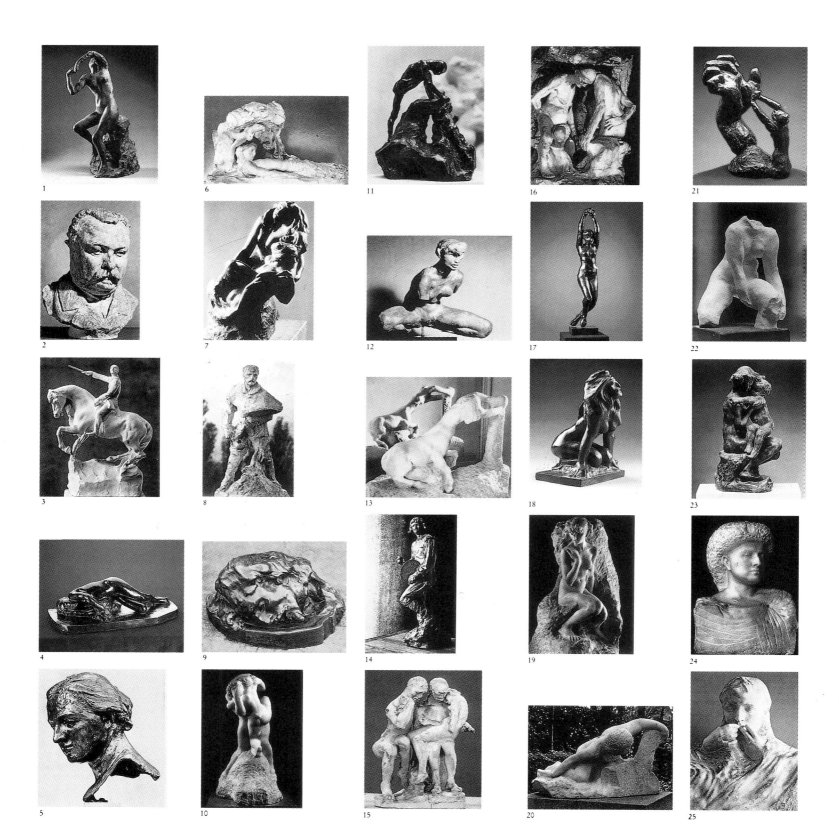

1. *Invocation.* 1886. Plaster. 56.2×24.2×26.7 cm. Musée Rodin.

2. *Omer Dewavrin.* 1886. Plaster. 26×20×15 cm. Musée Rodin, Paris.

3. *Equestian statue of General Lynch.* 1886. Plaster. 45×35×20 cm. Musée Rodin, Meudon.

4. *Exhaustion.* 1887. Bronze. 16×51×19 cm. Musée Rodin.

5. *Mme Russel.* 1887. Silver. 47×29×27 cm. Musée Rodin, Paris.

6. *Death of the poet.* c. 1887. Plaster. 27×45×25 cm. Musée Rodin, Meudon.

7. *The Sirens.* 1887. Bronze. 45×40×30 cm. Musée Rodin, Paris.

8. *Bastien Lepage.* 1887. Plaster. Musée Rodin, Meudon.

9. *Severed head of John the Baptist.* 1887. Bronze. 20×38×30 cm. Musée Rodin, Paris.

10. *The grasp.* Around 1888. Marble. 62×30×41 cm. Musée Rodin, Paris.

11. *Polyphemus and Acis.* 1888. Bronze. 28.2×14.9×22.5 cm. Signed A. Rodin. Spreckel collection.

12. *Large Bather Crouching.* c. 1876. Bronze. 19×24×15 cm. Musée Rodin, Paris.

13. *Centauresse.* 1889. Marble. 71×103×27 cm. Musée Rodin, Paris.

14. *Claude Lorrain.* 1889. Plaster. 36×21×19 cm. Musée Rodin, Meudon.

15. *The Death of Alcestes.* 1889? Study. Plaster. Height: 380 cm.

16. *Dried-up springs.* 1889. Plaster. 60×55×40 cm. Musée Rodin, Meudon.

17. *Aphrodite.* Before 1889. Bronze. 105×22×27 cm. Musée Rodin, Paris.

18. *The Succubus.* 1889. Bronze. 22.9×16×13.2 cm. Musée Rodin, Paris.

19. *Galatea.* 1889. Marble. 60.8×40.6×39 cm. Signed A. Rodin, undated. Musée Rodin.

20. *The Tragic Muse.* Unfinished marble. 92×146.5×96 cm. Unsigned, undated. Musée Rodin.

21. *Contorted hand with imploring figure.* After 1890. Bronze. 42×32×27 cm. Musée Rodin, Paris.

22. *Torso of Seated Woman, without head.* 1890. Plaster. 13.3×10×10 cm. Unsigned, undated. Spreckel collection.

23. *The brother and the sister.* 1890. Plaster. 39×18.5×21 cm. Signed "hommage de vive sympathie. A. Rodin." Spreckel collection.

24. *Study of woman.* Mme Russel. 1890. Marble. 56×43.5×31 cm. Unsigned, undated. Musée Rodin.

25. *The Farewell.* 1892. Plaster. 45×50×40 cm. Musée Rodin, Paris.

1

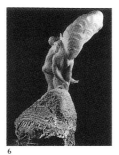
5

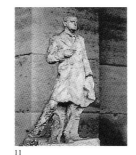
6

11

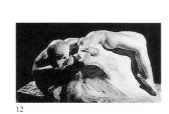
16

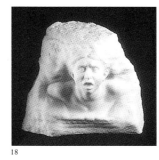
21

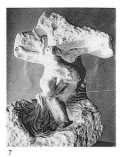
2

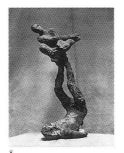
7

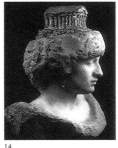
12

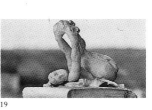
17

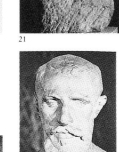
22

3

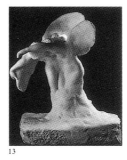
8

13

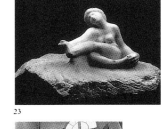
18

23

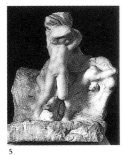
4

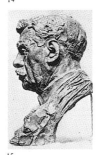
9

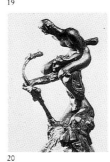
14

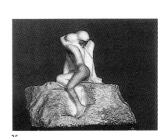
19

24

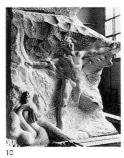
5

15

20

25

1. *Orpheus*. 1892. Bronze. 150×53×50 cm.

2. *The Tower of Labour*. 1893-9. Plaster. Height: 90 cm. Musée Rodin, Meudon.

3. *Séverine*. 1893. Bronze. 14.3×12.5×12.5 cm. Signed Rodin. Spreckel collection.

4. *Victor Hugo*. 1893. Bronze. 117×51×59 cm. Musée Rodin, Paris.

5. *Love carrying away its veils*. 1894? Marble. 75×60×65 cm. Unsigned, undated. Musée Rodin.

6. *The creation of woman*. 1894. Marble. 90×57×46 cm. Unsigned, undated. Musée Rodin.

7. *Christ and Magdalen*. 1894. Plaster. 88×73×45 cm. Musée Rodin, Paris.

8. *The Juggler and the Acrobat*. 1892-5. 39.8×29 cm.

9. *The Fall of Icarus*. *c.* 1895. Plaster. 45×69×36 cm. Musée Rodin, Paris.

10. *Apollo mastering Python*. *c.* 1895. Plaster. 250×225 cm. Musée Rodin, Meudon.

11. *President Sarmiento*. *c.* 1895. Model. Plaster. 64×32×32 cm. Musée Rodin, Meudon.

12. *The Fall of an angel*. *c.* 1895. Marble. 42×81×83 cm. Musée Rodin, Paris.

13. *The Benedictions*. 1896?-1911. Marble. 90×75.5×66.5 cm. Unsigned, undated. Musée Rodin.

14. *Pallas at the Parthenon*. 1896. Marble & plaster. 45×36×34 cm. Unsigned, undated. Musée Rodin.

15. *Bust of Falguière*. 1897. Bronze. 43×24×26 cm. Musée Rodin, Paris.

16. *Plan for façade of la Sapiniére*. 1897. Plaster. 30×148×23 cm. Musée Rodin, Meudon.

17. *Hallway of la Sapinière*. House in Evian. *c.* 1897. Stone quarried from l'Estaillade in the Vaucluse.

18. *The Storm*. 1898. Marble. 44.3×50.3×29.3 cm. Musée Rodin, Paris.

19. *Ecclesiastes*. *c.* 1898. Plaster. 30×40×35 cm. Musée Rodin, Meudon.

20. *Faun with Bow*. 1898. Bronze. 34×17×17 cm. Musée Rodin.

21. *The Earth and the Moon*. 1899. Marble. 125.5×78×58 cm. Unsigned, undated. Musée Rodin.

22. *Roger Marx*. 1899. Plaster. 40×20×20 cm. Musée Rodin, Meudon.

23. *The Shell and the Pearl*. *c.* 1899. Marble. 38.8×77.2×76.9 cm. Unsigned, undated. Musée Rodin.

24. *Plan for a monument to Puvis de Chavannes*. 1899. Plaster. 23.7×17.5 cm.

25. *The Kind Heart*. 1900. Marble. 74×81 cm. Copenhagen.

1. *Madame Fenaille.* 1900.
Marble. 64.6×59×49.5 cm.
Unsigned, undated. Musée Rodin.

2. *Nymphs playing.* After 1900?
Marble. 53.1×59×44.6 cm.
Signed Rodin, undated.
Musée Rodin.

3. *The Wave.* c. 1901. Marble.
63.8×119×62 cm. Unsigned,
undated. Musée Rodin.

4. *Barbey d'Aurevilly.* 1901.
Original wax. 28×33×20 cm.
Musée Rodin, Paris.

5. *Eve and the serpent.* 1901.
Marble. 50×33.4×22.6 cm.
Unsigned, undated. Musée Rodin.

6. *Mrs Simpson.* 1902.
58×54×33 cm.
Musée Rodin, Paris.

7. *Mme de Nostitz.* 1902.
Glass paste. 23×22×9 cm.
Musée Rodin, Paris.

8. *The English doctor.* 1902.
Marble. 55×52×46 cm. Signed
Rodin. Musée Rodin.

9. *Last Vision.* 1903. Marble.
49.6×66.8×25.5 cm. Signed
A. Rodin, undated. Musée Rodin.

10. *The Death of Adonis.* 1903-6.
Marble. 55.5×87.6×59.2 cm.
Unsigned, undated. Musée Rodin.

11. *George Wyndham.* 1903.
Bronze. 50×45×28 cm.
Musée Rodin, Paris.

12. *Muse for the monument to
Whistler.* 1903. Plaster.
225×85×120 cm.
Musée Rodin, Paris.

13. *Group of two figures and a
child.* 1903? Unfinished marble.
57×52×29 cm.
Unsigned, undated.

14. *The Athlete.* 1903. Bronze.
40×29×25 cm.
Musée Rodin, Paris.

15. *Mrs Potter-Palmer.* 1903.
Plaster. 66×48×45 cm.
Musée Rodin, Meudon.

16. *The Crying Lion.* After 1903.
Marble. 28×33.4×17.2 cm.
Signed A. Rodin, dated 11.05.1881.

17. *France.* 1904? Plaster and
earthenware. Date unknown.

18. *Nature. Eve Fairfax.* 1904-7.
Marble. 57×69×51 cm. Signed A.
Loie. Rodin.
Spreckel collection.

19. *Bacchus at the vat.* 1904.
Marble. 61.5×46.7×45 cm.
Unsigned, undated. Musée Rodin.

20. *Paolo and Francesca in the
clouds.* 1904. Marble.
66×68×56 cm. Signed A. Rodin,
date and inscription 1st model
1904.

21. *Renée Vivien.* 1904. Marble.
43×31×25.7 cm.
Unsigned, undated. Musée Rodin.

22. *Lovers' Hands.* 1904.
Marble. 44.3×56.9×36.5 cm.
Unsigned, undated. Musée Rodin.

23. *Eve Fairfax.* 1904. Marble.
53×57.7×45.5 cm. Unsigned,
undated. Musée Rodin.

24. *Mme Fenaille.* 1905-1908.
Marble. 58.9×81×65 cm.
Unsigned, undated. Musée Rodin.

25. *Cybèle, or Seated Woman.*
1905. Plaster. 35.5×25.5 cm.

1. *Orpheuse and the Menads.*
1905. Marble. 97.5×60×63.2 cm.
Musée Rodin.

2. *Psyche.* c. 1905. Unfinished
marble. Unsigned, undated.
59.8×29.2×26.2 cm.

3. *Adam and Eve.* 1905. Marble.
51×86.5×54.9 cm. Unsigned,
undated. Musée Rodin.

4. *Eve Fairfax.* 1905. Marble.
34×54×43.9 cm.
Musée Rodin.

5. *Bernard Shaw.* 1906. Marble.
50×68×40 cm.
Musée Rodin, Paris.

6. *Marcellin Berthelot.* 1906.
Bronze. 30×20×18 cm.
Musée Rodin, Paris.

7. *La Comtesse de Noailles.* 1906.
Terracotta. 41×45×24 cm.
Musée Rodin, Paris.

8. *La Femme slave.* 1906.
Marble. 63.4×68.3×61 cm.
Musée Rodin.

9. *Mrs Hunter.* 1906. Bronze.
46×44×22 cm.
Musée Rodin, Paris.

10. *By the sea.* c. 1906. Plaster.
56×83×58 cm.
Musée Rodin, Paris.

11. *Aurora and Tithon.* 1906.
Marble. 60×110×54.2 cm.
Unsigned, undated. Musée Rodin.

12. *Lord Howard of Walden.*
1906. Bronze. 63×50×30 cm.
Musée Rodin, Paris.

13. *Joseph Pulitzer.* 1907. Plaster.
69×92×49 cm.
Musée Rodin, Paris.

14. *Mme Elisseieff.* 1907. Marble.
Hermitage Museum, Leningrad.

15. *Obsession.* 1907. Marble.
57.5×43.3×47.5 cm. Unsigned,
undated. Musée Rodin.

16. *Day and Night.* 1907. Marble.
73.7×112.5×56.7 cm. Unsigned,
undated. Musée Rodin.

17. *Psyche carried off by the
chimera.* 1907. Marble,
48×57×49 cm. Unsigned,
undated. Musée Rodin.

18. *Flowers in a vase.* 1908.
Marble. 49.5×61.5×50.5 cm.
Unsigned, undated. Musée Rodin.

19. *Duchesse de Choiseul.* 1908.
Bronze. 30×23×16 cm.
Musée Rodin, Paris.

20. *Ariane.* 1908-11. Marble.
96×204×89 cm. Unsigned,
undated. Musée Rodin.

21. *The Poet and the Siren.* 1909.
Marble. 82×68.7×50 cm.
Unsigned, undated. Musée Rodin.

22. *Napoleon.* c. 1909. Plaster.
69×92×49 cm.
Musée Rodin, Paris.

23. *The Hawk and the Dove.*
1909? Marble. 117×72×71 cm.
Unsigned, undated. Musée Rodin.

24. *Lady Warwick.* 1909. Marble.
74.8×86.4×75 cm. Unsigned,
undated. Musée Rodin.

25. *Torso of Young Woman.*
1909. Bronze. 99×45×30 cm.
Musée Rodin, Paris.

1. *The Secret*. Marble. 1909. Unsigned, undated. 89×49.7×40.7 cm.

2. *Niobe*. 1909. Unfinished marble. 195.8×140×82 cm. Unsigned, undated. Musée Rodin.

3. *Gustave Mahler*. 1909. Bronze. 34×24×22 cm. Musée Rodin.

4. *Zephyr and Psyche*. 1909. Marble. 84×47.3×69.3 cm. Unsigned, undated. Musée Rodin.

5. *Edward H. Harriman*, 1909. Plaster. 48×22×25.4 cm. Musée Rodin, Meudon.

6. *Thomas F. Ryan*. 1909. Bronze. 58×54×54 cm. Musée Rodin, Paris.

7. *Right Hand*. 1910. Bronze. 9.8×4.9×3.2 cm. Signed A. Rodin. Spreckel collection.

8. *Crouching Dancer*. c. 1910. Terracotta. 9.5×13×17 cm. Musée Rodin.

9. *Female torso (to the waist)*. 1910. Bronze. 74.3×31.1×60 cm. Signed Rodin. Spreckel collection.

10. *Feeble mother and daughter*. 1910. Marble. 105×94×70.7 cm. Unsigned, undated.

11. *God protecting his creatures*. c. 1910. Terracotta. 20×26×11 cm. Musée Rodin, Meudon.

12. *Mozart*. 1910. 32×95×62 cm. Musée Rodin, Paris.

13. *Pan and Nymph*. 1910. Marble. 95.6×77.7×66 cm. Unsigned, undated. Musée Rodin.

14. *The Spirit of Eternal Rest*. 1910-14. Marble. 216×142.4×101.9 cm. Unsigned, undated. Musée Rodin.

15. *Puvis de Chavannes*. 1911-13. Marble. 81.9×120×55.5 cm. Unsigned, undated. Musée Rodin.

16. *Clemenceau*. 1911-12. Marble. 65×69×59 cm. Unsigned, undated. Musée Rodin.

17. *The Broken Lily*. 1911. Marble. Cemetery of Saint-Acheul, Amiens.

18. *Punishment and Chastisement*. Original version for Salon. 1912. Plaster. 37×27.6 cm. Musée Rodin, Meudon.

19. *Monument to Eugène Carrière*. Uncompleted project. Plaster. 41×20×21 cm. Musée Rodin, Paris.

20. *Edward H. Harriman*. 1913. Marble. 40×46×60 cm. Unsigned, undated. Musée Rodin.

21. *The Spring*. 1914. Marble. 90×56×74 cm. Unsigned, undated. Musée Rodin.

22. *Hand emerging from tomb*. 1914. Marble. 60×56×47 cm. Musée Rodin.

23. *John Winchester de Kay*. 1914. Marble. 54×71×44 cm. Unsigned, undated. Musée Rodin.

24. *Lady Sackville-West*. 1914-16. Marble. 57×75×57 cm. Unsigned, undated. Musée Rodin.

25. *Dancers standing, holding foot*. 1914-18. Unfinished marble. 114×70×47 cm. Unsigned, undated. Musée Rodin.

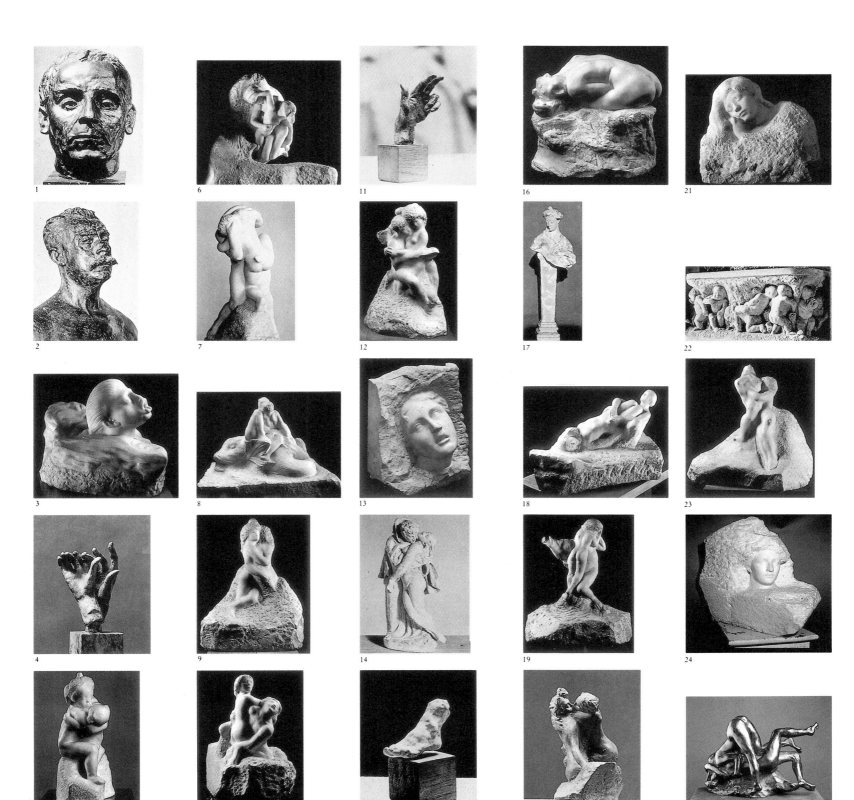

1. *Benedict XV.* 1915. Unfinished. Bronze. 26×18×21 cm. Musée Rodin, Paris.

2. *Etienne Clementel.* 1916. Unfinished. Bronze. 55×37×28 cm. Musée Rodin.

3. *Woman-fish.* 1917. Marble. 34×34.1×43.5 cm. Musée Rodin.

4. *Two Right Hands.* Plaster. 10.5×7.7×5.7 cm. Unsigned, undated. Spreckel collection.

5. *Children embracing.* Marble. 38.6×18.4×16.6 cm. Musée Rodin.

6. *Paolo and Francesca.* Marble. 81×108×65 cm. Unsigned, undated. Musée Rodin.

7. *Sin.* Marble. 62×31×41 cm. Unsigned, undated. Musée Rodin.

8. *Tritonus and Nereid on a dolphin.* Marble. 51×80×49 cm. Musée Rodin.

9. *Entwined women.* Unfinished marble. 76×56×45 cm. Unsigned, undated.

10. *Rapture and Delight.* Marble. 83×73×50 cm. Unsigned, undated. Musée Rodin.

11. *Left Hand.* Plaster. 14.9×8.3×4.8 cm. Unsigned, undated. Spreckel collection.

12. *Psyche and Cupid.* Marble. 68.5×44.3×46.5 cm. Unsigned, undated. Musée Rodin.

13. *Greek Head.* Marble. 35.6×29.8×17.4 cm. Signed Rodin. Spreckel collection.

14. *The Monk.* Terracotta. Musée Rodin, Meudon.

15. *Study of left foot.* Plaster. 7.8×3.8×10.8 cm. Undated. Spreckel collection.

16. *Andromeda.* Marble. 26×30×21 cm. Signed A. Rodin, undated. Musée Rodin.

17. *Bust of Mme Fenaille.* Musée Rodin, Meudon.

18. *The Fall of Icarus.* Marble. 41.7×85×51.5 cm. Unsigned, undated. Musée Rodin.

19. *Constellation.* Marble. 84×80×35 cm. Unsigned, undated. Musée Rodin.

20. *Bacchantes embracing.* Plaster. 15.9×8.3×14.9 cm. Signed: "Deux . . ." (indecipherable). Spreckel collection.

21. *Sleep.* Marble. 48.4×56×47.5 cm. Unsigned, undated. Musée Rodin.

22. *The Vendange.* Jardinière.

23. *Nymphs embracing.* Unfinished marble. 64×69.7×56.8 cm. Unsigned, undated. Musée Rodin.

24. *Aurora.* Marble. 56.2×59.9×53.3 cm. Musée Rodin, Paris.

25. *Damned Women.* Bronze. 21×28×11 cm. Musée Rodin.

Comparative chronology

	Rodin's life	Principal works
1840	Birth on 12 October, in the rue de l'Arbalète, of François Auguste Rodin, son of Jean-Baptiste Rodin and Marie Cheffer.	
1848	Enters School of the Holy Doctrine.	
1850	Starts to draw.	
1851	Goes away to board at his uncle's school in Beauvais.	
1854	Enters the Petite Ecole. Becomes pupil of Lecoq de Boisbaudran, and friend of Dalou and Legros.	
1855	Discovers sculpture.	
1857	Leaves the Petite Ecole.	
1858	Fails the competition for entry to the Beaux-Arts three times. Works with decorative sculptors such as Blanche and Cruchet.	
1862	Death of his sister Maria, at the age of twenty-five. Enters the monastery of the Holy Sacrament.	
1863	Returns to secular life on the advice of Father Eymard. Meets Carpeaux.	*Bust of Father Eymard.*
1864	Beginning of collaboration with Carrier-Belleuse. Meets Rose Beuret. Birth of Camille Claudel.	*L'homme au nez cassé* is turned down by the Salon. Bust of Jean-Baptiste Rodin.
1865	Takes part in the decoration of la Païva's house.	*Young woman in flowered hat.*
1866	Birth of his son, Auguste-Eugène Beuret, on 18 January.	*Bust of Mme Cruchet.*
1867	Works as *praticien* with several different sculptors.	*The Spring.*
1869	Travels to Strasbourg. Mobilised for the 1870 war.	*Mother and Child. Mignon.*
1870	Joins the 158th regiment of the National Guard, with the rank of corporal. Discharged because of his short-sightedness.	
1871	Leaves for Belgium, thanks to Carrier-Belleuse. Works on the decoration of the Bourse.	From 1871 to 1874 paints Belgian landscapes.
1872	Rose joins Rodin in Brussels. End of collaboration with Carrier-Belleuse, who returns to Paris.	*Bust of Docteur Thiriard.*
1874	Palais des Académies in Brussels. In Antwerp, monument to burgomaster Loos.	
1875	Travels to Italy, visits Turin, Rome and Florence.	Begins *The Age of Bronze, Suzon.*
1877	Shows *Le Vaincu* at the Brussels Cercle Artistique, and in Paris. Controversy about *surmoulage*. Returns to Paris with Rose.	
1879	Joins the Sèvres factory, as a non-permanent employee. Meets the Haquette brothers.	*L'homme qui marche*, study for *Saint John the Baptist.*
1880	State order for *The Gates of Hell*. Purchase by State of *The Age of Bronze* for 2200 francs. Studio at the Dépôt des Marbres.	Produce works for the Sèvres factory.
1881	Visits Legros in London. Meets Henley and Stevenson.	Presents *Saint John the Baptist* and *The Age of Bronze* at the Salon. *Les Limbes et les Sirènes. The Thinker. Young Woman and Child.*
1883	Meets Camille Claudel. Father dies.	First drawings for *The Gates of Hell. The Three Shades. Fallen Caryatid.*
1884	Order for *The Burghers of Calais* by the municipality.	*Bust of Victor Hugo.*
1885	Concentrates his activity on *The Burghers* and *The Gates of Hell.*	*Bust of Morla Vicuna*, niece of general Lynch. *Bust of Camille Claudel. Eternal Spring. Aurora.*
1886	Many representations of Camille and figures for *The Gates of Hell.*	*Psyche – Spring. Celle qui fut la belle Heaulmière. Idylle. Young Mother. Venus à sa toilette. La Danaïde. La Martyre.*

Artistic life	History
Birth of Claude Monet. Ingres: *Odalisque à l'esclave*.	Louis-Philippe king of France since 1830. December: return of Napoleon's ashes.
Birth of Octave Mirbeau and Caillebotte. Daumier: *La Révolte*.	1848 revolution followed by reaction and repression in Europe. Barricades in Naples.
Death of Balzac. Birth of Gallimard.	
1850-1 Salon. Courbet: *Burial at Ornans*. Millet shows *La Broyeuse de lin* in London. Death of Turner.	Louis-Napoleon's coup d'état of 2 December. Shooting on the boulevards. Gold rush in Australia.
At the Salon, Courbet shows *Les Demoiselles de village*. Wagner: *Das Rheingold*.	Marcellin Berthelot propounds the principles of thermochemistry. Crimean war and siege of Sevastopol.
1855 Great Exhibition. Courbet exhibited separately, because he had been turned down. Death of Françoise Rude and Gerard de Nerval.	Queen Victoria visits Paris. Opening of the Magasins du Louvre. Alexander II accedes to the thrones in Russia.
Charles Baudelaire writes *Les Fleurs du Mal*. Death of Alfred de Musset. Banville: *Odes Funambulesques*.	Napoleon III visits Le Havre. The conquest of Algeria is completed. Indian Mutiny.
Building of the Opera by Charles Garnier. Pissaro works at Montmorency. Whistler visits northern France.	Formation of the kingdom of Italy. Beginning of the American Civil War. Japan makes a commercial treaty with the United States.
Flaubert: *Salammbô*. Hugo: *Les Misérables*. Jean-Baptiste Carpeaux: *Ugolino and his children*. Gounod: *The Queen of Sheba*. Birth of Debussy.	Great Exhibition in London. French expedition to Mexico. Mexican War. Bismarck becomes prime minister.
Scandal of Manet's *Déjeuner sur l'herbe* at the Salon des Refusés. Jules Verne: *Five Weeks in a Balloon*. Death of Alfred de Vigny.	Cambodia becomes a French protectorate. Opening of the London Underground.
Fantin-Latour: *Hommage to Delacroix*. Manet: *Bullfight*. Offenbach: *La Belle Hélène*.	Cadart founds the Artist's Union. Laws on workers assemblies. Pasteur invents pasteurisation. Founding of the Red Cross.
Manet: *Olympia*. Lewis Carroll: *Alice in Wonderland*. Tolstoy: *War and Peace*.	Monnier invents reinforced concrete. Mendel establishes genetic laws. Slavery is abolished in the United States, Lincoln is assassinated.
Carpeaux shows *Flore* at the Salon. Degas: *Steeplechase scenes*. Monet: *Forêt de Fontainebleau*. Dostoyevsky: *Crime and Punishment*.	Economic crisis in London. First typewriter in the United States. First transatlantic telegraph cable.
Marx: *Das Kapital*. Death of Baudelaire and Ingres. Ibsen: *Peer Gynt*.	Paris Great Exhibition. Tellier invents refrigerating machine.
Carpeaux: *La Danse*. Manet: *The Balcony*. Daudet: *Les Lettres de mon moulin*. Death of Lamartine and Berlioz. Grieg: *Piano Concerto*.	Opening of Suez canal. Watt perfects the first electric motor. First transcontinental train in the United States.
Fantin-Latour: *Manet's studio at Batignolles*. Bazille: *La Toilette*. Renoir: *Baigneuse au griffon*. Death of Lautreamont, Merimee and Dickens.	19 July – France declares war on Prussia. 4 September – Third Republic declared. Siege of Paris.
Verdi: *Aïda*. Cezanne: *Neige fondante a l'Estaque*. Durand-Ruel exhibition of modern painting in London. Death of Bazille. Birth of Roualt.	18 March - 28 May, the Commune insurrection. April-May, second siege of Paris.
Jules Verne: *Around the World in Eighty Days*. Renoir's *Parisiennes en Algériennes* turned down at the Salon. Toulouse-Lautrec enters the Lycée Condorcet.	Meeting of the three Emperors. Invention of bakelite. Secret ballot in England.
Appearance of the word "impressionism". Death of Gleyre. First exhibition of impressionist group at Nadar.	Creation of Universal Postal Union. Laws on child labour. In Germany, Cantor establishes the theory of sets for irrational numbers.
Death of Corot and Millet. Caillebotte: *The Floor Polishers*. Huysmans: *Marthe*. Inauguration of the Palais Garnier.	Codification of international postal tariffs. Birth of Social Democratic Party in Germany.
Death of Courbet. Third Impressionist exhibition. Zola: *L'Assommoir*. Dostoyevsky: *The Brothers Karamazov*. Tchaikovsky: *Swan Lake*.	Queen Victoria becomes Empress of India. School becomes obligatory in Italy.
Death of Daumier. Manet: *Boat Ride*. Fantin-Latour: *Drawing Lesson at the studio*. Sisley and Cézanne turned down by the Salon.	Jules Grévy is President of the Republic. Founding of French Workers' Party.
Renoir: *Young girl asleep*. Manet: *At Father Latuille's*. Jongkind: *Day and Night*. Borodin: *In the steppes of Central Asia*. Death of Flaubert.	Tahiti becomes a French colony. Invention of celluloid. Free primary education.
Renoir: *Jeanne Samary*. Puvis de Chavannes: *The Poor Fisherman*. Maupassant: *La Maison Tellier*. Henry James: *The Bostonians*.	Electric lighting on the Grands Boulevards. Test of Pasteur's vaccination.
Birth of Kafka. Exhibition of Japanese prints at Georges Petit's gallery. Death of Manet.	Dion-Bouton steam-powered car.
First exhibitions of independent painters. Nietzche: *Thus spake Zarathustra*. Mark Twain: *The Adventures of Huckleberry Finn*.	Waldeck-Rousseau law authorises trade unions. Law on divorce. Anzin strike. Discovery of gold in the Transvaal.
Death of Victor Hugo. Bruant instals "Le Mirliton" in the boulevard Rochechouart.	Pasteur experiments on rabies. Freud at la Salpêtrière.
Gaugin's first visit to Pont-Aven. Toulouse-Lautrec exhibits at the "incoherents". Stevenson: *Doctor Jekyll and Mr Hyde*. Zola: *L'Oeuvre*.	Durand-Ruel puts on first Impressionist exhibition in the United States.

	Rodin's life	Principal works
1888	Camille and Rodin rent the Clos-Payen as a studio.	Illustrations for *Les Fleurs du Mal*. *Grande baigneuse accroupie*. *L'Emprise*. *Le Péché*. State order for *The Kiss*.
1889	Exhibition of Rodin and Monet's work at the Petit gallery. Order for monument to Victor Hugo.	*Le Rêve*, study for *The Eternal Idol*.
1890	Journey to Touraine and Anjou with Camille.	*La Petite Fée des eaux*. Bust of Rose. *Iris, messagère des dieux*. Studies for *Victor Hugo*.
1891	Order for statue of Balzac. Journey to Touraine with Camille. *Victor Hugo* project turned down.	Studies for *Balzac*.
1892	Made officer of the Legion d'honneur. Unveiling of the *Monument to Claude Lorrain* at Nancy.	*L'Adieu*. *La Convalescente*. *Orpheus begging for the return of Eurydice*.
1893	Rodin succeeds Dalou as president of the sculpture section of the Societé nationale des Beaux-Arts.	Statue of *Victor Hugo*. *Orpheus and Eurydice*.
1894	Journey to the south of France. Meets Cézanne at Claude Monet's house at Giverny. First attacks on *Balzac*.	Works on *Balzac*.
1895	16 January, presides over the Puvis de Chavannes banquet. *The Burghers of Calais* unveiled. Liaison with Camille renewed.	
1897	Moves to the Villa des Brillants in Meudon. *Balzac* crisis.	*La Voix intérieure*.
1898	*The Kiss* and *Balzac* at the Champ-de-Mars gallery. *Balzac* turned down by Societé des gens de lettres. Break with Camille.	Presentation of *Balzac*.
1899	Exhibition in Belgium. Prepares pavilion for the Great Exhibition. Order for a statue of Puvis de Chavannes.	*Woman undressing*.
1900	Inauguration of the Pavillon de l'Alma. Rodin gets his money back. Revelation of the erotic drawings.	
1902	Goes to Prague for his exhibition. Visits London. On 2 September meets Rainer Maria Rilke. Meets Isadora Duncan.	*La Main de Dieu*. *La Main du Diable*.
1903	Isadora dances for him at Vélizy. Succeeds Whistler as the head of the International Association of Painters, Sculptors and Engravers.	Exhibition in Germany.
1904	Liaison with a young painter, Gwen John. Meets the duchesse de Choiseul.	Exhibition at the Metropolitan Museum. *Bust of Eve Fairfax. Lovers' Hands. La France*.
1905	Rilke becomes his secretary. Travels to Spain with Zuolaga. Wanda Landowska plays for him in the gardens at Meudon.	Exhibits for the first time at the autumn Salon.
1906	April – *The Thinker* is placed in front of the Panthéon. Rilke is dismissed. Draws the *Cambodian Dancers*.	Project for a *Muse for a monument to Whistler*.
1907	Honorary doctorate at Oxford. Correspondence with Rilke.	
1908	Edward VII visits Rodin's studio at Meudon. Rilke discovers the Hôtel Biron for Rodin.	*The Cathedral*. Drawings of dancers. *La duchesse de Choiseul. Mother and child. Hanako*.
1909	Unveiling of statue of *Victor Hugo*.	*The Secret*.
1910	Grand officer of the Légion d'honneur.	Study for *La Danse*.
1910	Short visit to London. Conversations with Paul Gsell.	*Bust of Gustav Mahler. Assemblage*.
1912	Journey to italy. Break with the duchesse de Choiseaul.	*Nijinsky*.
1913	Camille interned. Rodin sends money for the asylum.	
1914	Journey to London, then to the south of France for reasons of health. Returns to London, then to Italy with Rose and Loïe Fuller.	*Main sortant de la tombe*.
1915	Further stay in Italy. Returns to Paris with Boni de Castellane.	Begins bust of Benedict XV.
1916	Further attack of hemiplegia. Gift and bequest to the State.	
1917	Marries Rose Beuret on 29 January. Rose dies on 14 February, and Rodin on 17 November. Funeral at Meudon on 24 November.	

Artistic life	History
..th Salon des Indépendants. Seurat shows *La Parade*. Departure of Van ..ogh to Arles. Debussy: *Ariettes oubliées*.	Founding of the Pasteur Institute. Dunlop and Michelin invent the pneumatic tyre. William II succeeds to the throne of Prussia.
..he Eiffel Tower is completed. Manet retrospective at the Great Exibition. Subscription for *Olympia*. Tchaikovsky: *The Sleeping Beauty*.	Great Exhibition. Military service for all. Suicide of Archduke Rudolf of Austria at Mayerling. Dockers strike in London.
..lympia in the Musée du Luxembourg. Monet's *Meules* series. Anatole ..rance: *Thaïs*.	Franco-Russian alliance. Internationalisation of 1 May as workers' holiday. Perfection of the bicycle. Bismarck resigns.
..ary Cassatt's first one-woman exhibition. Death of Jongkind and Seurat. ..augin leaves for Tahiti.	May 1 disturbances. Beginning of negotiations with Russia. Boulanger commits suicide in Brussels. Pavlov works on conditioned reflexes.
..eurat and Renoir retrospectives at the Durand-Ruel gallery. Maeterlinck: ..elleas and Mélisande. Massenet: *Werther*. Tchaikovsky: *The Nutcracker*.	Lorentz discovers electrons.
..onet: *Cathedrals* series. Lautrec meets Yvette Guilbert. Opening of the ..ollard gallery. Death of Gounod. Shaw: *Common Sense in Art*.	Founding of the confederation of Ruhr coalmines. The motorcycle appears in Italy. Invention of the diesel engine.
..ipling: *The Jungle Book*. Debussy: *Prélude a l'après-midi d'un faune*. ..vořák: *New World Symphony*.	Beginning of the Dreyfus affair. Unemployed march on Washington.
..alon des Indépendants. Art Nouveau exhibition at the Champ-de-Mars. ..eath of Berthe Morisot. Renoir in London with Gallimard.	Founding of the Nobel prize. The Lumière brothers invent the cinema. Röntgen discovers X-rays.
..onet: *Waterlilies*. Gide: *Les Nourritures terrestres*. H. G. Wells: *The Invisible Man*. Klimt founds the Vienna Secession.	Ader flies with a steam motor. First electric tramways. Troubles in Italy.
..auguin attempts suicide. Death of Edmond Maître, Mallarmé, and Taine. ..ola: *J'accuse*. Messenger: *Véronique*. Mann: *Buddenbrooks*.	Pierre and Marie Curie discover polonium and radium. Zola is attacked for his position on the Dreyfus affair.
..eath of Sisley. Gauguin founds *Le Sourire*. Ravel: *Pavane pour une ..fante defunte*. Debussy: *Trois Nocturnes*. Tolstoy: *Resurrection*.	Dreyfus is condemned. Boer war in South Africa. Marconi perfects the wireless.
..ergson: *Le Rire*. Pissaro: *Vues du Pont-Neuf*. Charpentier: *Louise*. ..uccini: *Tosca*. Death of Nietzsche.	United States goes onto the gold standard. King Umberto I of Italy is assassinated. The Maillot/Vincennes métro line is inaugurated.
..eath of Zola. Rilke: *The Book of Pictures*. Henry James: *The Wings of the ..ove*. Chekhov: *The Three Sisters*. Fauré: *Eight short pieces*.	Completion of the Trans-Siberian railway. Loubet is elected president of the Republic.
..irbeau: *Les affaires sont les affaires*. Death of Gauguin. Caruso makes ..is debut at the Metropolitan Opera. Satie: *Morceaux en forme de poire*.	Paris/Madrid car race. Ford factories open in the United States. The Wright brothers fly with a combustion engine.
..nd autumn salon. Death of Fantin-Latour and Gérome. Picasso at the ..ateau-Lavoir. Puccini: *Madame Butterfly*. Chekhov: *The Cherry Orchard*.	*L'Humanité* appears. Entente cordiale.
..casso's pink period. Scandal of the first Fauve exhibition. Appearance of ..e Brücke group in Germany. Ravel: *Miroirs*.	Separation of Church and State. Einstein establishes the theory of relativity. Strike in Moscow and Saint Petersburg.
..eath of Cézanne. Bergson: *L'evolution créatrice*. Birth of Beckett and ..illy Wilder. Matisse: *Still Life*. Renard: *Huit jours à la campagne*.	Fallières is President of the Republic. Courrières disaster. Law on Sunday as rest day.
..casso: *Les Demoiselles d'Avignon*. Death of Huysmans. Founding of the ..evue Indépendante. Gorky: *The Mother*.	Occupation of Casablanca. Formation of the Triple Entente. Lumière invents colour photography.
..eath of Ravel. Munch: *Mason and mechanic*. Strindberg: *The Blue ..ook*.	Creation of Ministry of Work and Social Security. Franco-German incidents in Casablanca.
..ide: *La Porte etroite*. Barrès: *Colette Baudoche*. Mucha: *Joan of Arc*. ..orice: *Rodin, the cathedrals*. Death of Catulle Mendès.	Treaty with Germany over Morocco. Briand ministry. Blériot crosses the Channel by plane.
..éguy: *Mystère de la charité de Jeanne d'Arc*. Mucha: *Slav Epic*. Debussy: ..rélude. Giacometti: *May Morning*.	Law on retirement for peasants and workers.
..laudel: *L'Otage*. Roualt: *Faubourg des longues peines*. Giraudoux: ..ecole des Indifférents. Death of Legros.	Caillaux ministry. New Franco-German treaty on Morocco and the Congo.
..avel: *Daphnis and Chloé*. Claudel: *L'Annonce faite à Marie*. Anatole ..rance: *Les Dieux ont soif*. Renoir exhibition at the Bernheim gallery.	Poincaré ministry. Morocco a protectorate. Occupation of Marrakesh.
..omain: *Les Copains*. Proust: *Swann's Way*. Fournier: *Le Grand ..eaulnes*. Man Ray: *The Village*. Vuillard: *View of Hamburg*.	Poincaré President of the Republic. Roland-Garros crosses the Mediterranean by plane.
..ide: *Les Caves du Vatican*. Monet: *Waterlilies*. Utrillo: *La Cathédrale de ..eims en flamme*. Birth of Tennessee Williams.	Jaurès assassinated. Germany declares war on France. Battle of the Marne. Battles of the Yser and the Artois.
..urdan: *Naufrage au Sémaphore*. Le Sidaner: *Doges Palace*. Wolf: *La ..raversée des apparences*. Sarah Bernhardt has her leg amputated.	First use of German poison gas. Allied landings at Salonika. Sinking of the *Lusitania*.
..eath of Henry James, Odilon Redon and Jack London. Max Linder films ..he Little Café.	Battle of Verdun. Capitulation of the Fort de Vaux. Joffre, maréchal de France. Nivelle, Commander in Chief of the French armies.
..eath of Degas. Klimt: *Madame Lieser, The Fiancée*. Matisse: *The Piano ..sson*. Rouault: *The Old Clown*. Giraudoux: *Lecture pour une ombre*.	German retreat in Picardy. Lyautey resigns. Chemin des Dames. American troops land at Saint-Nazaire.

Selected Bibliography

A. Rodin, Gustave Geoffroy. Editions Dentu, Paris, 1892.

A. Rodin, Roger Marx. Pan, Berlin, 1897.

Auguste Rodin, statuaire, Léon Maillard. Floury, Paris, 1892.

L'œuvre de Rodin, conférence au pavillon Rodin, 31 juillet 1900, Camille Mauclair. Editions de la Plume, Paris, 1900.

Rodin, Charles Morice. Floury, Paris, 1900.

Auguste Rodin, Rainer Maria Rilke. J. Bard, Berlin, 1903.

Le Sculpteur Auguste Rodin pris sur la vie, Judith Cladel. La Plume, Paris, 1903.

Auguste Rodin, Eine Studie, Lothar Briegel-Wasservogel. Heiz, Strasbourg, 1903.

Rude et Rodin à Bruxelles. W. Sanders-Pierron. Brussels, 1903.

Rodin céramiste. Roger Marx. Société de propagation des livres d'art, Paris, 1907.

Auguste Rodin, l'œuvre at l'homme, Judith Cladel. Van Œst, Bruxelles, 1908.

Rodin l'art, entretiens réunis par Paul Gsell. Grasset, 1911.

Le Vrai Rodin, Gustave Coquiot. Jules Tallandier, Paris, 1913.

Entretiens avec Rodin, Dujardin-Beaumetz et Henri-Charles Etienne. Dupont Paris, 1913.

Auguste Rodin, Camille Mauclair. Renaissance du Livre, Paris, 1918.

Rodin intime ou l'Envers d'une gloire, Marcelle Tirel. Edition due monde nouveau, Paris, 1922.

Rodin, Léonce Bémédite. Rieder et Cie, Paris, 1926.

Rodin's Thinker and the Dilemmas of Modern Public Sculpture, Albert E. Elsen. Yale University Press, 1927.

Rodin in Gesprächen und Briefen, Hélène de Nostitz, 1927 et 1949.

Rodin, l'homme et l'œuvre, Claude Aveline. Les Ecrivains réunis, Paris, 1927.

Lettres à Rodin, Rainer Maria Rilke. Emile Paul, Paris, 1928.

L'Esthétique et la Technique de Rodin, E. Schaub-Koch. Editions de la Nouvelle Revue, 1933.

Rodin sa vie glorieuse, sa vie inconnue, Judith Cladel. Grasset, Paris, 1930.

Rodin, devant la douleur et l'amour. Pierre Geyraud. Editions Revue moderne des arts, Paris, 1937.

Rodin, Georges Grappe. Edition du Phaidon, Paris, 1939.

Rodin et l'anatomie, professeur L. Sauve. Paris, 1941.

A. Rodin, A.G. Romme. Moscou-Léningrad, 1946.

Les Sculptures de Rodin, Jean Charbonneaux. Fernand Hazan, Paris, 1949.

Ecrits sur l'art et sur la vie, Emile Antoine Bourdelle. Plon, Paris, 1955.

Rodin, Cécille Goldscheider. Fernand Hazan, 1956.

Rodin, sa vie, son œuvre, son héritage, Cécile Goldscheider. Les Productions de Paris, Paris, 1962.

Auguste Rodin, Robert Descharnes et Jean-François Chabrun. Edita Lazarus, 1967.

The World of Rodin, William Harcan Hale. Time-Life Library of Art, 1972.

Rodin's Sculpture, Jacques de Caso and Patricia B. Sanders. The Fine Arts Museums of San Francisco Tuttle, 1977.

Dans l'atelier de Rodin, Albert Elsen. Phaidon et Musée Rodin, 1980.

Auguste Rodin, Dessins, Aquarelles, Claude Judrin. Editions Hervas Paris, 1982.

Le Musée Rodin. Monique Laurent. Hazan, 1984.

Rodin, les mains, le chirurgiens, M. Mrerle. M. Laurent, D. Gutmann. Musée Rodin, 1984.

Rodin sculpteur et les photographes de son tempts, Hélène Pinet. Philippe Sers, 1985.

Auguste Rodin Zeichnungen Aquarelle. Verlag Gerd Hatje, 1985.

Rodin Sculpture and Drawings, Catherine Lampert. Art Council of Great Britain, 1986.

Rodin, dessins érotiques, Philippe Solers et Alain Kirili. Gallimard, 1987.

Marbres de Rodin, Nicole Barbier. Musée Rodin, 1987.

Correspondance de Rodin, Musée Rodin, 1987.

Rodin, La Porte de l'Enfer, Carol-Marc Lavrillier et Yann le Pichon. Port Royal, 1988.

Rodin, Pierre Daix. Calmann-Levy, 1988.

Camille Claudel, Monique Laurent et Bruno Gaudichon. Musée Rodin, 1984.

Dossier Camille Claudel, Jacques Cassar. Librairie Séguier-Archimbaud, 1987.

Camille Claudel, Reine-Marie Paris. National Museum of Women in the Arts, Washington D.C., 1988.

Photographic credits

Photographs are by Bruno Jarret © A.D.A.G.P. except:

Collection R. Descharnes	Page 24
Adam Rzepka © A.D.A.G.P.	25
J.C. Marlaud	26
J.C. Marlaud	27
Adam Rzepka © A.D.A.G.P.	29
R. Descharnes (above)	30
Tate Gallery (right)	
A. Rzepka © A.D.A.G.P.	31
R. Descharnes (below)	33
René Dazy (above)	34
Musée du Louvre (below)	
Musée du Louvre (left)	38
1 and 2. Bastin et Evrard (above)	40
Roger Viollet (right)	
Roger Viollet (below)	42
Musée du Louvre (above)	44
Roger Viollet (below)	48
R. Descharnes (above)	50
Roger Viollet (above)	52
Roger Viollet (centre)	58
A. Schaeffer	70
A. Schaeffer	71

A. Schaeffer (below)	76
R. Descharnes (above)	76
A. Schaeffer (centre and below)	79
Roger Viollet (above, below and centre)	80
Roger Viollet (above)	82
Musée d'Orsay	93
R. Descharnes (above and below)	95
R. Descharnes (below)	97
A. Schaeffer (above)	100
A. Schaeffer	101
Roger Viollet (left)	112
R. Descharnes (above)	116
Druet	117
R. Descharnes	118
1. 2. 4) Roger Viollet	120
3) Kharbine-Tapabor	
8 and 10) Kharbine-Tapabor	121
6. 7. 9 and 11) Roger Viollet	
Roger Viollet (above)	140
Roger Viollet (centre)	142
Roger Viollet (centre and below)	144
Roger Viollet (centre and below)	146